Social Theories of Art

A Critique

D0901295

Also by the author

Exploring the Hermeneutics of the Visual (with Barry Sandywell)

Social Theories of Art

A Critique

IAN HEYWOOD

NEW YORK UNIVERSITY PRESS
Washington Square, New York

First published in the U.S.A. in 1997 by
NEW YORK UNIVERSITY PRESS
Washington Square
New York, N.Y. 10003

This book is printed on paper suitable for recycling and
made from fully managed and sustained forest sources.

Library of Congress Cataloging-in-Publication Data
Heywood, Ian, 1948–
Social theories of art : a critique / Ian Heywood.
p. cm.
Includes bibliographical references and index.
ISBN 0–8147–3372–7 (clothbound). — ISBN 0–8147–3531–2
(paperbound)
1. Art and society. I. Title.
N72.S6H47 1997
701'.03—DC21 97–15323
 CIP

Printed in Hong Kong

For my parents, George and Edith Heywood

Contents

List of Plates

Acknowledgements

I would like to thank the following for their various contributions the completion of this work: Barry Sandywell for his sustained support, encouragement, suggestions and criticism; staff of Goldsmiths' College, in particular Mike Phillipson for his teaching, continued interest and discussion and Chris Jenks for support, advice, discussion and help with this project, as well as others; John A. Smith for a collaboration of great importance in the development of my ideas; Maurice Roche and Neil Sellers for energetic enquiry in Sheffield; Malcolm Barnard and Stephen Featherstone for intellectual enthusiasm and stimulating conversations over many years; staff and students of the former Leeds Polytechnic BA Fine Art course – now part of the School of Art, Architecture and Design, Leeds Metropolitan University – from whom I have continued to learn about art during the research for this work, in particular John Bicknell, Alyson Brien, Judy Cain, Pete Ellis, George Hainsworth, Brian McCallion, Kevin O'Brien, Sandy Sykes, Barry Ward, Sandy Weatherson; Emma Rose for her commitment and support; and recently Gérald Cipriani, Nicholas Davey and Nigel Whiteley for opportunities to exchange and develop ideas relating to those explored here; Professor David Chaney and Arthur Brittan for comments on preparatory research.

I am also grateful to Sandy Sykes for allowing me to use part of one of her paintings for the cover.

My research has received support from The Faculty of Cultural and Education Studies and the School of Art, Architecture and Design of Leeds Metropolitan University.

I would also like to thank the following for their permission to use reproductions of works in their collections: Dulwich Picture Gallery, London, for Poussin's *A Roman Road*; The Tate Gallery, London, for Turner's *Venice: Night Scene with Rockets*. Details from the Lorenzetti fresco are reproduced courtesy of the Museo Civico di Siena, Siena.

Introduction

The Art of the City/Art's City

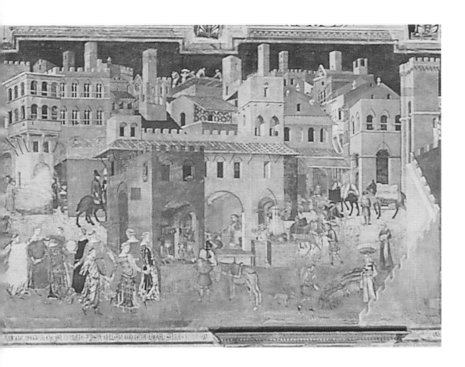

Plate 1. Ambrogio Lorenzetti, *Effects of Good Government*,
c.1337, detail of left-hand section.

1

Ambrogio Lorenzetti's fresco paintings, *The Allegory of Good and Bad Government* (1337–1339) in Siena's Palazzo Pubblico, contain an evocative image of social harmony. In the fresco known as *The Effects of Good Government in the Town and Country* we find, on the left of the picture, the interior of a city opened up for us to see the life and culture made possible by good government (Plate 1).

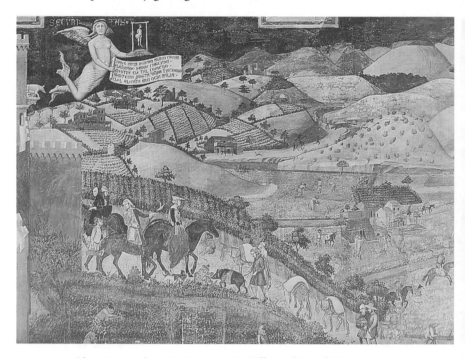

Plate 2. Ambrogio Lorenzetti, *Effects of Good Government,* c.1337, right-hand section.

To the right, beyond the city wall, the countryside is tended and fruitful (Plate 2). Over the wall hovers a winged *Securitas* holding a scroll on which is written:

Senza paura ognuom franco camini
Elavorando semini ciascuno
Mentre che tal comuno
Manterra questa don[a] i[n]
signoria
Chel alevata arei ogni balia

Without fear, let each man freely walk,
and working let everyone sow,
While such a commune
This lady will keep under her rule
Because she has removed all power from the guilty.

(Schmeckebier, 1981, p. 82)

Although they are clearly distinguishable – for example, in the predominant colours used for each area and in the contrast between the linear divisions of the city and the curvilinear organisation of the country – the two 'worlds' are not represented as wholly distinct and separate. Within the landscape we find the characteristically linear patterns of human activity, in buildings, orchards, vineyards, roads, a bridge, hedges. The landscape is populated by figures who seem to belong to the country; their bodies, often bent in toil, echo the curving shapes of the environment they tend (Plate 3). But we also see people who seem to belong to the city, setting out from or returning to it (Plate 2). While the country is obviously the scene of work for many, figures hunting and hawking remind us that it is also a place for recreation.

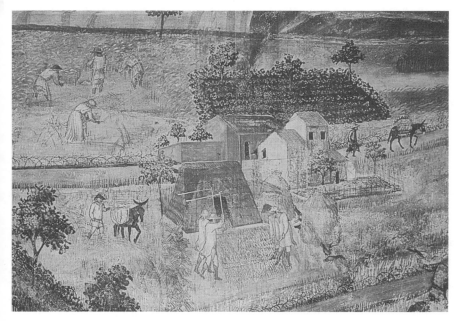

Plate 3. Ambrogio Lorenzetti, *Effects of Good Government*, c.1337, detail.

Turning to the city (Plate 1), although the skyline and middle distance are dominated by buildings, some still under construction, in the foreground can be found many animals and people associated with the countryside: pack horses, donkeys, a flock of sheep driven by a peasant, a hen cradled by a country-woman. Within the buildings, windows reveal signs of life: a head passes a window, a bird cage hangs from a window frame, a vase of blue flowers rests upon a window ledge.

Many of the activities characteristic of the city are also forms of work: buying and selling, the manufacture of cloth and shoes. But centrally situated in the foreground is a circle of elegantly clad women dancing to song and a tambourine (Plate 4). We are surely meant to see this as an image of a kind of culture that only a just and productive society can attain; in their beauty and in their pleasure these women represent the pinnacle of that society's social development. Their activity is not a form of labour but of art. It is through art that the most significant achievements of a society are expressed. This group of dancing figures represents not only the fruits of good government but also art itself.

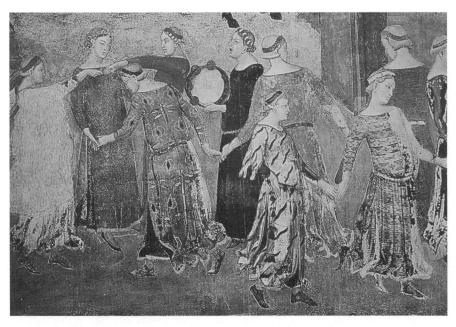

Plate 4. Ambrogio Lorenzetti, *Effects of Good Government*, c.1337, detail.

In its treatment of art as a language and practice, and in its concern for the social relationship between art and other discourses – in particular social scientific discourse – this essay could be said to visualise art as such a city in contact with an 'external' environment. The essay's concern for the nature and quality of the social relationships enacted by forms of theorising resembles the concern of Lorenzetti's fresco for the relationships within the city, and between city and countryside, sustained by good government. Equally, its focus on the relationship between the theory of art and art itself, between a particular kind of text and a particular kind of image or artefact, could be seen as similar to the picture's concern for the interior of the city, its boundaries, and the exchanges that its boundaries regulate.

However, the image of the contemporary city of art and its surroundings from which this essay begins differs in important ways from that offered to us by this part of Lorenzetti's fresco. The scene is not as peaceful and productive as that imagined by Lorenzetti. To put the matter dramatically, the city has been under attack internally and externally. Destruction has occurred through the actions of declared and undeclared enemies, although some of these would claim, and probably believe themselves to be, on the side of art, seeking to deliver it from other powerful, hostile forces. Many of the citizens have not seen the danger, and even when they have done so some of their defensive actions lead only to further encroachments and greater damage. On the other hand, there have been and continue to be examples of successful resistance. So the first task of this essay is to contribute to the defence of art by arguing that some social theorising is socially destructive, both of art and ultimately, perhaps, of theory.

I provide evidence for the general plausibility of this picture in the chapters that follow. A caveat, however, needs to be offered here. The embattled city is, as an image, in some ways misleading, in that a domain which is bounded, settled and supplied unproblematically with internal coherence is simply not what art has been like in the modern period. There is the need for a less clear-cut, more ambiguous image, and in particular one that acknowledges the power and forcefulness of art itself, or at least of cultural weaponry which art can supply.

The *tu quoque* argument is extensively employed in the discussions that follow. It is used to suggest that what is often stated about art as a language or discourse by social theory might and should be applied also to social theory, unless it can be convincingly argued that there are reasons why it should be excluded from the terms of the argument. There

are no such convincing reasons, and the *tu quoque* argument reveals *aporiai* which make necessary a reconsideration of the initial critique.

The social scientific critique of art must share the fate of its victim, ordered by the regime it institutes, because it cannot demonstrate convincingly why it deserves to be treated differently. However, the more radical the scepticism of the self-consciousness of art and other discourses, the more they are either negated or reconstructed by theoretically defined reflectivity, the more difficult it becomes for social science to preserve the sanctity of its own self-consciousness; it carries on business as usual only by actively avoiding, ignoring or denying the reflexive, meta-theoretical questions it generates. To believe that this haunting of sociological worlds by disturbing, displacing concerns could or should make any difference to their everyday practical transactions is, however, perhaps naïve or idealistic. Disciplines, institutions, enterprises cannot be haunted, only individuals.

A second, related task is to explore possible 'political' configurations of the relationship between art practice and social theory, some of considerable historical importance, in the context of other powerful discourses within contemporary culture, particularly those of science and technology. Of course, no political arrangement can be expected to be permanent. Temporary stability – the best that can be expected of any essentially political arrangement – in the relationship between art practice and social theory seems to entail a new art world confidence in its practices, a fresh assertion of those beliefs and values which are philosophically, socially and even psychologically necessary to its continuity and flourishing.

In Lorenzetti's picture the difference between city and country is marked by a wall (Plates 1 and 2). The wall which, towards the centre of the picture, divides the scene almost vertically provides a clear boundary between 'inside' and 'outside' although, as we have seen, the two realms interpenetrate in various ways. The wall certainly does not serve to seal off the city from its surroundings.

The position of the spectator, the vantage point from which city and country are seen, is not pinned down by a unified system of perspective. But the general placing of the buildings suggests that the spectator might be positioned in the vicinity of the wall itself (Plate 1). From an unseen parapet or a tower we look *into* both city and countryside. This might suggest the importance – in the effort to 'place' the practices of art worlds and social theory within either a genuine conversation of discourses or, perhaps more realistically, in a somewhat more distanced relationship of mutual respect – of a position which belongs fully to neither, but which

is nevertheless defined by them. The writing here is thus perhaps best heard as situated 'between' social theory and artistic practice.

The question arises within Lorenzetti's fresco: if the land is so fruitful and the citizens so busy and contented why is the wall necessary? In the context of this essay the answer might be that a condition of good government, understood as living fruitfully with profound differences of language, value spheres, individually and socially articulated realities is a sense of identity, or rather of identities. If art is a language related to other languages it must develop and sustain a positive and negative understanding of what kind of language it is. The wall, here a reminder of the importance of a sense of limit, does not serve to seal art off hermetically from other social worlds, other discourses. Rather, it stands as the condition for a civilised or cultured relationship between worlds, between 'inside' and 'outside'. Consequently, a third task of this essay is to reflect on the distinction between art and language as such. While this difference is made possible by language, the identity of art is lost if its achievements are valorised, most frequently by followers of Nietzsche and some poststructuralists, as self-dissolving instances of difference as difference, of primal chaos or the Protean creation and destruction process of language itself. This is essentially an image of art generated by the needs of particular style of philosophy which, in France at least, has always had deeply political ambitions. If art is to be theorised from the point of view of this philosophy of language it is important to recognise that when art 'resists' analysis, concepts, reflective articulation it does so for its own purposes, not in order to 'mean' or 'represent' something for theorising. Were art to gather itself around difference as difference, or sheer 'thatness', its difference would be reduced to the status of a sign for the being process, or of shifting forces and relations of power generating 'meanings', when its real significance and achievements reside elsewhere; in the production of artefacts with what Charles Taylor calls 'epiphanic' qualities.

Looking closely at Lorenzetti's fresco we note the preservation of the details of depicted objects beyond the foreground; things in the middle distance and even towards the horizon do not lose their sharpness, in an effect that later painters learned to use in order to enhance the illusion of recession and space. In this we witness perhaps Lorenzetti's proximity to earlier Gothic painters. It also resonates, however, with another feature of this essay, specifically the way in which it is written. Both spontaneous practice and deliberate choice determine the specific approach to reading and writing. The voice and character of the author emerge, I hope, from and within a series of conversations with other reader–writers, themselves in dialogue with predecessors and contemporaries. I try to

develop and sustain, irrespective of agreement or disagreement, an attentive, critical yet positive relationship with texts which are important to my argument. While I have attacked specific instances of sociological aggression, and even maintained that a certain violence lies at the core of sociological discourse, my analysis of the problems of discursive relationships characteristic of modernity is, of course, inconceivable without the achievements of social theory. More specifically, the essay provides readings of Durkheim and Weber which reaffirm the importance of their concerns, if not of their specific answers, to a range of urgent contemporary problems in cultural and intellectual life.

This practice of reading and writing is meant to convey a sense of an engagement with tradition. A fascination with a strange coincidence of revealing and making, characteristic of artistic practice – when it goes well – will also be apparent. This coincidence resonates with an ideal form of theorising which respects the work of others, yet which recognises the activity, the constructions, even the projections which this re-animation of tradition demands; a practice arrested by excessive respect becomes inert or even corrupt, while insufficient respect leads only to triviality or monomania. If the relationship with others which tradition represents is vital to art, it is certainly no less vital to theorising.

Chapter 1

Art's World and the Social World

I begin with three sociological accounts of art. Each springs from an influential sociological approach and is reasonably representative of that approach. The works providing these accounts are: Howard Becker's *Art Worlds* (1982), Janet Wolff's *The Social Production of Art* (1981) and *Aesthetics and the Sociology of Art* (1983), and Peter Bürger's *Theory of the Avant-Garde* (1984). The theoretical approaches from which the accounts derive are respectively: symbolic interactionism, Marxism, and critical theory. There are, of course, other sociological approaches, and I do not intend to offer a comprehensive survey of extant sociologies of art. However, I will argue that these works raise certain characteristic or symptomatic[1] issues for a sociology of art *per se*.

At various points the authors confront the nature of the social relationship with art which their account fashions. A sociological account is never just an account *of* some phenomenon but also necessarily *constitutes* a social relationship of one kind or another. Sociology does not just describe or analyse moral phenomena; it is itself inextricably bound to moral questions concerning its own practices. I am not suggesting, however, that consideration of the moral character and consequences of sociological accounts is to be preferred under all circumstances to consideration of their truth claims (however these might be determined), as distinct from their moral character. Rather, I will argue that the former deserves to be given more prominence and treated more rigorously than is often the case in much contemporary sociological practice. In fact, the social relationships with other languages and worlds which a theory constructs should be considered as part of its claim to truth.

The everyday life of art: the reconciliation of art with social life

In the first chapter of *Art Worlds* the American sociologist Howard Becker lists topics that should be considered when art is treated as a social phenomenon. Urging us to think of art as an *activity*, as opposed, for example, to a set of artefacts or individuals with special properties, he draws attention to the kinds of tasks that need doing across different types of art. Initially someone needs to have an idea. This can only be realised through the use of materials and the application of techniques of making; the materials used in production must themselves be produced. Artists need to sustain themselves, and perhaps their dependants, while they are producing art, and there are a variety of ways in which artists can be in contact with the broader society in order to make a living. As Becker includes the appreciation or reception of art in his notion of activity, then there must be an audience capable of identifying the work as art, and of responding to it appropriately. This entails the existence of certain shared conventions and understandings. Within this group – the audience – are people whose function it is to create and maintain the rationale according to which such production and reception are worthwhile. Finally, the activity of art is seen to depend upon an anticipated stability in social affairs which is ultimately guaranteed by the state and the prevailing social, economic and political system. Becker's argument in sum is that art is the outcome of a complex activity which involves many people and a variety of social conditions. It is these chains of socially organised, interacting people and circumstances that constitute what he calls 'art worlds'.

Becker's approach is empirical in tone and emphasis.[2] For example, he distinguishes his interests from a range of familiar philosophical questions about art 'quite different from the mundane organizational problems with which I have concerned myself' (Becker, 1982, p. 39). Discussing debates about the 'institutional theory'[3] he writes:

> None of the participants in these discussions develops as organizationally complicated a conception of what an art world is as does this book. If we use a more complicated and empirically based notion of an art world, however, we can make headway on some problems in which philosophical discussion has bogged down. (ibid., p. 150)

Thus, in considering art as a social activity, and not just as a set of artefacts and their direct producers, he urges and, where available employs the results of, empirical research into the components and conditions of everyday art work. The book deals with such topics as

conventions, resources, the state, editing, the distinction between art and craft, changes in art worlds, types of relationship to art worlds, aesthetics and criticism, and reputations.

Much of what Becker has to say about these topics is informative and unexceptionable. For example, Becker is surely not being generally inaccurate when he describes the relationship between the state and art worlds as follows:

> It [the state] creates the framework of property rights within which artists get economic support and make reputations. It limits what artists can do when it protects people whose rights may have been infringed by artists intent on producing their work. It gives open support to some forms of art, and to some practitioners of those forms, when they appear to further national purposes. It uses state power to suppress work which seems likely to mobilize citizens for disapproved activities or prevent them from being mobilized for appropriate purposes. (ibid., p. 191)

Clearly other sociologists with different theoretical, methodological or ideological commitments could interpret these facts differently, or would want to stress other facts, but few, presumably, would wish to argue that Becker's is not a reasonable generalisation of the kinds of relationship often encountered between the arts and the state. Of more interest here, however, are those points in his argument where a specific social relationship between art and social theory begins to take shape in the practice represented by his account. This occurs principally in two chapters, those on aesthetics and criticism, and on reputations.

Aesthetics and criticism: the institutional theory

Becker's critical view of aesthetics and aestheticians is premised upon a rejection of the claim of traditional aesthetics that the 'artness' of the work of art lies in some inherent and perceptible quality of the object. Rather, whether or not something is to be described as art depends upon the contingent relationship between the object and a relevant social context. Following the American philosopher Arthur Danto and others[4] Becker calls this approach the 'institutional theory'. He portrays the development of this theory as a response by philosophers of art and critics to a crisis precipitated by the success of a type of modernist or avant-garde work. Pieces like Marcel Duchamp's *In Advance of a Broken Arm* (a commercial snow shovel) and *Fountain* (a signed urinal), and later, Andy Warhol's *Brillo* (a large Brillo box) could not be explained and justified in the terms of existing mimetic, expressive or formalist

theories of art; yet they were accepted, bought, sold, exhibited, written about, and eventually respected, indeed revered, by the much of the fine art world in Europe and America.

> Confronted by this fait accompli, aestheticians developed a theory that placed the artistic character and quality of the work outside the physical object itself. They found those qualities, instead, in the relation of the objects to an existing art world, to the organizations in which art was produced, distributed, appreciated and discussed. (ibid., p. 146)

Thus, the institutional theory is a quasi-sociological theory developed by aestheticians and philosophers under pressure from the success of modernism, and the decline or collapse of earlier styles along with the critical theories supporting them. Becker maintains that the institutional theory, supplemented by the findings of proper, detailed sociological research, is capable of dissolving once and for all some recurrent philosophical troubles associated with these older approaches to art.

The account of reputations in art worlds is concerned with similar factors, and also finds a target in some traditional ideas about art, which Becker labels the 'theory of reputations'. This theory suggests that reputations arise and are justified because certain works of art indubitably display the exceptional qualities of their makers, be these of skill, insight, imagination, intellect or sensibility. The unusual quality of certain works evidences the unusual quality of the great artists who produced them. Becker's view, however, is that reputation rests not on the evident qualities of works but on the machinations of art worlds. Looking at reputation as a social fact he points out its dependence on the efforts of critics and historians, a distribution and exhibition system, a market, the approval of relevant audiences and so forth: 'All the co-operation which produces art works, then, also produces the reputation of works, makers, schools, genres and media' (ibid., p. 362). I return to these ideas about reputations later.

Becker also attacks the view that history is the only ultimately reliable arbiter of aesthetic quality. He represents this approach as maintaining that works which last do so because they have been widely and consistently regarded as good and that this must be because they touch universal human sentiments, '... something so deep in human experience that everyone is vulnerable to them' (ibid., p. 366). He notes that even eminent sociologists have accepted this view; they have preferred the study of great works and their creators to, for example, popular traditions of art because they believed that high art was capable of profound insight into the social, historical and psychological conditions

of human beings. Great works of art have been seen as peculiarly interesting for sociology because they have been taken to encapsulate the general outlook of epochs, nations, classes or groups.[5]

While accepting that this view cannot be proved wrong, Becker argues that there is a lot of evidence against it. For example, works with high reputations survive not necessarily because a lot of people like, understand or are affected by them but because they have been, at some time, established as historically important; they have become notable historical and cultural events and have ceased to be, if they ever were, sources of pleasure or insight. Also, if reputations are the result of a judicious comparison of works of the same period or style it has to be admitted that the works which are deliberately compared with one another are usually a very restricted sample of the total number of works produced in that period or style. What about the lost pictures and unplayed symphonies? Some artists now considered of the first rank were ignored for centuries and had to be rediscovered; conversely, artists of great renown in their own day are now almost completely forgotten.[6] Becker summarises the issue:

> the process of selection through which art worlds operate and art reputations are made leaves out most of the works which might be, under other procedures of definition and selection, included in the corpus of what is recognized as art, good or competent art, and great art. (ibid., p. 368)

What counts as art and as great art is contingent upon historical, political and social circumstances.

Becker seems to assume that many specialists, and perhaps the majority of ordinary art world members, are cheerfully wedded to the ideas that 'artness' is some special quality of the object, and that reputations rest solidly and reliably upon comparative judgement of all relevant works by experts or the historical process itself. As we have seen, the former is taken by Becker to be a philosophical pseudo-problem dissolved by the adoption of a sociological perspective while the latter, as a view of history, is either too simplistic or simply wrong. Yet some of Becker's arguments, if accepted by art world members, would tend to undermine beliefs crucial to what many of them would see as art's practical existence and its deeper values.[7] Becker recognises this.

It is necessary to review Becker's arguments about the so-called institutional theory in more detail. It is unsatisfactory to be given a sociological answer to a philosophical question unless it can be shown that sociology is preferable to philosophy either generally or in the particular case. Becker does not argue that sociological accounts are

inevitably superior to philosophical analyses (although there are passages which indicate that this is probably his opinion).[8] However, as we have seen, he does propose the sociological dissolution of some outstanding aesthetic problems. The details are somewhat paradoxical. First, he denies any concern with the development of a 'sociologically based theory of aesthetics' (ibid., p. 145) by which he means a normative theory of aesthetics grounded in sociological facts. Yet what he certainly does propose is a sociologically based theory of aesthetic theories which does have, whether he recognises it or not, significant normative implications. Second, he touches on the irony of a situation in which a sociological theory eliminating outstanding philosophical problems was developed by philosophers in response to a social – or at least critical – crisis in an art world. The problem of the relationship between the claim that the institutional theory is true or more convincing than rival aesthetic theories, and the account of the social and historical conditions of the theory needs to be examined more carefully.

Aesthetic theories and their associated problems are presented as a kind of discursive accompaniment to the internal and external struggles of art worlds. This implies that we should not worry about whether they are true or false because this could only be established as a consequence of their *usefulness* in the context of the concrete, everyday social problems with which art world members have to deal. Concerning oneself with the *truth* of aesthetic theories and judgements is about as sensible as concerning oneself with the veracity of advertising. The point of advertising is to sell things, and the point of aesthetics and criticism is to produce, stave off or manage change in art worlds. Perhaps it is wrong to say that Becker dismisses the problems of the validity of aesthetic judgement? Perhaps it would be more accurate to say that he embraces a *pragmatic* theory of truth?

Even if aesthetics is not wholly vitiated by sociological enlightenment the relationship between members and key beliefs about art is altered. Even if talk about art which includes aesthetic concepts, which affirms the reality and legitimacy of beliefs negated by sociological critique, is allowed some continuing social role – perhaps as a necessary mediation of social and historical forces – a certain *ambivalence* is introduced into the experience of judgement.

Without judgement art is impossible. Producing and interpreting art require the possibility of making practical distinctions between art and non-art, good art and bad art; it is also necessary for members to believe that these distinctions are not merely temporary and contingent but have some real, abiding validity. The language of this kind of

judgement requires ideas and values often associated by sociological critics with 'essentialism'.

If concepts and arguments associated with 'aesthetics' and sometimes with 'essentialism' have been widely used in art world discussions what does this mean? It is not the case, I would argue, that all those who employ this vocabulary are fully and self-consciously committed to a philosophically articulated aesthetic theory but rather that this language has often come to serve, in the usage of those who speak it competently, the ends of art. From the point of view of art world members, as it might be rationally reconstructed if members were allowed this degree of sophistication, it would have to be demonstrated that the language of sociological critique – of sociological ideology – could come to serve the ends of art better.

Returning to the notion that a certain ambivalence must come to characterise the experience of judgement once the insights of sociological critique are accepted, the following points should be made. First, members' interest must survive the translation from an implicit affirmation of the possibility of judgement to something like a willing suspension of disbelief in this capacity. Second, it must also survive the transformation of questions about the qualities of objects into questions about the socially functional consequences of judgement.

More sophisticated social theories of art suggest that we are to see judgements about art made without the benefit of sociological critique as mediations (rather than mechanical reflections) of the social processes that characterise art worlds, along with all other human institutions. If mediation means merely however that social and historical processes have to go the long way round – via prevailing norms, codes, conventions, languages, that is, via culture – in order to find expression, then it would still seem difficult for members to take their own language seriously. After all, they will have come to hear in it only social forces working themselves out, whether mediated or not. It is difficult to see either how it would be possible to believe in the possibility of a significant connection between self-consciousness and thus deliberations about choice of words and the effects of speech, or how one might decide that it was better to say one thing rather than another. The resultant demoralisation would become especially acute if members began to suspect that sociological enlightenment might itself need to be taken at less than face value, that it might even be a myth and, for all except sociologists and their practical purposes perhaps, not a very productive one at that.

Yet mediation might suggest that members have to maintain certain beliefs, to speak a certain language, if there is to be a particular, desired

outcome. Awareness of mediation would suggest the recognition that, although beliefs can only be legitimated pragmatically – in terms of their outcomes – no other beliefs, including those associated with sociological critique, possess validity of a different kind. This kind of approach to judgement suggests a particular type of modern, or perhaps even postmodern, consciousness, but not of a kind one would naturally associate with the straightforward, everyday folk who populate Becker's art worlds.

Social theory and scepticism

What would be the consequences of this kind of enlightenment if applied to sociology and social theory? Sociology and social theory also belong, of course, to a social context, and it would be reasonable to regard some of their features, including aspects of theorised reflection, with proper sociological scepticism. If one were to take seriously the need to expose sociological accounts and the sociological worlds that produce them to what Ricoeur has called the 'hermeneutics of suspicion', to the same apparatus of explanation and critique deployed in relation to art worlds, then it is easy to see how confidence in sociological practice and its accounts would tend to be weakened, or would at least undergo a change of mood.

This is of course an issue familiar to the sociology of knowledge; it has also become a topic for the history and philosophy of science. Elaborate theoretical arguments have been developed which either deny that there is a real problem in need of solution or accept historicity as an inevitable feature of social and historical reasoning.[9] The forging of a new and higher level of reflection in the debate about history, society and knowledge has a certain prophylactic function with respect to everyday sociological activity. Members can get on with the job in hand more or less confident that these necessary, but sometimes difficult and even embarrassing dimensions of sociological self-consciousness, are being dealt with somewhere else. Equally, there have been in recent years intellectual fashions – particularly the postmodern view that worrying about epistemological or metaphysical problems is *passé*[10] – as well as pressing practical reasons, for example a much harsher economic climate for higher education, that have militated against sustained reflexive enquiry of the kind I am suggesting. For many, the intractability of meta-theoretical problems and the need for a more business-like approach have made such thoughts unwelcome. It is however reasonable to consider the implications and consequences of this closure.

To be consistent, to fulfil the terms of the *tu quoque* argument, it must be admitted that the institutional theory, with the details filled in by empirical sociological research, is as socially located and motivated as any other theory of art. Indeed, Becker supplies, as we have seen, a brief history of the social conditions of the institutional theory. The obvious question then is: if we rid ourselves of aesthetic theories by attending to their social conditions do we not also rid ourselves of the sociological theory of aesthetics by attending to its social conditions?

One response might be to argue that the truth of a theory has nothing to do with its social and historical origins or contemporary conditions. But it was precisely this kind of argument, connecting validity to social circumstances, that was used to disqualify aesthetics, essentialism, and so forth.

Perhaps art and social science are *differently* related to their social conditions? Perhaps it is only the organised, systematic self-reflection of social science that really deserves the title 'knowledge' at all, while the lay reflections of art world members, whatever their standing among their peers, is merely opinion or ideology? Here the *methodical* character of social science would enable it partially to stand aside from its conditions so as to see them objectively or critically. But now one would require some assurance that method itself was untainted by its social conditions; why should one not suspect that the truth of method is to be found in its rhetorical functions within the social existence of scientific theorising as a discourse situated within its own science world? Why would it be unreasonable to think that behind the supposedly clarified self-consciousness of social science there lay mundane, practical interests? The interests admitted to by social scientists might just be part of the rhetoric; the real controlling motives might have more to do with the survival and prospering of this social world and its members than with problem-solving or social reform. These points and similar have been raised about the natural and social sciences at least since the days of the Frankfurt School, and remain pertinent.

Instead of pursuing the epistemological questions involved we might ask what difference would these ideas make to sociology and social theory, if acknowledged? The question would receive different answers. For example, it might be suggested that the discipline has had to recognise that it will never be completely transparent to itself, that it will never be in a position finally to judge whether proper allowance has been made for the influence of the contemporary social and historical context on its own accounts. The implication might be the need for modesty and open-mindedness. It might also imply that if sociology is condemned to

a degree of opacity in relation to its social context and character then it is no position definitively to enlighten other sub-cultures about theirs.

Another response would stress the desirability of business as usual. It has become commonplace to recognise that methodological issues cannot be neatly divorced from wider theoretical and value questions, but it is said that this need not constitute an excuse for self-indulgent wallowing in reflexivity. The sophisticated theorist would claim only that sociological accounts should be treated as valid for certain practical purposes and within a particular sociohistorical framework; given these restrictions, epistemological worries need not be too much of a problem. However, theoretical difficulties thus dismissed may yet return as concrete troubles. Certainly the political radicalism and activism of the 1960s and 70s is no longer fashionable with students or academics, and there are good, practical reasons why sociologists have felt it necessary to distance themselves from this rebellious pose. Theoretical pragmatics, buttressed by postmodern theory, may well be part of the ideology that legitimates the shaping of sociological research towards more practical needs, in particular the exigencies of social science in the late-modern semiprivatised academy.[11] Yet the new realism does threaten an important component of sociology's critical tradition. Even those who would see themselves as inheritors of sociological radicalism – while refraining from overt political activism – under the impact of the supposed obsolescence of epistemological questions have often endorsed pragmatics at a theoretical level.[12] The sociology of knowledge leads to instrumentalist conclusions: the important questions to ask about any idea, any representation, are who produced it and why?, what has it been used for?, and what might it be used for in the future? Individuals and groups construct knowledge on the basis of their perspectives, and in terms of their concrete social purposes. For those of a radical or conservative or simply wised-up outlook, who are no longer in the grip of metaphysical, epistemological illusions, human knowledge is a tool-set; but just as everyday tools belong to specific purposes, new purposes will require that knowledge is rejigged.

A question arises here about the subjectivity of both realism and radicalism as incorporating a pragmatic stance at a theoretical level. Both presuppose that the subject, individual or collective, can distinguish between a useful and a less useful or useless theory. This in turn is only possible insofar as the adequacy of subjectivity is presupposed. How does the pragmatist know that what *appears* to be useful in terms of his or her purposes really is useful? If this adequacy is not simply *assumed* it is quite possible to imagine that a purpose which seems to serve the ends of one

group might actually benefit those of another, or that a purpose which seems fundamentally at odds with the prevailing social system could actually contribute to its survival. Everything would depend upon whether social purposes belong to the subjects who have them. The critique of subjectivity, its dismantling in the name of the social and historical context, would suggest that pragmatic self-consciousness of supposedly post-epistemological social science might be no more legitimate, no less misleading, than the aesthetic self-consciousness of art. There is absolutely no reason why scepticism of consciousness and self-consciousness should or can be brought to a halt at the level of philosophical or epistemological reflection; pragmatic interest is equally vulnerable.

To summarise, Becker does not say explicitly that just because a theory or a practice can be shown to have connections with history and society it is *ipso facto* invalid. This would suggest that questions about its truth, about how it supports claims to the validity of the judgements it provides for by referring to the nature of its object, to the area of experience it deals with, to methodology, predictive power and so forth, are of a different order to questions about its historical and social conditions.

The issue is of a kind familiar to the sociology of knowledge, and need not be explored further here. The relevant point is that if the upshot of approaches like Becker's is taken to be the negation of the aesthetic by the disclosure of its social conditions then there may well be troubling implications for sociology itself. Scepticism is difficult to keep in place, and will ultimately turn back upon the sceptic.

Reputations

Turning now to Becker's arguments about reputations, the problem is less elaborate. The view that the reputations of artists, works and styles rest on a dispassionate, comprehensive judgement of their aesthetic value by well-qualified experts is fairly easily disposed of by sociological and historical findings which suggest their dependence upon a host of more mundane selection procedures. However, recognition of a flawed procedure does not invalidate the search for one less flawed; that is, cultural hierarchies do have social conditions but this does not mean that the very notion of a relationship between evident qualities of an object, aesthetic judgement and reputation is invalid and has to be abandoned. Certain works which have been singled out for praise and attention may in fact be of outstanding aesthetic value however their rank was concretely achieved. In the same way it would not matter if it could be shown by historical research that an old but still accepted

scientific theory was approved of by the scientific community of its day only after a systematic campaign of bribery by its supporters, provided that it had subsequently stood up to proper experimental tests.

Is not this rejoinder unjustifiably pedantic? Surely it is reasonable to assume that the aesthetic judgements of individuals are coloured (to put it no stronger) by the hierarchies of artists, styles and conventions in force at the time, and that these hierarchies are very unlikely to be the outcome of comprehensive, comparative judgement? The situation may however be seen in another way. One can accept that many individuals simply accept the artistic taste of their day, and that dominant tastes or conventions may be corrupt, as one might find in other areas of social life. Not everyone may be capable of independent aesthetic judgement, and even those who are may succumb to the pressure of fashion, or be misled or talked out of its proper use. Dominant tastes may fail to recognise excellence. But the fact that individuals or communities fail to exercise aesthetic judgement properly does not necessitate the conclusion that such judgements are impossible. As Mary Douglas has pointed out,[13] there is an important distinction between attacking aesthetic judgement on epistemological grounds and demonstrating its misuse for social purposes. All too often this distinction collapses under pressure from a glib dismissal of the possibility of aesthetic judgement on the basis of the inevitable partiality of historical example.

Becker comes close to recognising that the arguments against the possibility of aesthetic judgement which he accepts would weaken, if they became widespread, important assumptions routinely made by members of art worlds:

> The appeal to what lasts as a way of identifying great art is an argument against applying relativism to the evaluation of art works... The theory that explains what lasts is a theory of universals. (ibid., p. 366)

'Relativism' here is a condition which would ensue from an inability to make reliable distinctions between art and non-art, and between good and bad art. The belief that history is the final and the only good judge of value may be seen as a last-ditch stand against relativism in this sense.

> In this view, works develop a lasting reputation because, with all vagaries and contingencies of art world operation and reputation-building processes, some works always develop a reputation for having the highest quality. [This view] admits the reputational process... and sees that reputa-tions that last are a product of consensus and that consensus arises through an historical process. (ibid.)

But for Becker, this historical process cannot so easily be saved from contingency; survival and value are not the same. It certainly cannot be assumed that the factors which make a thing worth preserving in the first place are necessarily anything as elevated as its supposed aesthetic qualities.

Yet elsewhere Becker seems to acknowledge that relativism in this sense might not be good for art worlds. The institutional theory, by shifting the focus of attention away from the supposed intrinsic qualities of objects, and the group of skilled or gifted individuals producing them, towards the relationship between objects and their social context, appears to invite the conclusions that anything can be art and that anyone could do it. As the objects produced (or selected) by the Dadaist avant-garde failed to exhibit any signs of skill, inspiration, beauty or expression – at least when judged by established standards – and were in some cases merely ordinary manufactured objects, the distinctions between art and non-art, good and bad art, and even between artists and non-artists were in danger of breaking down. It is difficult to imagine a society, traditional or modern, capitalist or socialist, democratic or totalitarian, in which such an art could flourish. Equally, as ethnomethodologists have pointed out, lay sociological practice is a condition of the existence of everyday life; but if there were no essential, or rather socially sustainable, differences between lay and specialist practices sociologists would be redundant, logically if not literally!

The history of modern art shows, according to Becker, that the purely logical implications of the institutional theory had to be abandoned in order to blunt the relativistic consequences of Dadaism. The argument was developed that while a snow shovel or a urinal can be eminent art objects – it is just a matter of managing the social context correctly – you have to be a genius to see this in the first place; this is essentially Danto's view of Warhol's supposedly colossal philosophical achievement. Art practice after the death of art seems to require a special talent to invent new games, new manipulations of the social context, perhaps laced with some wit, insight or style. Post-art cultural practitioners – Duchamp, Warhol, Johns, Bueys, Koons, Richter *et alia* – turn out to be pretty special people after all. Somewhere within the anti-museum of post-art cultural practice can probably be found pieces which complete the circle by reminding us that what counts as inventiveness, insight, criticism or wit is itself socially and historically contingent.

Art worlds and relativism

Despite the expedient inconsistencies of critics, the main thrust of Becker's argument about reputations is towards relativism. But what would be the consequences for art and art worlds of the institutionalisation of relativism? Can such a thing be imagined?

It is surely important for art world members to have the ability and confidence to make judgements about the differences that define their world and the gradations of value within it? Looking at the text more closely it becomes evident that Becker does not believe that relativism is, or could be, a serious problem for an art world; it could not become a social crisis. This is because he has ultimate confidence in the capacity of members for making sound, coherent judgements and discriminations:

> The constraints on what can be defined as art which undoubtedly exist in any specific art world arise from a prior consensus on what kinds of standards will be applied, and by whom, in making these judgements. Art world members characteristically, despite doctrinal and other differences, produce reliable judgements about which artists and works are serious and worthy of attention. (ibid., p. 155)

This on-going consensus is not the mere parroting of ready-formed opinion but 'the systematic application of similar standards by trained and experienced members of the art world' (ibid.). As long as members go on making temporary yet solid collective judgements relativism is kept at bay; it remains a merely academic or philosophical problem remote from the social tissue of art worlds. Members are likely to go on making these necessary distinctions because, more often than not, they are primarily concerned with practically sustaining their everyday lives rather than with hopeless theoretical disputes. Thus, what limits the scope of speculation and thereby prevents theoretical problems becoming social crises 'despite doctrinal and other differences' is members' pragmatic interest in forming a consensus without which the negotiated achievements of everyday life would be impossible. The task of the theorist of art, in this respect, is to point out and support the wisdom inscribed in members' common sense.

The sociologist guards art by reconciling it with everyday life. He or she has confidence that within everyday social action, guided by a pragmatic interest, are patterns of decision-making capable of sustaining art. In re-grounding art in social life the theorist protects art against hubris on the one hand and marginalisation on the other. The

supposedly extraordinary achievements of art – the cult of genius, the great work transcending history and society, the expression of a *Zeitgeist*, and so forth – are in fact best understood as the products of very ordinary social processes.

The price art must pay for its reintegration with everyday life, as conceived of by Becker, is the abandonment of its aspirations to a difference which matters, to an elevated place in a hierarchy of cultural practices. It is indeed essentially a modest social activity, like preparing and eating good food, taking a holiday, good conversation and so on. Only entrenched high culture elitists would be offended by such comparisons!

Important among the things that art is being distinguished from here are practices directed towards the accumulation and deployment of knowledge (science and technology), and from practices in which right conduct is determined and realised (the moral and political spheres). It is also being distinguished from philosophical or metaphysical views which make art special by relating it to some ideal or transcendent reality beyond the everyday. Art is not inherently about the systematic exploration of the nature of things, the use of knowledge for production or control, the fostering of individual morality or social justice; nor does it testify to the existence of the transcendent. Its character must be sought elsewhere, especially in things peculiar to it as a social world. Science, technology and politics are best understood as *ordinary* social practices (knowing, manipulating and acting) made more *systematic*; art, however, does not need to be systematic or rigorous, or even to define itself sharply from other practices. Art does not threaten the tissue of society with infectious dreams of a higher and better world that, by their very existence, devalue everyday reality. For Becker, then, art's enrichment of life need not be premised upon a distorting transformation in which everyday social reality initially conceals, and then must be shaped to serve, the ideal, the extraordinary.

To summarise, Becker's attention to the everyday, to details of social life that, once pointed out, seem almost too obvious, can be seen as an attempt to return art to what he would regard as its real grounds. In a moment of irony social theorising is employed to protect art from theoretical appropriations which have in the past, and may again, align art with myths of transcendence capable of provoking a damaging and unrealistic rejection of the only world that really matters, the here and now. The care Becker displays for art worlds reminds members of the care they should have for the familiar. While familiarity may not invariably breed contempt it is capable of concealing the fragility of the social world, its vulnerability to distorting, dogmatic idealisations.

This has consequences in at least two directions. First, when art is itself it has realistic ends. In terms of its status within the culture it is to be regarded as on a par with any other business or pastime. Second, debates about its nature and significance, and about gradations of worth within it, are not based in reasons but in (usually unwitting) attempts to steer social change and resolve its problems. The 'characteristically reliable judgements' we can expect from art world members, if left alone to get on with the job, are reliable in the sense of their *practical adequacy* for social purposes; their adequacy does not relate to any other distinctive ends which art might have.

Although, for Becker, social worlds may, from time to time, be difficult to sustain practically, essentialist ideas conceal dependency on a language and mode of reflection rooted in ordinary, everyday, practical concerns and realities. Aside from inevitable concrete difficulties of one kind or another, they seem only to be threatened seriously by tendencies towards idealisation and transcendence. The traditional theorist is a potential social problem because he or she has a professional interest in intractable speculative dispute rather than pragmatic agreement. Social worlds need theorists (like Becker) only to protect them from idealising, dogmatic and divisive theories like essentialism. The emergent social worlds pictured by Becker are the spontaneous outcome of the interactions of individuals and networks of individuals. If we learn from the wisdom of everyday life, suggests Becker, we see that nineteenth-century European fears about the problems posed by individualism to social order were unjustified. Overarching, unitary systems of belief, central value systems, compelling collective representations, none of these is actually necessary or desirable. In modern societies individuals, interest groups, even social worlds require only a mature recognition of the universality of self-interest in order to negotiate a society together on a day-to-day basis.[14]

A key question here would be whether or not it is possible to imagine a practical, critical discourse of art which did not employ essentialist concepts, or at least a language capable of preserving a sense of the intrinsic goals and achievements of art, and of their unique importance. Becker is familiar with the ways in which much ordinary art world talk employs ideas, images and values from many sources, some of them even philosophical. But he does not seem to hear the paradoxical way in which this kind of language enables members to treat art as an ordered practice, as a set of objects with particular properties, as something which demands of the individuals who participate in it particular talents, skills, sensitivity or qualities of character. That is, he does not

attend to the ways in which this talk – when it goes well – both employs and distances itself from other powerful public languages – in particular from those of knowledge and theory – in the interests of art.[15] Rather, he is concerned to place everyday life under the protection of an idea, specifically the idea that pragmatically oriented interaction is the tangible, familiar and final ground of all social practices, of all social worlds. In this sense his critique of art could well be complemented by a critique of science, politics, ethics or any practice that came to see itself as transcending everyday life.

Social facts and the language of art

A practice of art cured of its philosophical (metaphysical, transcendental) delusions would consign all talk about an independent aesthetic reality to irrelevance; with it would go ideas about the enduring aesthetic proper-ties of certain objects, of the unique talents and insights of great artists, and of the special importance of art to human life. All this is high-flown chatter disguising the mundane self-interest of social groups or individ-uals. For Becker, there is nothing basically wrong with self-interest; we cannot conceive of social life without it. But one imagines that enlight-ened members, those who had rid themselves of aesthetic delusions, would see little point in continuing to disguise the real character of their talk, at least from themselves. In talking about art they would know that their deliberations could only be about the continuance or reproduction of their social world. The result, it needs emphasising, is that anything could be defined as art, and anyone an artist, provided *only* that the results were in the interest of the social world of art. The objects and values associated with art would now be devoid of any determinate character, and the supposedly unique experiences associated with aesthetic properties a sham or the products of self-delusion.

This translation of familiar ways of talking about art into the terms of pragmatic interest would ironically do considerable violence to those recognisably ordinary, widespread social practices of art which Becker seems anxious to protect. For some, this is only because widespread and ordinary practices are imbued by essentialist, idealist ideology. Even if this point were accepted, however, it would be incumbent upon the critic, assuming that he or she shared Becker's concern for art, to demonstrate how art could be practiced given the essential vacuity of these previously important concepts. If those concepts which seem to be related to the articulation of art's distinctiveness and significance are necessarily empty of meaning then it is difficult to see how one could

be concerned with the possibility of art or art worlds at all. Becker's reform of the language of art seems only to offer members a vision of their activity as nothing other than the interested pursuit of power, if only the power to go on being whatever it and they contingently are already. Survival is not so much a means to an end but the end itself, and the actual processes, artefacts, arrangements and so on which we associate with the everyday life of a practice signify only the contingent expediencies of the struggle.

I have tried to indicate some of the ways in which Becker treats such things as the aesthetic properties of certain objects, aesthetic judgement, artistic reputation and so on as *social facts*. It is interesting to compare this notion of a social fact with Durkheim's classic discussion. For Durkheim, sociology has to have its own peculiar type of phenomena; without distinctive social facts to study the discipline could not exist. He rejects the idea that everything found within human society is *ipso facto* social. Even widespread, conventional forms of behaviour and belief do not necessarily qualify. Rather, the social fact 'belongs to a category of facts with very distinctive characteristics: it consists of ways of acting, thinking, and feeling external to the individual and endowed with a power of coercion, by reason of which they control him' (Durkheim, 1938, p. 3). Of course, Durkheim is aware of the trap of arguing that everything that human beings feel constrained by is socially necessary. A distinction is required between 'normal' and 'pathological' social facts, and the third chapter of *The Rules of Sociological Method* develops this distinction in terms of a medical metaphor. Yet in the last analysis, for Durkheim, the 'generality' of a phenomenon must be taken as a reliable indicator of its 'normality': 'In order that sociology may be a true science of things, the generality of phenomena must be taken as the criterion of their normality' (ibid., pp. 74–5). It is interesting that at this point in his argument Durkheim ties together the possibility of sociology with the possibility of society. The science of sociology is made impossible if we believe that 'the most widely diffused facts can be pathological' (ibid., p. 74), for we might then come to suspect that the normal has never existed. We would then have no reason to respect and study the facts: 'By such arguments the mind is diverted from a reality in which we have lost interest, and falls back on itself in order to seek within itself the materials necessary to reconstruct the world' (ibid.). The congruence of the normal with the widespread must be assumed if sociology is to be possible.

But Durkheim goes even further; respect for certain concepts and values is not just crucial to a particular intellectual discipline, but to the politics of a humane and prudent society:

Our method has, moreover, the advantage of regulating action at the same time as thought. If the social values are not subjects of observation but can and must be determined by a sort of mental calculus, no limit, so to speak, can be set for the free inventions of the imagination in search of the best. For how may we assign to perfection a limit? It escapes all limitation, by definition. The goal of humanity recedes into infinity, discouraging some by its very remoteness and arousing others who, in order to draw a little nearer to it, quicken the pace and plunge into revolutions. (ibid., p. 75)

Of course, Durkheim does not have art specifically in mind. He is speaking of what he conceives of as the benign effects of sociological observation. But he implies that observation preserves what it sees, or at least links intentions and actions to a pre-existing context of values,[16] preserving a social environment from capricious representations, and thus from mania or disillusion and indifference. It is possible for sociology simply to denaturalise cultural and historical phenomena, supposedly to free human realities from constraint, by dissolving the framework of the ideas and practices of members which give them life.[17] The sociologist discerns only the historical and sociological contingency of the world in question, and translates members' ideas about the nature and value of their practices into concepts which define the structures of sociological artefacts (models of society). Members themselves typically become cultural dopes of one kind or another, or abstract rational agents. For Durkheim, the moral character of sociology is thus seen to rest in a recognition of the significance of certain social values and practices, and a conviction that sociological practice itself was in part defined by respect for these lay achievements.

While there are many difficulties with the general position outlined in *The Rules of Sociological Method*, and while Becker is under no obligation to follow Durkheim, the underlying themes are of considerable importance. Durkheim's identification of the normal or healthy with the widespread is nothing other than a limitation of scepticism which constitutes the possibility of sociology for him. But not just the possibility of sociology as the unrestricted pursuit of knowledge of a certain kind; also the possibility of a positive view of sociology's ethical or social character. I have suggested above a parallel with art. A set of ideas closely related to important practices in art sometimes resembles the discourse associated by Becker and other sociological critics with philosophical essentialism. This discourse, adapted to meet the needs of art, is, however, vital to these practices, which are historically rich and still fruitful today. That is, art world conversations often draw fairly loosely and eclectically upon so-called essentialist theories. This 'impure' discourse, which mixes

metaphysics with practicality, provides for distinctions between what is art and what falls below its level, between what is highly placed within art and what is not. The ordinary language of art enables not merely the reproduction of everyday life but judgement upon it, the construction of hierarchies of significance and value, and sustains a sense among members of art's unique importance among other cultural pursuits. Becker might be seen to be at one level in sympathy with Durkheim's respect for the social and cultural framework he studies, and in this way could be heard to speak for a hermeneutics of retrieval rather than one of unmitigated deconstruction and suspicion. Yet his sustained assault, in the name of sociological knowledge, on members' key beliefs contradicts this impulse. If the sociologist is sympathetic to a social world and its practices – and seeks to display reflexively his or her reconstruction of the social bond between reader and writer – then the critique of the values and assumptions contained in its discourse should be supplemented by a specification of new values and assumptions which could provide for and nourish the life of the practice at least as successfully as those they are to replace. From the point of view of pure sociological knowledge or logic there is, of course, no such obligation. He or she might also have to reflect upon any similarity between the discourse the sociologist is required to speak in order for his or her practice to be possible, and the discourse heard as the effects of mere – although perhaps motivated – historical contingency. One of my intentions here is to reflect upon the tensions within sociology and social theory between this pursuit of knowledge and a reflexive awareness of sociology itself as a social practice.

In sum, Becker sets out to correct certain popular beliefs about art and artists by setting them against a view of art's social reality. He also maintains that some long-standing philosophical puzzles about the nature of art can be cleared up once and for all by an acknowledgement of the complex social organisation of art worlds. I have suggested that while Becker recognises the dangers represented to social worlds by what he calls 'relativism' – essentially a situation in which judgements and distinctions cannot be made to stick – some of his own arguments would, if accepted by members, produce just this kind of social crisis. This becomes particularly evident when his own sociological critique is subjected to the kind of scepticism to which it submits art.

The intention behind this application of the *tu quoque* argument is to point up the ethical consequences of a particular sociological account of art. Sociological accounts construct social relationships, and in this case we are interested in the relationship Becker forms between sociology and art as ways of representing and living in the world. Becker tries to place (or replace) art into everyday life. In this he tries to mend a rent in the social

fabric. He believes that traditional understandings of art, by making art extra-ordinary, produce a division between art and life that is misleading and of no real benefit to either. The demystification of art is, for Becker, in the service of a reconciliation with life. Other discourses or practices – like science, technology, politics and so forth – are to be understood as further horizontal divisions of the social; this reflects the fact that modern societies have neither the need nor the ability to rank the different worlds that constitute them. Sociological critique represents an impulse to modernise those social worlds which are survivals from a period when the imposition of order – in the form of a ranking of practices, institutions and roles underwritten by religious or metaphysical beliefs – was necessary. While Durkheim was troubled by the idea that the alignment of individuated desires released by modernity could not be simply presupposed or assumed to come about of its own accord, via technological determinism or the rational pursuit of economic self-interest, no such doubts seem to trouble Becker. The presupposition of the universality of enlightened self-interest is sufficient to rule out serious conflicts between different practices or social worlds. Of course, this assumes what Durkheim and much of the classical sociological tradition sets out to explain – the very possibility of the social under modern conditions.

In Becker's account, art is depicted in such a way that it can be seen already to belong to a pre-given community. Its demystification merely removes obstacles that impede this recognition. I have argued that there are in Becker's account some reflexive, ethical difficulties, particularly in its construction of art and its relationship with other discourses. Durkheim's radicalism resides in the suggestion that modernity raises the question of the *possibility* of the social, but difficulties with the reconstruction of the social bond by sociology itself lend more support to Durkheim's deeper worries about modernity than to Becker's confidence.[18]

Becker also attacks the discourse in which much art criticism, practice and pedagogy have been conducted, and in this he takes it both too seriously and not seriously enough. He takes it too seriously insofar as he does not see that members use concepts – often derived from specific theories – eclectically and practically. He does not recognise that a language which includes philosophically rooted discriminations and notions of transcendence, which he believes threaten the social, may help members to bring about their sometimes extraordinary achievements in the midst of everyday social concerns. In this way he fails to take the sociologically impure discourse of art worlds seriously enough, he does not see its paradoxical achievements.

Chapter 2

Towards a Critical Sociology of Art?

Purging Art

This chapter continues the consideration of sociological accounts as moral constructions. It has been argued above, with specific reference to the work of Howard Becker, that in some sociological accounts of cultural phenomena like art there can be found a characteristic tension: a careful attention to the details of everyday, routine social life is coupled to a critique of beliefs and values so fundamental that their negation would engender a grave social crisis for the practice. Art is urged to secure itself by rejoining the familiar, everyday world from which philosophical theories and elitist attitudes have divorced it. The price of this new security is the relinquishment of its claims to be extraordinary, and of the belief that a life lived with art is significantly different from a life lived without it, other than subjectively. To seek to return art to its real grounds in everyday social life in the hope of avoiding dangerous and intractable disagreements about these representations is to presuppose that everyday social life reflects a real community of interest, a substantial practical agreement about fundamentals which, once established, is simply reproduced, providing the distractions and temptations of exclusive values and hierarchies are avoided. Art should not be encouraged to put itself at risk. But in every genuine artistic act conventions and settlements with the demands and interests of everyday life are put in jeopardy; the ideas and values essential to art demand rebirth in new forms.

In Janet Wolff's *The Social Production of Art* (1981) and *Aesthetics and the Sociology of Art* (1983) the tensions between a concern for the distinctiveness and integrity of the phenomenon, and what she rightly sees as a critique with invasive, destructive potential, are present far more dramatically than parallel tensions in Becker's work. Indeed, they

constitute the explicit core of the issues Wolff chooses to confront. They give rise to a whole series of profound ambiguities and dichotomies. Before discussing them it is necessary to say something about the idea of sociology as critique.

The sociological project as a critical, rather then merely descriptive, analysis of society belongs to its Enlightenment heritage. For the Left, it has come to signify the view that injustices, oppression, illegitimate restrictions of human freedom, which can be found within all historical societies, but particularly in contemporary capitalist society, are in part made possible by untrue (but often convenient) ideas which depict these problems as due to inexpungable features of the human condition. In dissolving these false ideas in critical analysis sociology clears the path to human emancipation. For traditionalists of the Right, the function of sociological criticism would be to curb the excesses of utopian state politics by reminding would-be reformers and revolutionaries of intractable features of human societies, perhaps reflecting aspects of human nature – which express themselves in persistent and widespread groupings, associations, habits, customs and traditions – making such schemes unrealistic and probably dangerous. Such a sociology would seek to protect the fragile and limited measures of order, liberty and justice for the individual which societies sometimes, and with difficulty, manage to achieve. For modernisers of the Right, however, the purposes of studying social phenomena – if such there are – would be more limited, being restricted to furnishing largely empirical data about social conditions and problems on behalf of markets or the institutions of a slimmed-down state. Famously, Thatcher's neo-liberalism, not having any need for the idea of a society, clearly had no need either of a bogus science devoted to its study.

Sociology's relationship with the modern period which gave it birth, and to which it has contributed, has been complex and diverse, sometimes critical, sometimes affirmative, and from a diversity of points of view. Historically, the early development of sociology has often been presented as part of an antagonistic reaction by bourgeois intellectuals against the rise of socialist political organisation and thought during the later part of the nineteenth century. During the 1960s and 70s, sociology provided a base for Marxist and neo-Marxist critiques of the institutions and ideologies of advanced capitalism. In recent years, a more sophisticated view of sociology's relationship with modernity has begun to emerge, in for example works by Bauman, Touraine and Wagner.[1]

A proper discussion of social science as critique would have to consider, among other things, the epistemological, ethical and political

claims made in order to ground its legitimacy. Here, I only want to repeat the suggestion that a critical demolition of art by sociology would cause few worries to the theorist who believed that art had either no place, or only a very minor one, in his or her preferred form of society. In practice, few are prepared to be seen endorsing the rejection of everything conventionally associated with the term 'art'. The critical project is more usually one of purification and restitution. The problem is, then, how to purge the phenomenon of its impurities without, at the same time, fundamentally weakening or destroying it. This type of approach is well exemplified in the works of Wolff. It should also be noted that *The Social Production of Art* has proved to be a highly successful book, one of the most widely used introductions on undergraduate courses.[2] Not only this however; the kinds of view for which this work is known, and which it sets out with considerable clarity, have been widely accepted, almost without question. The general outlook has become almost an article of faith among many who think of themselves as sociologically informed about art. This is not the product of one book of course, but rather of a considerable number of publications and media events during the 1970s and 80s. In examining Wolff's arguments, therefore, one is also considering some important aspects of what has solidified into a new orthodoxy with regard to the critical theory of art.

Throughout *The Social Production of Art*, Wolff is keen to disabuse her audience of common-sense but false ideas about art which they almost certainly hold. For example, in the first chapter she attacks the idea that art is a unique type of human activity which is essentially free and creative because it somehow manages to escape the constraints of history and society. She also attacks the related idea of the artist as creative genius, similarly detached from his or her society. What must be combated is 'the mystification involved in setting artistic work apart as something different from, and usually superior to, all other forms of work' (Wolff, 1981, p. 13). In place of the non-sociological, mystified view, she provides the idea of art as productive labour or manufacture. Artistic work is a form of labour, and labour is essentially the creative, practical transformation of nature in accordance with human needs. However, under capitalism labour is alienated, the transformation of nature not to meet the real needs of all humanity but a pattern of needs distorted by the dominance of a particular capital-owning class, and the concomitant absence of a species–subject. For Wolff, what we ordinarily think of as productive labour is therefore not really free, creative and social at all. It is in this context that art has come to be seen

as wholly different from ordinary work, as a unique area within society in which the individual may act freely and creatively. Wolff summarises the argument:

> I have argued that, essentially, artistic work and other practical work are similar activities. All, in the long run, have been affected by the capitalist mode of production and the social and economic relations thereof. For historical reasons, artistic work came to be seen as distinct, and really 'creative', as work in general lost its character of free, creative labour, and as artists lost their integrated position in society and became isolated and marginalized. (ibid., p. 19)

It is a common mistake, then, to regard art in capitalist society as holding out the possibility of free, creative labour or its fruits; art is just one more kind of alienated labour, unable to offer the individual anything more elevated or free than work in a factory or office.

Aside from the particular institutional and cultural conditions of art worlds – such things as systems of funding, patterns of expectations and conventions, divisions of labour and so on – is there anything distinctive about art as a form of alienated labour? For Wolff, art belongs to a category of cultural work which is ultimately less important than the primary forms of material production through which men and women obtain the basics of life, such things as food, clothing and shelter: 'practical activity is the necessary result of human needs (natural and created), and it is "essential" in this contingent, non-metaphysical sense; it happens to be the case that people need to eat' (ibid., p. 16). Other characteristically human activities, for example politics, play, language use and so forth, in the last analysis depend upon this primary production: 'the possibility of *homo ludens* and *homo politicus* arose much later, and is not in the same sense "essential" to humanity' (ibid.).[3]

Is there, then, anything distinctive about this inessential, alienated labour which is art? Here, again, Wolff is anxious to correct widespread, erroneous opinions. The product of art is not just a set of concrete objects – paintings, poems, novels, films and so on – which provide pleasure, insight or instruction. Rather, the *real* product of art is a particular *ideological* contribution to the perpetuation and strengthening of the economic and political grip of the dominant capitalist class. As she notes, many sociologically inspired studies in recent years have emphasised art as ideology:

> these developments are extremely important, because they begin to show the real nature of art, and to demystify the ideas of our age which maintain

the autonomy and universal quality of works of art...They question what is meant by the 'Great Tradition', and expose the social and historical processes involved in its construction, as well as the construction that it is somehow 'above history' and social divisions and prejudices. The hidden meanings of art are laid bare, and the particular interests of specific groups which are implicitly served by those meanings becomes clear. (ibid., pp. 28–9)

To summarise, art in contemporary society is inessential, alienated labour productive of ideology which perpetuates injustice by serving the interests of the ruling, capitalist class. Wolff might almost be indulging in humorous irony when she continues the paragraph quoted above with the suggestion that studies of art as ideology are meant 'in no way to devalue the works as masterpieces of painting, sculpture or writing' (ibid.). However, all is not lost; artists need not feel terminally depressed or guilty after this forceful but gloomy revelation of the real nature of their activity. There is still the possibility of critical, subversive art practice. It is reasonable to believe that 'art, at least in certain conditions, has this potential transforming power, and that cultural practice and cultural politics have a part to play in social and political change' (ibid., p. 74).

How then does art become effective cultural action? Wolff mentions and largely dismisses both 'tendency literature' (the simple transmission of the correct political line) and the eternal verities of supposedly great works, at least insofar as effectiveness means a capacity to educate and mobilise politically relevant groups. She sees more future in attempts to subvert processes of ideological reproduction by dislocating the codes and conventions of that dominant mode of representation – realism. The more successful efforts in this field have so far been largely restricted to film and photography. For some, the image of this newly purified art is acceptable, or even welcome. The most consistent of these Left modernists would admit that the perspective cancels out virtually the whole of historical tradition (except of course for historical proto-deconstructionists), and seems only to require of its practitioners (not artists *nota bene*) a hybrid knowledge of basic sociology, radical politics and fashionable avant-garde styles.[4]

Saving art

Wolff's writing suggests here and there that this outcome – although consistent with the argument – might not be wholly to her taste. For example, she notes that sociological approaches have been relatively unsuccessful in fashioning a 'new aesthetic': 'Even the better attempts at this conclude by collapsing artistic merit into political correctness' (ibid., p. 7). Again rejecting the notion of universal, trans-historical aesthetic values she states that, while remaining agnostic on the question of 'beauty' or 'artistic merit', 'I do not believe that it is reducible to political or social factors' (ibid.). Or again:

> The sociological study of art does not constitute a denial by exposure of aesthetic enjoyment and aesthetic experience, a denigration of cultural production, or an equalisation of all cultural products. The relative value of different works is determined within the discourse of art and aesthetics, and is not amenable to appropriation by a different discourse... In other words, the fact that it is an historically contingent matter that we have a separate 'aesthetic sphere' or discourse of art in no way negates that sphere. (ibid., pp. 142–3)

In her later *Aesthetics and the Sociology of Art* Wolff is equally explicit:

> the sociology of art has in some way exceeded its own brief, in so far as it fails to account for the 'aesthetic'. Indeed, the central theme of this book is the irreducibility of 'aesthetic value' to social, political or ideological co-ordinates. (Wolff, 1983, p. 11)

In this work two demands run strikingly alongside one another; what is required is a radical sociology of art which, although not ducking the specifically sociological problem of the aesthetic, does not deny its existence or validity either.

The main arguments of *Aesthetics and the Sociology of Art* are already familiar from *The Social Production of Art* and from Becker. What has traditionally been thought under such headings as 'art', 'high art', 'criticism', 'art history' and 'aesthetics' has been made 'problematic' (which usually seems to mean dubious, unjustifiable or impossible) by a sociological critique that insists upon the centrality of concepts of history and ideology. To say that art, aesthetics and so on are historical is to maintain that the ephemerality of all standards, values, hierarchies and judgements has been conclusively demonstrated by historical research. History demonstrates more however: that it is not only a *fact* that aesthetic judgements and the like exhibit little stability or continuity, but also that such things are somehow impossible *in*

principle. To say that art, and its associated discourses and practices, are ideological is to assert that they are social products whose meanings operate to advance or defend the political interests of antagonistic groups in particular societies under particular circumstances.[5]

But Wolff again has doubts; she seems to feel that the results of the popularisation of the historical–ideological approach to art could be its intellectual destruction. She recognises that art worlds are in part made possible by routine discriminations and judgements about the nature and quality of art which rest on ideas whose validity is denied by the sociological critique she endorses. What is the radical, critical sociologist to do with distinctions between art and non-art, good and bad art? It might be suggested that it is not the business of the sociologist *qua* sociologist to join in this kind of debate; rather, whatever decisions members make must be accepted as evidence. However, for radicals who see their own practice as 'political' this would be rank positivism of the worst kind. And clearly, if aesthetic experience and tradition are merely ideological myths, then just about the only place left to go is politics. Art is, in the last analysis and beneath all its overdeterminations, to be read and weighed as politics. The argument is back where Wolff's anxiety began.

Do the detailed arguments presented in *Aesthetics and the Sociology of Art* offer a way round these difficulties? In the first chapter she writes:

> My main argument in this book is that we need to rescue some concept of the aesthetic from both the imperialistic claims of the most radical sociology of art which would equate aesthetic value with political worth, and also from the total relativism and incapacity into which the self-reflexivity urged by the social history of the arts and of criticism might lead aesthetics. (ibid., p. 21)

Thus, the overall intention is still to preserve art while developing an adequate sociological account, although difficulties and tensions arising from certain sociological tendencies are explicitly recognised.

The specificity of art

Considerable importance is placed on the notion of the particularity (or specificity) of art. This is because Wolff believes that rescuing the aesthetic is equivalent to the construction of a sociological theory which adequately distinguishes art from other phenomena within the general field of culture.

She discusses three broad interpretations of the idea of the specificity of art, but eventually decides that only one is relevant to her purposes. First, there have been theories that seek to describe the historical emergence of art as a social institution. Second, there have been efforts to determine how much autonomy from the direct influence of the economic and political spheres art has enjoyed. Third, and more significantly, some theories have tried to address the issue of the particularity of art as a cultural practice. A satisfactory answer will require 'a theory of aesthetics within a sociological or materialist framework' (ibid.). The main contenders are discourse theory (Foucault, Laclau), philosophical anthropology (Timpanaro, Williams), and psychoanalysis (Fuller, Lacan).

The insights offered by discourse theory, as Wolff describes them, seem very close to views we would usually associate with theories of autonomy (invariably 'relative') mentioned above. Foucault and Laclau may be more radical than Althusser, Macherey, Eagleton *et alia* in claiming that discourses actually constitute the social, but there seems to be an underlying agreement about the existence of relatively independent[6] realms of conventions, codes or structures within which artistic realisation and reception take place. Beyond this, however, discourse theory is useful because 'it posits as relatively, if not totally, autonomous the level of the cultural' (ibid., p. 93). But, of course, a theory about culture as a whole may not of itself be capable of defining a practice *within* the culture.

Turning briefly then to what she calls the 'philosophical anthropology' of Timpanaro and Williams, Wolff seems uncertain that our understanding will be much advanced. The main difficulty is that the whole attempt to explain salient features of the aesthetic response in terms of trans-historical, trans-cultural facts about the physiological and psychological makeup of human beings –for Timpanaro and Williams simply the materialist position – is tantamount to a desertion of the sociological approach itself; it represents a reversion to a 'metaphysical or pre-sociological belief in some fundamental features of human nature' (ibid., p. 99). Only psychoanalysis remains.

Wolff's principal discussion of Fuller's application of Kleinian object–relations theory to the problems of aesthetics is generally critical. The mistakes of philosophical anthropology are repeated and make Fuller's conclusions dubious. Lacan is of more interest.[7] It may not be immediately apparent how a theory of the emergence of gendered subjects in the process of language acquisition helps with the development of a sociological theory of aesthetics. However, for Wolff, Lacanian psychoanalysis 'offers the possibility of the identification of

those aspects of the personality, unconscious, or consciousness which respond to the particular features of the aesthetic' (ibid., p. 104). Thus, psychoanalysis is taken to offer a theory of aesthetic pleasure, something missing from the sociological approach so far. But here again, Wolff sees the approach as insufficiently sociological; the emphasis on more or less fixed, universal features of the human psyche must become more historical, more open to variation according to social context. What is required is not so much psychoanalytic theory as a sociological theory of the psyche. Given Wolff's reservations about some of its fundamental presuppositions, it would seem that psychoanalytic theory could only represent the identification of the right area of enquiry; as an answer it is unsatisfactory.

In Wolff's discussion of Bourdieu[8] there is reported a remarkably straightforward sociological theory of aesthetic pleasure; could this be the kind of thing she has in mind? She reads it as saying that people find aesthetic pleasure in (or at least express approval for) works which embody the particular values of the ideology of the social class to which they belong. Members of the bourgeoisie in contemporary France like form in artefacts, whereas members of the working classes appreciate function. Wolff is well aware of the difficulties: does the sociological theory of aesthetics imply that questions of aesthetic value can only be answered by a description of who likes what, where and when?, or by an explanation of why they like it?; does the fact that the workers – and thus, presumably, Marxist sociologists also – like function mean that function *is* actually superior to form?; more generally, does not the identification of the truth or falsity of judgements of this kind with their historical or social origins – a strong version of the sociology of knowledge – tend towards either complete relativism or a philosophy of history of Hegelian ambitions? Although a psychoanalytic or socio-psychological explanation of aesthetic experience might make the account more complex and sophisticated it is difficult to see how it would resolve Wolff's basic difficulty: how the significance and value of aesthetic experience is to be preserved in the face of its sociological explanation.

Two worlds, two selves and conscience

Wolff persistently identifies an adequate sociological theory of the specificity of art with an account capable of preserving it from a damaging reduction, an imperialistic translation into the concerns, the language, the world of another discourse. This identification is

understandable from the point of view of sociology. Reductionism is seen as the danger of oversimplification, and as such due to technical deficiencies in theorising. The concepts currently available – viewed as research tools – are too crude to discriminate properly between art and other cultural, superstructural activities. Hence, what is distinctive and valuable about art is somehow lost. The tools must be sharpened and then used with more precision.

A question strikes Wolff's reader immediately and forcibly: how to avoid the suspicion that the technical improvement of sociological discourse would lead only to a more effective, more powerful expropriation? Are we to understand that the ability to capture the specificity of art, to determine exactly the functioning of art within the superstructure, and the social coordinates of aesthetic experience, is 'saving the aesthetic'? Wolff's failure, or perhaps refusal, to recognise the problem is due more to hope than logic, but it is important to consider this hope.

An adequate sociological account of art would, for Wolff, embrace art in its individuality. It would demonstrate a kind of care for the life of art. This is what she seems to mean by the whole idea of a good theory. Insofar as she stands within the knowledge project of sociology it seems reasonable to believe that this theory could be produced through a process of technical refinement. However, Wolff's sympathy for art means that she also puts herself partially in the position of an art world member. It is this point of view that triggers all her doubts and difficulties about the moral impact of sociological explanation. To carry these doubts back into the sociological world, and to express them there, is to invoke the voice of conscience. Conscience here is a moral concern for the social relationship between worlds, including that of sociology, constructed in and by sociological theorising.

In the social context Wolff's theorising represents, in its recognition of the significance of a range of different practices, value-spheres or languages, it is evident that a single individual is confronted by a range of possible selves and worlds. These worlds, their selves and their languages may interrelate in a variety of ways. Sociology both reports on and constructs social relationships between other languages and practices, its accounts constituting the theoretically supported idea of a society. It places worlds within a world, but it is also just one more language, a part of the society it provides for. From this point of view, sociology is under an ethical imperative reflexively to consider not only its knowledge claims but also how its practices, particularly its representing practices of writing and speaking, participate in providing the social as such.

A visit to the Studio

We can imagine what a sociological conscience – the expression of this reflexive imperative – might register when Wolff's protagonist visits the Studio, here the home of an art world. Even in the midst of trying to understand and explain she wonders about its moral implications. For example, she sees artists and their works. The institutional theory suggests that some things become art objects and some people artists through a largely arbitrary process of institutional definition and selection. Yet the works she sees around her and artists' descriptions of what they are doing – perhaps in particular those provided by artists who have either not heard of the institutional theory, or who have rejected it – suggest the subjective and intersubjective importance of intention, deliberation, talent, skill, training, self-criticism. Members tend to believe that the evident or demonstrable qualities of objects, and the capacities of individuals – either natural or acquired – are important. They believe that the actions which constitute the practice can be rational, or at least reasonable, within the world they inhabit. According to the institutional theory, such views would seem naïve. But would it be possible to produce art or to have an art world without them?

Or again, what would it be for art world members to see their activities as inessential, as having less status than other kinds of work, like the manufacture of goods or the development of new and more powerful technologies? Here Wolff's sociologist is perhaps uncomfortably aware that she echoes populist anti-art sentiments, as well as political views which see art as either an elitist luxury good or a marketable commodity like any other. She is also aware, however, that it might be difficult for members to see things this way. They are inclined to think that producing work year after year with very little reward or recognition – something all genuine artists must be prepared for – is not easy physically, financially or psychologically. Dedication and sacrifice require faith that the activity is important, even if it goes largely unrecognised. The visitor realises that, as a sociologist, she could not endorse this faith. While sacrifice and dedication are not unknown to politics or economic activity, faith in art becomes unintelligible, like faith in God, once critique has exposed the nullity of its fundamental convictions.

Art world members typically believe that art is different from other forms of work, from, for example, the mechanical toil of the production line or the monotonous routine of the office. They feel that they have more control over and responsibility for what they produce, that

they will have some personal connection with the outcome of their labours, and that their work might come to occupy a special and significant place in the lives of others. In these ways and in others art can still be seen as offering a concrete image of what work might be like if it could be organised on a different basis. To see art not only as alienated, but also as peculiarly ignorant of its own character because blinded by its dubious mystique, is to stamp on a hope, when hopes must animate the desire for improvement.[9]

The attitudes, ideas, strategies and feelings that art world members have towards meaning are of considerable complexity.[10] Wolff's Marxist sociologist sees things as pretty straightforward. By refusing knowledge and political instrumentality, by failing to make a conscious decision to structure work around emancipating social criticism – if not in terms of overt content then by disrupting the representational codes of realism (but with just enough 'content' to establish whose side they are on) – artists serve injustice.[11]

A gulf opens up here between many who work in the Studio and its visitor. For the former, knowledge and rational action – beginning with a defined aim as to the effects the work should achieve, a clearly stated meaning (a message, content or signified) for which a suitable vehicle must be found or developed – is not how art is made. Art is not communication as rational action. Artists step aside from the power of communicable content or pre-given meanings and from the utilisation of those conventions, codes and systems of representation which must be accepted if communication is to be quick and effective. This complex displacement is achieved in many different ways. For example, the artist may step into the dense connections of image and form provided by a tradition of visual representation; in doing so, complete control is renounced in favour of a play of meaning. Again, at certain stages in making the piece, the artist may deliberately work with unclarified intentions, allowing meaning and form to emerge from a vague sense of direction, accidents or opportunities of material process, and constant intuitive corrections. In withdrawing from specific intentions and given meanings, from the apparatus of subjectivity and rational action, the artist seeks to give the piece a life of its own. There is no contradiction between the refusal to practice art as a form of instrumental–rational action and an acceptance of responsibility for the work. I have been careful to qualify descriptions of this aspect of art. There is a withdrawal from an effort to achieve *total* control; unclarified intentions characterise *some* phases of the making process. The complexity involved here is not just technical, not essentially to do with a quantitative problem which

logical analysis or empirical research could eventually lay out in its essential, structural simplicity. The processes are paradoxical, elliptical, indexical, heterogeneous, fugitive from description, rule or formula.

The sympathetic imagination of Wolff's sociologist undercuts her purely professional conclusions. The prescription of rational action informed by critical enlightenment would produce, for all practical purposes and give or take a mediation or two, propaganda for the cause and not art. The concepts have been applied and the arguments followed, but the sociologist finds herself finally where she did not mean to be: at odds with the world she is visiting and with forebodings about a violation to which her words might contribute.

One could go on to describe other moments of tension, but perhaps the point has been made. Suffering from a sympathetic imagination the sociologist finds herself standing in a world alongside its members. Her words now sound alien, and in them is sensed a threat. But these troubles must be interpreted, understood, and to the sociologist as sociologist they signify the presence of technical problems, the need for further conceptual or methodological refinements. The discipline of enquiry cannot rest with this failure.

Back to the Seminar

On returning to her knowledge world Wolff's sociologist voices some of these doubts. The very intractability of the problems she sets herself is perhaps due not so much to the peculiar difficulties and complexities of understanding art as a particular cultural phenomenon, as to the fact that the aesthetic becomes the focus of doubts about what she feels compelled to see as the sociological project *per se*. Yet, despite her honesty and insight, Wolff does not reflect sufficiently on her conclusions.

Sociological language routinely constitutes a world in which sociology appears as a legitimate and important practice. It privileges itself in this way by claiming a difference from other representing practices which it reports on, notably of course, the lay sociological practices of members. Sociology does not typically regard itself as unimportant simply because it is, by Wolff's Marxist definitions, 'superstructural'. Its dignity, if not its power, is seen to reside in its higher concerns for truth, lucidity and justice, as well as in its array of concepts and methodologies.

While it might be correct to see sociology as one more form of alienated labour – for Wolff *all* labour is alienated under capitalism – she would probably want to claim that it does at least avoid a mystique-

induced blindness to its own real character. Although sociology would not pretend to speak with Olympian detachment and pure objectivity, neither would it happily see itself as yet another ideology, at least insofar as this implies a set of socially determined and interested delusions. In this it differs from the supposed peculiar ideological blindness of art.

But how secure are these beliefs? Thinkers from Nietzsche through to Bauman, Rorty and Lyotard have raised a succession of profound questions regarding them. Might not the dignified pursuit of truth and justice be just a selling point, a move in a rhetorical strategy? Might not the very claim to a higher, reflective self-knowledge be simply another, and more profoundly alienated, ignorance? And if the conceptual and methodological means by which sociology claims to differentiate itself from ideology do not escape the taint of history and society then how legitimate is this claim?

Crucial to the sociological world is a sense of its demonstrable reasonableness as a discourse. The claim to the reasonableness of a discourse is here taken to precede and to be more fundamental than the claim to truthfulness of some particular statement made within it. Extravagant claims for the corpus of sociological knowledge are unfashionable; it is widely accepted that sociology is affected by the same historical and social factors it seeks to describe and analyse. Despite this, sociology is seen to be, at least in principle, a rational, self-guided activity. The ability to grasp what lay members do not, and to evaluate its significance, is gained by an education in the discipline on the basis of certain personal qualities, perhaps intelligence and a sympathetic imagination. Socialisation into sociology enables the individual to speak with the voice of the discipline, whose concepts and methods ensure that opinion can be replaced with truth. Equally, socialisation provides for the choice to ignore or misread the discipline, its principles, practices and corpus of knowledge; it makes it possible for the individual to fall short of or betray the discipline. The individual becomes a sociological actor within a world that includes sociology as a possible social practice.

An erosion of the nexus between sociological action and the reasons which guide it conceptually and methodologically, and through which a corpus of knowledge is built up, is not difficult to imagine. Asking after the nexus could be understood as simply the inclusion of the discipline within the discipline's field of enquiry. But to erode the nexus would be to diminish or erode the world in which sociology itself makes sense and has legitimacy.

At some point the adequacy of self-consciousness has to be accepted (or postulated) if the practice and its practitioners are to have a world in which what they do is reasonable, that is, in which it could count as a practice at all. It may be possible, and for some even desirable, to be endlessly sceptical about self-consciousness, to insist that, even in its awareness of its limits and dependency, there lie concealed limits and dependencies of unsuspected potency and profundity, to the extent that the causality of intentional action and its significance are denied. From this point of view, neither self-consciousness nor its world exist in any valid sense. Self-consciousness re-enters, and by this act restores a world, insofar as these forces can be grasped and taken into account. A general scepticism about this possibility amounts to a general scepticism about the possibility of selves and worlds, and the result is a kind of nihilism in which practitioners (of sociology or art) are gripped, and ultimately disabled, by fundamental doubts about the possibility of their practice. Where these doubts were, paradoxically, only available through the practice, then the activity and its results would still be describable as related to a specific practice.[12]

Lyotard has neatly expressed an entirely proper question here.[13] Modernity begins with the delegitimation of traditional knowledge by science. The inception of *post*modernity is marked, then, by the delegitimation of science; for Lyotard, it has now been widely accepted – a constitutive feature of the postmodern condition itself – that the language game of science can only be legitimated from within. This is another way of expressing the continuing effects within social and cultural theory of the linguistic turn. In the context of the relationship between art and sociology, the demand of the Studio for the grounds of the sociologist's critique can only be met to the extent that the Studio can be brought to play the knowledge game of sociology. The imperialism, the rhetorical aggression of sociology – and perhaps of all knowledge languages – is an inescapable feature of its everyday life. It can only be seen as reasonable by destroying or disembedding the life worlds of those it seeks to persuade. It is this violence which so troubles Wolff.

In sum, Wolff seeks to save art through a theory of its particularity as a specific ideological force in modern, capitalist societies, but any such theory would enhance just that discursive imperialism about which, at another level, she is profoundly anxious. Wolff, the Marxist social scientist, is compelled to submit herself to the task of forging the advanced theoretical weaponry which hits the target it is designed for; as Lenin famously remarked, revolutionary social change entails a few broken eggs, and so too does sociology.

But Wolff is also concerned with theorising's ethical character,[14] the social effects of theorising. She does not spell it out, but if her theory were accepted art would become simply rationalised action directed towards the realisation of some particular political end. The difference of art as a practice, for example the prevalence of a highly individual starting point, the use of the accidents of material process, the importance of intuitive judgements and so on, would then have to be understood as merely the eccentricities of this particular process of production.

Yet it is possible, even sociologically reasonable, to be as sceptical about sociological self-consciousness as sociology is about what it takes to be art's self-consciousness. If one cannot rely absolutely on methodology to purge accounts of subjectivity, interest, and historical and cultural influences, then strong claims made about the difference between art and sociology are weakened. If sociology can still be 'valid for all practical purposes', despite its social and ideological context, then, presumably, so too can art. If sociologists are capable of taking account of the local circumstances and forces that might influence them, why should it be assumed that artists lack this capacity? If revisions of view through common sense or critical debate are out of the question for art then how are the everyday practices of sociology possible? If sociology has the right to claim intellectual and practical validity, despite the ways in which it also provides grounds for scepticism about such claims, why would it be right to assert that art does not?

For Becker, the issues of methodology, of the status of sociology as a science, and of its relationship with other important social practices are not of great importance. He assumes that there is little of substance between cultural spheres, between different practices at this epistemological level. What matters are the diverse and quite concrete ways in which human beings actively make their lives individually and collectively. For Wolff, however, epistemological concerns are at the very centre of her approach and much of what she tries to say about art can be read as an attempt to state and, less satisfactorily, to resolve tensions between knowledge and opinion, detachment and involvement, science and politics, explaining and understanding. The work of Peter Bürger, considered next, begins explicitly with this set of problems – essentially those springing from an attempt to square science with politics – and tries to resolve them by making his theoretical apparatus more theoretically sophisticated, and thus more adequate to the task.

Chapter 3

The Critical Theory of Art: Modernism and Violence

The critical theory of the avant-garde

Peter Bürger's *Theory of the Avant-Garde* (1984) could be seen to begin where Wolff leaves off. Issues which, in Wolff's work, remain the focus for anxieties, for Bürger become the centre of theoretical debate. Of particular concern are the consequences of a recognition that the theorist does not speak from a position beyond history and society, and the nature of the relationship between critique and the beliefs and practices that form its object.

Bürger's work derives from the tradition of critical theory. The influence of Hegel, Marx, Adorno and Habermas is clear, and at a methodological level there is a debt to the hermeneutics of Gadamer.[1] His political commitments are left-wing and his evaluation of the object of his study – the European avant-garde (Dadaism and Surrealism) – is generally positive.

The basic argument about the avant-garde is roughly as follows. Dadaism and Surrealism mounted an attack on a European art establishment dominated by 'aestheticism', by which Bürger means the 'art for art's sake' outlook manifested in the critical writings of Gautier in France and Pater in England, and in the literary works of Mallarmé, Valéry and Hofmannsthal. Aestheticism, for Bürger, represents the full development – almost a terminal point or *telos* – of a tendency of art within bourgeois society towards autonomy. 'Autonomy' meant the attainment of some degree of freedom from direct economic, political or religious control for the art world within the wider society. In nineteenth-century France this came about through the demise of the Academy system and the rise of independent critics and dealers.[2] But, for Bürger, the moment this limited amount of independence was

achieved, art began to lose its substance, its 'political' contact with 'life-praxis', with the interactions and exchanges of everyday life dominated in a developed capitalist economy by means–ends rationality. Art's belief in its freedom and distinctiveness represents a loss of critical, political content; the cost of autonomy is vacuity.

The vanguard artists of the last years of the nineteenth century and the early years of the twentieth sensed this as a betrayal of art, and reacted by producing works and events which were intended to destroy art as an autonomous institution and forge a new unity between art and life.

> For reasons connected with the development of the bourgeoisie after its seizure of political power, the tension between the institutional frame and the content of individual works tends to disappear in the second half of the nineteenth century. The apartness from the praxis of life that has always constituted the institutional status of art in bourgeois society now becomes the content of works… At the moment that it has shed all that is alien to it, art necessarily becomes problematic for itself. As institution and content coincide, social ineffectuality stands revealed as the essence of art in bourgeois society, and thus provokes the self-criticism of art. It is to the credit of the historical avant-garde movements that they supplied this criticism. (Bürger, 1984, p. 27)

In its attempt to destroy art the avant-garde failed. Works intended to be antithetical to the art market and tradition were eventually bought and sold for high prices, singled out for critical acclaim and exhibited in major galleries and museums alongside examples of the reviled European high culture. Although failing in some of its major aims the avant-garde did, however, significantly change the face of European and American art. First, it made visible for the first time art as a social institution; Bürger argues that this had profound consequences for both art and the possibility of a critical social–scientific account of it. Second, it drew attention to the social or political ineffectualness of art within bourgeois society. Third, it was made impossible for any one type or style of artistic practice to appear as a norm for all other practices, thereby guaranteeing aesthetic pluralism. Fourth, it pioneered the development of a new type of 'art object' organised 'non-organically'.[3]

How, in general, does this approach to the sociology of art differ from those of Becker and Wolff? In order to answer this question it is necessary to consider Bürger's reflection on the kind of theory he is employing. He claims that his account of the European avant-garde has

been produced by an approach he describes as 'critical science'; given his specific intellectual heritage, 'critical theory' would seem to be as appropriate. In various places throughout *Theory of the Avant-Garde* he discusses the nature of this approach. For the purposes of this chapter two issues are particularly salient, both of which have a bearing on the relationship between theorist, object and discourse. They are what Bürger refers to as the 'dialectical' link within critical science between the categories of a theory and the historical development of the object it seeks to explain, and the 'dialectical' relationship established within critical science between theories (ideologies) subject to criticism and the practice of criticism itself. The latter touches on the distinction between hermeneutics and ideology critique.

Theory and history

Bürger maintains that the business of critical science is to reveal the connections between ideas, theories, cultural products in general and the societies in which they arise. All cultural products bear the stamp of their times, and to understand them one must grasp their relationship with their parent social world. More specifically, one must grasp what the products did within their original historical context and, to the extent to which the products we are considering have been taken-up into our culture, we should also ask after their contemporary functioning.

Bürger's critical science wants to admit to its embodied character. It accepts – indeed insists – that it has the same 'conditioned' relation to the human world, to its society, as the theories and ideas it criticises. It is necessary to reject the traditional philosophical view that 'the only knowledge that can truly orient action is knowledge that frees itself from mere human interests and is based on Ideas – in other words, knowledge that has taken the theoretical attitude' (Habermas, 1972, p. 301). It must, therefore, have a general theory of how all theories (or ideologies) are rooted in the human, historical world. The essential point is that, for Habermas and Bürger, critical theory is not essentially different from its objects of knowledge. It is to be seen as inescapably a part of its social, historical environment, and as a form of action – specifically, the production of knowledge ultimately oriented towards emancipation – within that environment.

What does this recognition actually do in the operation of critical science? How does this stance make it differ from other kinds of social science? For Bürger, what is important is that a theory grasps the connection between the historicity of its own categories and the wider

structural contexts of history. The act of grasping this connection is what he calls 'historicizing a theory'. To 'historicize' a theory is to develop an 'insight into the nexus between the unfolding of an object and the categories of a discipline or science' (Bürger, 1984, p. 16). Bürger's own treatment of the avant-garde serves as an example of what he has in mind.

The condition for the development of an objective theory of art in bourgeois society is that art as an institution must be visible. According to Bürger, it became possible to recognise art as a social institution during the later part of the twentieth century – specifically via the insights of critical theory as expressed in Bürger's own work – through an explicit theoretical recognition of the significance of the practical attacks made upon traditional or bourgeois art by Dadaism and Surrealism before and after the First World War. This is, on the face of it, a rather incredible claim from a social theorist, seeming to imply that before *Theory of the Avant-Garde* was written social and cultural theory has had nothing interesting or true to say about art. Bürger's real intention is, however, to suggest that it is only recently – because of real historical developments – that critical social science has managed to free itself from traditional ideologies which prevented it from taking a radical, clear-eyed view of its object; his discussion of the Lukács–Adorno debate, outlined below, illustrates this contention. It must be emphasised that, for Bürger, the new critical theory of art with its essential category – 'art as a social institution' – is seen to depend upon the real historical achievements of earlier, non-theoretical avant-garde activities.

The model for this kind of argument about the relation between an object and the conditions for understanding it is, according to Bürger, Marx's discussion of the development of the concept of 'labour in general' in the Introduction to the *Grundrisse*. Here we are concerned with a key concept in political economy. Marx attributes its introduction to Adam Smith, and argues that its precondition was the development of a society in which labour had become diversified in a particular way: 'Indifference towards any specific kind of labour presupposes a very developed totality of real kinds of labour, of which no single one is any longer predominant' (Marx, 1973, p. 104 quoted by Bürger, ibid.). The general category 'labour' appears in a society where a complex division of labour excludes the possibility of the predominance of any one form of work, and where it can become obvious that what these many, diverse activities share is that they are all forms of labour. 'As a rule, the most general abstractions arise only in the midst of the richest possible concrete development,

where one thing appears as common to many, to all' (Marx, ibid.).
However, another more psychological factor seems to be involved:

> this abstraction of labour as such is not merely the mental product of a
> concrete totality of labours. Indifference towards specific labours
> corresponds to a form of society in which individuals can with ease transfer
> from one labour to another, and where the specific kind is a matter of
> chance for them, and hence of indifference. (Bürger, ibid.)

A certain arbitrariness of the general condition and experience of labour
is suggested as the precondition for a kind of mental detachment from
particular kinds of work, and hence an openness to the notion of labour
in general.

What has all this got to do with 'historicizing' theories? At one level
there seems to be some suggestion that the theorist must recognise a
dependency upon the simple visibility or presence of the object to be
explained.[4] At another level the argument is about the development of
general concepts, that is, of the theory itself. Theories require general
concepts, and having such concepts available amounts to having an
ability to see many things as instances of one thing; Marx makes this
point more clearly than Bürger. General concepts become possible
when one thing emerges as, or diversifies into, many different forms,
but also, crucially, when no one form exercises in our experience
predominance over the others, thus enabling their common element or
essence to be grasped. Thus, for Bürger, the critical theory of art in
bourgeois society admits to its dependency upon a central concept (art
as an institution) and formulates the real historical conditions for the
availability of that concept. But clearly, the idea of art as an institution
leaves open the question of what *kind* of institution it could be; equally,
different social theories will have different views about the nature of
institutions in general and about art in particular. Bürger is thus forced
to go beyond the simple idea of art as an institution towards something
more specific; art thus becomes the kind of institution that operates to
produce objects and events whose meanings constitute part of the
ideological conditions for the reproduction of bourgeois society.

We are considering the reflective question of what it might be like for
a theory to recognise its own historical character, and what difference
this would make to it. For Bürger, a theory is 'historicized' when its real
historical preconditions are recognised. But presumably false theories,
as well as true ones, have historical preconditions. The difference
between true and false theories, in this respect, must have something to
do with different kinds of relationship with historical preconditions.

For critical theory, it would be untrue to assert that art in bourgeois society is wholly autonomous or that it cannot be treated as a social institution. Here, then, critical theory formulates explicitly what the avant-garde managed to achieve practically. Untrue theories of contemporary art are made possible by the same historical conditions but fail to grasp their deeper significance. Thus the whole Lukács–Adorno debate on the nature of modernism is seen by Bürger as 'historical' (here meaning *passé* or obsolete) because the 'two authors do not thematize the attack that the historical avant-garde movements launched against art as an institution' (Bürger, 1984, p. 86). In other words, Lukács and Adorno failed to free themselves from art's view of itself because they failed to see its corpse lying at their feet. They were, perhaps, too much in love with art to accept the fact of its death. Critical science, on the other hand, is free to anatomise the corpse because it sees the significance of the destruction of art's normative power to which it is heir. The false theory fails to disengage itself from its object; in order to achieve objectivity it requires greater structural–historical distance – not just the elapsing of time – and, on this condition, a profound disengagement or indifference.

There are a number of points to be made about Bürger's account of the development of a social theory of art. First, the concept of art as a social institution is certainly not unique to critical theory. While Bürger may well have been helped in his analytical efforts by the historical example of avant-garde critique, the grounds for believing that it has been important to the formation of other sociological theories or a broadly sociological perspective on cultural phenomena are surely slight, either empirically or logically. Seeing art as a social institution of some kind is surely the result of the development of a general sociological paradigm and not the recognition of the supposed lessons of European modernism.

Second, Bürger regards art as a social institution of a certain kind, specifically as contributing to the reproduction of the ideological conditions necessary to capitalism. This notion of art is indebted to Marxist theories developed in their essentials before the main period of avant-garde activity. Bürger's response might well be that, although it had been possible for most of the century to see art as an institution of ideology, theorists – leading Marxists among them – failed to press home this view, and to develop its implications, perhaps because of their sentimental, nineteenth-century affection for high art. However, another interpretation is possible. It may not have been that these theorists were fooled by art's mystique; rather, they had some sense of

art's particularity, not just as a variant within ideology in general, but as an important, distinctive and valuable human possibility. They were not so much unable to finish art off with the weapons of criticism as unwilling to try, and this unwillingness was due not to naïveté but because of the loss they knew its destruction[5] would bring.

Third, it will have become apparent that there are two strands to Bürger's view of how objectivity is possible; the object must have developed fully, and the subject must have achieved some distance from it. This image of the possibility of cognition almost suggests the way in which an initially confusing visual perception – say of a 'painterly' image – resolves itself into recognisable shapes or objects if seen from a distance rather than close to. However, distance here cannot imply that the subject has assumed a position outside or beyond history and society. The distance, which Lukács and Adorno supposedly failed to gain, is produced by a recognition of the implications of the avant-garde critique – that the history of art had come to an end, while its critical–scientific study was just beginning. The Hegelian resonance is audible; the distance required for cognition is not so much a distance *from* history as one provided *by* it. If knowledge is taken to mean 'truth' in the sense of correspondence (which does seem to be Bürger's approach), and not just world views or perspectives, then this would suggest a connection between history and the categories of epistemology. A philosophy proposing a 'logic' of history is implied.

It is not necessary to pursue this issue. But one point does need making because it bears on the problem of the historicising of critical theory itself. If distinct historical periods or forms are the precondition of knowledge, then knowledge of the connection between critical theory's categories and its social environment can only be grasped when critical theory itself has reached its term. Because history is distinct from and more important than mere temporality, and because the notion of history is equivalent to the notion of development into form, it follows that critical theory, and in particular its real historical preconditions, can of necessity never be grasped in the present; critical theory itself, unlike its object or target theories and ideologies, is thus not available for historicisation. For the Hegelian dialectic this problem does not arise, because its position is that of attained wisdom, the terminus of Spirit's odyssey of self-realisation. For Bürger, however, the difficulty is embarrassing and intractable.

Critique, immanent and external

It is necessary now to consider Bürger's view of the relationship between critical theory and other theories, or the aspiration to a dialectical relationship between theories in which the critical discourse does not simply demonstrate the untruth of the other, thereby negating it.

It might be noted in passing that the problem of the relationship between critical theory and its objects cannot be neatly separated from that of the relationship between theories. The critical scientist maintains that contacts with objects are always mediated by theories:

> The immediacy of the glance that believes it is focusing on phenomena is self-deception. The objects with which the literary scholar deals are always given to him, as mediated ones. (ibid., p. lv)

In the terminology of hermeneutics our contact with objects of human significance and meaning is always mediated by tradition. Bürger describes his theory as having a 'dialectical', as opposed to a 'dogmatic', relation to other theories. The former does not remain external to its object, unlike dogmatic criticism which believes that the supposed correctness of its own insights condemns all other theories to untruth. Certainly, dialectical criticism will identify contradictions and *aporiai* in other theories but these are not taken to be

> indications of insufficient intellectual rigor on the part of the author, but an indication of an unsolved problem or one that has remained hidden. Dialectical criticism thus stands in a relation of dependency to the criticized theory. (ibid.)

Dialectical criticism shares with hermeneutics a sense of the importance of a common intellectual and cultural framework or tradition. In encountering the work, the theorist brings to bear what Gadamer calls 'prejudices' – general or particular ideas about the text or object derived from the discipline in which he or she has been trained – and from the wider culture. Interpretation thus has the form of a dialogue between the tradition, as a kind of stock of practical hypotheses about being and meaning, and the work. Bürger also draws attention to the hermeneutical question of application, which refers to the ways in which an interpreter understands things from the point of view of his or her own historical situation.

Citing the critique of Gadamer by Habermas, Bürger goes on to argue that conventional hermeneutics makes tradition absolute, and fails to understand how the historical present motivates and guides

interpretation, by ignoring the contradictions and divisions within
society. The interpreter cannot uncritically assume the standpoint of
the present because the present, in a class-divided society, affords no
such universal viewpoint. Tradition must be approached from the point
of view of either the oppressors or the oppressed, and it will be
understood, evaluated and mediated differently according to which
point of view is adopted. Thus, a critical hermeneutics becomes
identical with the critique of ideology.

In discussing the idea of ideology critique, Bürger gives pride of place
to Marx's attack on religion in his *Critique of Hegel's Philosophy of Right*.
He is anxious to avoid what he sees as a vulgar-Marxist approach to
ideology which believes that it has thoroughly negated a belief when it
has demonstrated its social origins.

> The young Marx denounces as false consciousness an intellectual construct
> to which he does not deny truth – and therein lies the difficulty but also
> the scientific fruitfulness of his concept of ideology. (ibid., p. 6)

For Bürger, Marx's dialectical criticism of religion is that religious belief
is an illusion, in that there is no God, but that its truth is the unhappy
yearning for something better. However, insofar as religious belief and
practice compensate for the depredations of an oppressed life they can
be seen to contain and blunt proper criticism of the social order
ultimately responsible for that suffering. There is a need for a critique of
religion which will pick the imaginary blooms from the 'chain' of
oppression 'not in order that man shall continue to bear that chain
without fantasy or consolation but so that he shall throw off the chain
and pluck the living flower' (Marx, 1975, p. 244).

Various claims are made for this model of dialectical criticism. First,
because it conceives of the relation between ideas and social reality as
contradictory (the truth *and* untruth of religious belief, for example) it
allows the analysis of particular cases 'the necessary cognitive scope that
will prevent it from becoming a mere demonstration of an already
established schema' (Bürger ibid., pp. 7–8). This seems dubious. The
discussion of any belief system in order dutifully to reveal its true,
untrue, and ultimately reactionary features would seem to be just as
open to mechanical and pedestrian treatments as any other approach.
Second, Bürger repeats the commonly made point that ideologies are
better conceived of as the product of a social reality than as its copy or
reflection. But this idea and its implications are not pursued further.
Third, he stresses again that, in this model of criticism, the aim is to
identify and separate truth and untruth.[6] Critical theory claims not to

reduce the object, or other theories and beliefs, to mere concrete instances of its own categories and concerns because it recognises its dependency upon them, both as actual historical events and as earlier but necessary stages in the development of knowledge. All theories and ideologies are both 'right' and 'wrong'. Thus, for example, Aestheticism's view of the autonomy of art was true insofar as art had, by the end of the nineteenth century, become a developed social subsystem within bourgeois culture, but it was false insofar as this was taken to imply that art was capable of transcending social and historical conditions in general, and specifically, its ideological functions for a capitalist society.

This raises a question about the nature of the truths that this type of criticism incorporates. In the case of Marx's critique of religious belief the element retained is a dissatisfaction with the world as it is: 'Religious suffering is at one and the same time the expression of real suffering and a protest against real suffering' (op. cit., p. 244). Here Marx transforms or recasts religious belief. It becomes an 'expression' of this-worldly suffering and a 'protest' against it. This does not touch on the core of religious belief – the affirmation of the reality of the transcendent. This decisive moment is not incorporated, of course, because this is precisely what Marx believes to be untrue about religious belief. But the point remains; what Marx incorporates is not an element of religious belief but a particular explanation of it derived from the application of his 'prejudices'. With Bürger's theory of Aestheticism, the element taken up – the idea of the historical completion of the development of the social subsystem of art – is specifically denied to be a view attributable to the movement's artists or critics. Again, the 'truth' dialectically preserved is really a social–scientific explanation of why others came to believe an 'untruth' – that art is not reducible to its supposed social or historical effects.

Neither Bürger nor Marx can be said to redeem elements of the beliefs they criticise. In the passages considered they deny the truths of religion and art, and then attempt to explain their occurrence. The crucial affirmations of religion and art do not appear insofar as Marx and Bürger reconstruct these beliefs as expressions, products, blind responses to circumstance, consequences of a particular kind of society. The nature of real truth on the other hand, the content of their theories, is something else again, not caused but in some sense chosen, not a blind response but a correct view of how things really are, not mechanical consequences but an act of human freedom.[7]

To summarise, this negation of beliefs follows from the very idea of critique as the unblocking of routes to social emancipation by the removal of false ideas, perhaps not as the sole means of producing change but nevertheless an important contribution. Certain ideas are shown to be the product of their historical circumstances – they are 'explained' – but in addition their validity is denied, either explicitly or implicitly. Despite the logical distinction between questions of validity and questions of genesis, the explanation of other's beliefs is in practice assumed to 'explain away' their foundation. This deep historical prejudice, that ideas must be false if they have social origins – if they can be seen to be caused rather than chosen – gains its force from a deeply ingrained objectivism.

If the immanent critique that Bürger aspires to 'demands surrender to the life of the object' (Hegel, 1977, p. 32) or is 'a refusal to intrude into the immanent rhythm of the Notion, either arbitrarily or with wisdom obtained elsewhere' (ibid., p. 36) then, at least in the cases considered here, there is a clear difference between it and ideology critique as Bürger deploys it. His relationship with other theories and beliefs exhibits the distance required for objectivistic claims about the real character (socially motivated and therefore untrue), and for a destructive negation of them in the name of emancipating social change.

Art supplanted by critical science

The point of drawing attention to inconsistencies between Bürger's aspirations for his critical theory and what it is in practice is not to suggest that the work is necessarily uninteresting or inconsequential because of its inconsistencies. The point is rather that his work is beset by familiar tensions arising from a dual commitment to science on the one hand and politics or ethics on the other; this is, of course, in line with critical theory's view of itself as combining theory with emancipating struggle. Leaving to one side general questions about their intrinsic compatibility, here they swamp another commitment, best seen as an aspiration to a more intimate, entangled, immanent or dialectical relationship with his objects, and crucially with other subjects. Despite his avowed intentions, the substantial message of *Theory of the Avant-Garde* is the familiar litany of the social–scientific attack on art, although with particular features derived from its specific Hegelian–Marxist tradition.

Certainly Bürger is in some respects more radical than his predecessors, in particular Lukács and Adorno. He believes, as we have seen,

that art expired sometime during the early years of the twentieth century, and that this should not be, all things considered, a source of regret. It died as a result of wounds it received on the boulevards of Paris, and in nightclubs in Switzerland and Germany. Its once celebrated powers of expression, its claims to noble ancestry, its touching belief that it was somehow still important to everyday life despite its withdrawal into bohemianism, even its tiresome family squabbles (mimesis versus expression, line versus colour, form versus narrative, realism versus modernism and so on) – all had been done away with by the virile young radicals of the avant-garde.

However, because they represented an *artistic* attack on art, art's assassins did not long survive their victim. Things called 'art' have gone on being produced. Some of these objects have even been claimed to be 'avant-garde', 'trans-avant-garde', 'radically critical', 'decisive interventions' and so on. But this latter-day sub-Dadaism is, for Bürger, only of value when it is a direct contribution to political action directed, not by spontaneous rebellion and cultural transgression, but by knowledge based in critical theory. The battlefield is no longer art but ideology defined and illuminated by critical social science.

For Bürger, with the abandonment of the norm of organic totality, the individual sign or basic element of the art work need not be subordinated, by ideological demands made in the name of reactionary aesthetics, to a principle of formal unity. It can come to stand as 'an important statement concerning the praxis of life, or as political instruction' (Bürger, 1984, p. 90). While, for Adorno, the refusal of organic totality (unity, harmony, the pleasing)[8] was certainly part of the political or ethical dimension of modernist work, for Bürger it 'enables political and non-political motifs to exist side by side in a single work' (ibid., p. 91). Bürger is not explicit about what such 'non-political motifs' might be, and it is difficult to see how the new, politically directed avant-garde work would avoid either a wholly arbitrary relation between form and political content – along the lines of an argument that form doesn't matter so long as it can repel judgements of taste – or a relation in which every feature of the work is subordinate to the political message.

Street-fighting men: exercising or excising violence

I have argued that within some sociological accounts of art there can be found tendencies towards acquisitive, expropriating social relationships. Both Becker and Wolff are troubled by aspects of the relationship

between sociological theorising and art worlds, the former being concerned by the ways in which theorising might disturb or even fracture social cohesion rooted in members' common sense and common speech, while the latter is anxious about reductionism and violence. Bürger's approach promises to soothe such worries by showing how social theory can avoid a false objectivism on the one hand and oversimplifications on the other. In acknowledging its own embeddedness in the historical, social world, in accepting its own finitude and partiality, it hopes to avoid constructing and enacting an aggressor–victim relationship with other theories and beliefs. It seeks to affirm this embeddedness by accepting its dependency upon predecessor theories and by recognising the structural, historical conditions for its real and logical conditions of existence. It seeks to accept that its scientific accounts of the world must also be seen reflexively as forms of practical action on and in the world. Recognition by theorising of its this-worldly, historical character is expected to cure it of its careless or violent tendencies.

Why does the idea that social theorising might be an inherently violent activity cause embarrassment or unease? Perhaps, following Marx and Nietzsche, discursive practices of this kind should be seen as belonging to a *Kampfplatz*, a scene of struggle, defeat and conquest, and the social theorist as a warrior, aristocratic or of the people?[9] One difficulty is perhaps that while images connoting revolutionary destruction have periodically become chic, when stripped of its glamour, violence – discursive or otherwise – cannot easily be seen as an ordinary social relationship, a normative social bond, at all; it is thus usually an idea which marks a limit for social theorising as a practice. Even that theorising which explicitly conceives of itself as social criticism proceeds with caution here. If the society or institution to be criticised can be shown to be inherently or routinely violent the conclusion might follow that it is not a true social relationship at all, and therefore that action against it is justified, perhaps even violent action.

Yet a more sceptical, and therefore perhaps more enlightened, view of modern theorising would suggest another interpretation. Wishing to diminish and justify the intrinsic violence of his or her cherished practice the theorist identifies a greater, illegitimate violence capable to justifying it. Here Bürger's rhetorical practice – as opposed to its declared aims – suggests that this supposed hermeneutical revision of objectivisitic social science does not really eliminate its violence. In Bürger's critical practice what connects theory with practice, science with criticism, 'is' with 'ought', is not so much convincing epistemolog-

ical argument or hermeneutical practice but an invocation of intolerable injustice, a wrong which makes a right.[10]

It might be suggested that to reread a text like *Theory of the Avant-Garde* for some supposed rhetorical functioning repeats the very error of which this text has been accused. It divorces overt claims made by the author for the reasonableness of what he says from some version of its effective reality, its functioning as rhetoric. A covert message, an insistent, contradictory subtext, is revealed. Even if strong claims for the rereading as a demonstration of what the text really or essentially says are avoided, perhaps in favour of the idea that there might be a plurality of equally feasible readings, in some way the damage is already done. The reader is distanced from a simple acceptance of what is said; trust fades to be replaced, at best, by a suspension of disbelief. Feelings and ideas about the text become subject to ambivalence. An oscillation is set up.

Another example: we have seen Bürger suggest that in order to get a clear view of something like art one must be free of its normative power. Put bluntly, in order to see the social reality of religion and art one must have ceased to believe in them. Like Odysseus, the social scientist is expected to report on the world of the dead, to inhabit the Halls of Hades and Persephone, and the sociological account is a book of the dead. Unlike Odysseus and his crew, Bürger approaches his task not with melancholy and trepidation but in a spirit of buoyant zeal.

It is important to note that the freedom of the theorist's imagination from the normative force of its object is not presented as the product of some expedient bracketing or process of abstraction self-consciously undertaken, of the kind that Dilthey, for example, saw at the root of the natural sciences:

> We are able to control the physical world by studying its laws. These can only be discovered if the way we experience nature, our involvement in it, and the living feeling with which we enjoy it, recedes behind the abstract apprehension of the world in terms of space, time, mass and motion. All these factors combine to make man efface himself. (Dilthey, 1976, p. 172)

Progressive disenchantment is not just something observed by sociology; it is what makes that observation possible. Rents of this kind in the fabric of the social world are both the precondition for social theorising and reflect the socio-cultural divisions of modernity. For Bürger, the anger of the avant-garde towards an art which, in allowing itself to be cut off from everyday life, conspired in its corruption, is no longer appropriate. While one might regard the corpse with

distaste there would be little point in continuing to abuse it; better by far to see it interred. The critical scientist can be expected to become exasperated by those who remain anachronistically attached to art, and would wish that increasing numbers of people could be brought, through the interventions of expert, critical knowledge, to s*ee through* art; professional curiosity would eventually supplant both enthusiasm and hostility.

How is Bürger's theorist able to be so confident that indifference is in this case the result of a change in the object or, what here amounts to the same thing, in the social relationship with the object, rather than in the desires, will or violent actions of the theorist? How does the theorist manage to absent himself so convincingly?

It may not be possible to *do* anything with this recognition of ambivalence. Theorising may just have to get used to being unable with certainty, or even confidence, to distinguish finding from making, conditions from products, construction from destruction. Nevertheless, from the point of view of this essay, the absence, in *Theory of the Avant-Garde*, of any sense that the theorist may have some responsibility for the world of the dead reported on serves to insulate him or her from the very anxieties and troubles that give substance and relevance to the efforts of Wolff to confront more reflexively the relationship between theory and art.

The icon of theory

Bürger has an explicit interest in the moral character of theorising, which he tries to grasp in terms of first, the historical and social being of both theorist and theorised, of self and other, and second, a theorising practice which replaces the violent negation of other with dialogue. Dialogue, in which criticism is combined with affirmation and acceptance, can be seen as a social relationship premised on and concerned with difference; it is not only the efforts of merely antithetical positions to subdue and negate one another.

Trying to understand the finite, historical being of the theorist and the theorised is, for Bürger, an attempt to see real, historical preconditions for the development of key concepts by which the conversation is to be structured. In the genesis of these concepts indifference to the concrete (the multiple appearances of the idea) is vital. But indifference is not so much an act of the subject as, in itself, an historical event. It occurs when the influence of the object over the mind and emotions of the theorist has lost its potency. Two implications appear: first, that

while indifference is depicted as the precondition of the rationalising tendency of social–scientific theorising there remains the suspicion that the very impulse to conceptualise, to grasp the concrete through its idea, is to rob the concrete violently of its uniqueness and vitality. Second, if it were to grasp itself in its finitude and partiality critical science would have to be able to regard even itself with indifference; it would be required to treat itself as complete, a spent force; this despite its sense of its own analytical and critical vitality, as uniquely timely, indeed as having just begun.

In both cases ambivalence threatens to colour the theoretical project. But Bürger's critical theorist, committed to the pursuit of knowledge and justice as one indivisible task, allows no space for its emergence. Thus, any anxiety that might be associated with the confident pronouncement of the end of art is dissolved by the argument that art is only available as an object for social science because it is already over. Or again, worries about critical negation are to be allayed by its dialectical incarnation. But, for Bürger, the idea of criticism suggests that the preservation and incorporation of the truth of other's speech can only be understood as the causal explanation of ideology. So the speech of other is now to be understood as a moment in a sequence of causes and effects. The social bond is reaffirmed but as objective, not normative. Any doubts about the moral quality of theorising are quelled by the invocation of a given, objective sociality that speaks through the words of others.

In this density of denial there is no space for either anxiety or ambivalence. What kind of reconstruction of the social bond is at work here? The objectifications of a social science are themselves eloquent testimony to alienation. Critique exemplifies the violence inherent within alienated social relations, even if and when it seeks a cure. The cure is twofold: the recognition that the real possibility of theorising is a given sociality, and that analysis is merely one part of an action by which this mere givenness could be transfigured as value. Thus, anxiety is allayed by an image of unity. Theorising is not simply the means towards some distant end but is already fused with ends. It belongs to the future while being a part of the present. The suspicion that, in practice, its means – its effective rhetorical functioning – are at odds with its ends is kept at bay by the image of unity, an icon. While Becker's and Wolff's anxieties relate to the problems of the social relationship between worlds constructed in and by theorising, critical theory takes itself to be the image of a third world in which such oppositions are consigned to the past. Antagonisms, represented as

antitheses between worlds (fact and value, means and ends, pure reason and practical reason and so on) are dissolved by the projection that they are merely mirror-images of one another, falsely separated; we are invited to see corporeality as a value (our common social body), and how value may be made corporeal (the realisation of our freely chosen ends). Tensions between worlds and the ambivalence of theoretical practice are expunged by the epiphanic image of theory.

In sum, when the language in which critics, historians and philosophers have discussed art has contained so-called essentialist concepts, this has not meant that these discussions have been necessarily incapable of responding to and respecting the life of art. Neither has this language necessarily been incompatible with creative visual practice guided by contextual knowledge and judgements, sensibility and intuition. Art worlds often find ways of using, but keeping their distance from, the abstractions and interests of theorising, or of turning them to their own advantage. Bürger's unfulfilled reflexive intentions suggest not only the need to recognise the complexity and sophistication of members' practices and practical reflections but also the imperative for theorising to review the limits, context and consequences of theorising itself.

While at one level it does not make much sense to distinguish sharply between a discourse and a practice, in everyday contexts, for example those of criticism and pedagogy, the language in which discussion occurs has often been targeted by those seeking radical change. The strategy is often effective; weaken lay confidence in the ways in which something is routinely discussed and one will often weaken confidence in the thing itself. To undermine ways of discussing art which have shown themselves capable of sustaining a range of creative visual practices is to undermine the possibility of art, unless it can be shown that a new language can do the job; this need not be a concern for the knowledge project, but for those, like Bürger, with reflexive intentions, it certainly is.

The meta-language of a practice – comprising its concepts, metaphors and tropes – shapes a world in which the practice is possible and reasonable, in which its central claims make sense and where its principal aspirations may be fulfilled. To see both art and sociology as reasonable and possible practices is to affirm that, through the consciousness and discourse of members, an awareness of the world may be expressed, and that intentions framed in language may be realised through action in and upon the world. Typically, practices are theoretically negated by the denial of a difference between conscious-

ness and the world; a theory of ideology, like that employed by Bürger, takes beliefs to be caused by, or to reflect (with greater or lesser degrees of complexity) features of the world. With opinion (or ideology or common sense) the world – and in particular power relations that distort ideal sociality – is insufficiently excluded from the account. The solution is some version of methodology which creates a distance between consciousness and its object. A situation embracing knower and known is to be set up where the object realm exists independently of, but in relation to, consciousness and its discourse. Freed from the effects of the world, the subject – individual or collective – can truly know and act rationally to shape the world in accordance with his or her wishes. However, this project of knowledge and freedom, of enlightenment, has now itself fallen under widespread suspicion; the critique of ideology in the name of comprehensive, subject-centered reason cannot easily escape from the terms of its own argument. The human sciences, as an essential feature of modernity, are confronted by modernity with a choice between seeking legitimisation through strong claims for their methodology or by pragmatically presenting themselves as technical contributions to practical projects. Sociologists like Bürger, however, for whom neither pure science nor technical contributions to social problem-solving is acceptable, must seek a third, dialectical course, which has been outlined above.

At this point sociology's difficulties in some ways come to resemble those of art. For contemporary critical theory, however, the only alternative to varieties of nihilism is the resumption of an 'incomplete' Enlightenment project of critical and practical reason.[11] Whatever its other merits, as carried out by Bürger, it does not live up to the requirements placed upon it. Despite his stated intentions, Bürger achieves a total expropriation of art. In this sense his work represents an effective completion of the technical revisions that Wolff both seeks and dreads.

Chapter 4

Pragmatism, Individuation and Totalisation

Philosophy and pragmatism

The work of Richard Rorty provides an opportunity to extend the arguments above in a somewhat different direction, towards wider questions about languages and practices, their interrelationship, and social theory. Like Becker, Wolff and Bürger, Rorty is convinced of the inappropriateness of many traditional philosophical and theoretical concepts, and he believes that the time is right to liberate ourselves from them. With Becker, he thinks that the various things taken to represent knowledge and value within different communities are to be traced back to how particular social groups attempt to resolve the mundane practical problems that confront them. He gives greater prominence than Becker, however, to the beneficial social or ethical effects for a modern liberal society of the deconstructive efforts of 'edifying' theorists, which are directed against the tendency of all practical agreements to become fixed, and so to confine and limit human creativity or, in his terminology, the open 'conversation' of (ideal) human existence.

There is in his work the outline of the philosophical basis for a liberal, postmodern social theorising, which I propose to examine from the point of view of the kind of account which it might offer of modern art. The questions are: What could this make of art? and What does this make of theorising?

While Rorty does not discuss visual art directly, his work is relevant to a social theory of art that rejects both traditional philosophical and critical concepts, and reductionist, structural accounts of cultural phenomena. His approach is also explicitly concerned with its own social, ethical or political character, and is thus relevant here for three

reasons. First, he is critical of the language in which, until recently, things like visual art have been discussed, insofar as this language includes 'essentialist' or 'metaphysical' notions. Second, he seeks, in a somewhat complex way, to link cultural phenomena like art and science to the practical concerns and public discourses of particular and historically contingent social groups. Third, he seeks to understand and defend his practice of theorising largely on the grounds of its capacity to contribute to the further development of a liberal society in a post-Enlightenment context.

It is necessary first to sketch out Rorty's pragmatist theory as it is relevant to cultural phenomena like visual art. In *Philosophy and the Mirror of Nature* (1980) and *Consequences of Pragmatism* (1982) Rorty explores some of the consequences that follow from a rejection of 'essentialist' philosophical theories in favour of the notion of contingent, historically and socially located 'conversations'. These conversations typically produce 'ordinary, retail, detailed, concrete reasons' (Rorty, 1982, p. 165), not reasons in the sense of ideal objects (Plato) or definitive rules for the construction of experience (Kant). Thus 'reasons' in the first sense – identifiable as those moments in a conversation where participants decide to accept something that has been proposed or asserted – are seen to be determined by an interest in action.

There are, however, different kinds of conversation in the context of which an agreement might arise. Sometimes conversations appear to be directly instrumental, to arise from a practical project at hand in the real, everyday world. Approving of Gadamer's notion of *wirkungsgeschichtliches Bewusstein* (often translated as 'effective historical consciousness') Rorty remarks that in it is displayed 'an attitude interested not so much in what is out there in the world, or in what happened in history, as in what we can get out of nature and history for our own uses' (Rorty, 1980, p. 359). The attitude is directed not towards 'truth' but towards our capacity to shape or determine the world according to interests or desires; as with some other postmodernisms influenced by Nietzsche, this can be heard as a toned-down, liberal endorsement of the primacy of the will to power. On other occasions, however, the action–interest alive in conversation is simply an interest in conversation for its own sake: 'We are not conversing because we have a goal, but because Socratic conversation is an activity which is its own end' (Rorty, 1982, p. 172).

The first position would seem close to Becker's. Rorty is interesting because he explores the theoretical consequences of a pragmatic approach more thoroughly than Becker, applying it in particular to

traditional philosophy and its views of science and truth; he also makes an attempt to see its moral consequences. Thus: 'To be behaviourist in epistemology... is to look at the normal scientific discourse of our day bifocally, both as patterns adopted for various historical reasons and as the achievement of objective truth, where 'objective truth' is no more and no less than the best idea we currently have about how to explain what is going on' (Rorty, 1980, p. 385). For Rorty, the notion of what might be accepted 'for various historical reasons' offers an opportunity for conversation about values.

The particular subjective conditions for a science are not to be found within the logic of inquiry (Rorty gives the example of what he sees as Habermas's neo-Kantianism) but are simply

> the facts about what a given society, or profession, or other group, takes to be good ground for assertions of a certain sort. Such disciplinary matrices are studied by the usual empirical-cum-hermeneutic methods of 'cultural anthropology'. (ibid., p. 385)

Applied to sociology and art this suggests that what these communities accept and practice is to be seen sceptically as the outcome of various historical and social conditions, yet also given credence as what effectively constitutes art and artistic worth in the first case, and the truth about society in the second. There would be little point in complaining that the first of these conditions seems to undermine the second; for Rorty this 'bifocal' vision, despite the difference in mood, or in the intensity of affirmation, between the two kinds of belief, is essentially what constitutes an enlightened, modern, or perhaps post-modern, consciousness. Such a consciousness must embrace, simultaneously, belief and unbelief; it must be, simultaneously, sceptical and, in Hegel's sense, pious. To condemn Rorty's recommendation of this kind of consciousness as simply an attempt to normalise a dichotomy which is unsatisfactory, both philosophically and psychologically, would, to the pragmatist, represent a lapse into essentialist sentimentality. It would be to negate the historical and cultural reality of the modern world in the name of delusive abstractions and impossible aspirations.[1]

The view of discourse about such things as art, values and society provided here involves, in a way similar to Becker, images of interminable yet divisive chatter (traditional essentialist philosophy, aesthetics) contrasted with a harmonious community coming to practical, fruitful agreements. Agreements are not rooted in theoretical or philosophical abstractions but in an intuitive, unreflective, strategic sense of what is likely to be constructive practically. Yet Rorty is more

critical of daily life than Becker. Routine communal agreements are prone to inertia and conservatism, and in stifling criticism or, more radically, the introduction of new 'vocabularies' the conversation they represent easily becomes 'boring'; hence the need for edifying philosophers like Rorty himself.

> The danger which edifying discourse tries to avert is that some given vocabulary, some way in which people might come to think of themselves, will deceive them into thinking that from now on all discourse could be, or should be, normal discourse. The resulting freezing-over of culture would be, in the eyes of edifying philosophers, the dehumanisation of human beings. (ibid., p. 377)

Normal discourse is thus contrasted not only with traditional philosophy – which is secretly devoted to silencing conversation in the name of the Truth – but also with edifying conversationalists, alive to any signs that participants might be getting a little too comfortable with yesterday's arrangements and conclusions.

Pragmatism and modernism

A problem regarding the applicability of this image to visual art that would strike many immediately is the extreme difficulty of regarding much contemporary art as part of a 'normal discourse' in any sense at all, and certainly not in the Kuhnian sense employed by Rorty. For Kuhn, normal science is largely 'mopping up' a series of more or less routine problems generated by a scientific community's paradigm.[2] It is routine research work, problem-solving. Normal science is conservative in that it seeks to extend a given body of knowledge, not to challenge it with fundamental anomalies and the new theories which might resolve them. But perhaps modernist, avant-garde art and edifying theory are not normal discourses at all, in that both seek not the closure represented by practical agreements but change for its own sake, the openness of pure possibility?

The views of the American critic Harold Rosenberg can be taken as representative of what are still widespread beliefs about the nature of much contemporary art in this area.[3] For Rosenberg, vanguard artists of the twentieth century have characteristically taken up an adversarial position with respect to older, established art. From the point of view of the artist, the 'logic' of development becomes:

> 'Since such and such has been done, it follows that art must…' Mondrian leaves 'naturalistic' art behind, and it's up to the artist who comes after him

to leave Mondrian… behind. But not Rubens or Correggio, since Rubens was left behind by other people. It follows that Mondrian is Art, but Rubens and the others are tombstones in a receding series, not even containing anything that can be negated. (Rosenberg, 1959, pp. 78–9)

Rosenberg acknowledges that when 'the only vital tradition of twentieth century art to which criticism can appeal is that of overthrowing tradition' (ibid.) both art and criticism threaten to become absurd.

> At war with themselves, revolutionary art and criticism cannot avoid the ridiculous. Yet upon the contradiction of revolution depends the life of art in this revolutionary epoch, and art and criticism must continue to embrace its absurdities. (ibid., p. 83)

Contemporary criticism must finally endorse this transgressive compulsion, but simultaneously denies itself the possibility of the abiding standards and values its own practice requires, hence its 'absurdity'. For Rorty, of course, this kind of criticism need not be absurd, providing that it rejects the traditional search for absolute grounds or rules. There is absolutely no 'reason' why it should, or indeed could, aspire to standards and values which are any less provisional and temporary than those of the art it finds interesting.

The problems of critics and theorists aside, the image of a modernist practice that Rosenberg and others like him present does not much resemble Kuhnian 'normal science', or the workings of pragmatic communities imagined by Becker and, in a more critical way, by Rorty. This is because, in its avant-garde manifestations, modernist art, like edifying theory, is taken to have quite different values. But if modernist art and edifying theory have chosen not to stabilise themselves around paradigms, standardised methodologies, more or less shared values, a common and relatively static vocabulary and the like, then, on this view, it is difficult to see how they could be regarded as organised practices with any coherent character at all. As Rorty remarks, abnormality makes no sense without normality. Without agreement, that is, normality, there is no truth, no art, no knowledge of society. The pragmatist recognises that 'abnormal and "existential" discourse is always parasitic upon normal discourse' (Rorty, 1980, p. 365). It would seem that both modern art and edifying philosophy depend upon practical background agreements, learnable communal patterns and languages, and a fairly stable hermeneutical environment, even when the stasis these supposedly represent is precisely what innovation and edification deconstruct.

Two points should be made here. First, in the case of the avant-garde modernist art that Rosenberg – and probably Rorty – would wish to defend *on the ground of its novelty*, it is not immediately apparent what this bedrock of 'normality' might be, or even what it could be. If there are *no* pre-existing criteria or values for understanding or judging avant-garde works they must have a completely arbitrary relationship with established ideas and existing practices of art; it is not the works that can be interpreted or justified but only the principle of arbitrariness they represent. For example, in his essay 'The New As Value' (in Rosenberg, 1964) he seems more confident than in earlier essays about the validity of deliberate cultural novelty and the kind of critique he thinks it often represents. Although critical of the tendency of curators and critics to chase after the next trend or fashion fad[4] he insists that avant-garde art and criticism should not be dismissed out of hand; cultural innovation – which might take many different forms – is valuable because of the novel states it induces in the subject as a response to the world:

> In the traditions devoted to exploring and transforming the human self and the human condition, the value of the new is measured not by pre-established standards but by the genuineness of the novelty and the possibilities to which it gives rise. (ibid., pp. 233–4)

The key to this new optimism appears to be that Rosenberg no longer identifies art values with formal values. Formal criticism which 'consistently buried the emotional, moral, social and metaphysical concerns of modern art under blueprints of "achievements" in handling line, colour and form' (ibid., p. 232) became transparently inappropriate when contemporary artists started to incorporate found objects into their works without modifying them in a way which suggested any concern for formal values. For Rosenberg, somewhat tautologically, novelty can be regarded as a legitimate value in art provided that art values are not restricted to the formal. The justification for this view he finds in the whole character of 'our times' or, one might say, modernity: 'Art in our time, characterised by continuous experiment, belongs to the alarming realm of thought and action which since the Renaissance has elevated novelty as a value inseparable from its deepest aims' (ibid., p. 234). In a manner which is coherent with Rorty's approach, he links the new key metaphors for modern art and constant innovation as a cultural form – terms like 'experiment', 'pioneer', 'transformation', 'avant-garde' – to 'vocabularies... of the New World of science and exploration, the New Man of psychic rebirth, the New Order of revolu-

tionary politics (the *Novus Ordo Seclorum* celebrated on the U.S. dollar bill)' (ibid.).

One might wonder here quite how this permanent revolution could really be described as a 'tradition'; certainly, the question of how genuine a novelty might be and the question of the authenticity of the possibilities it spawns should not be confused. But Rosenberg's answer to the question of what kind of normality underpins avant-garde art, providing it with significance and value, is that in accepting modernity, in living as moderns (perhaps now as postmoderns), we value possibility more than actuality, change more than continuity, tomorrow more than today. He does not really tell us *why* we are right to do so.

This is related to a second question. There is a clear implication that, from the point of view of edifying theory, the actual *content* of the agreement – particularly in the case of agreed beliefs, accepted principles or important representations – is of far less significance than the *fact* of the agreement, and what the agreement makes possible.[5] As an example, take the issue of formal concerns within avant-garde visual art. Rosenberg's strategy in defending avant-garde novelty and its deconstruction of all existing art values (or what Rorty would call its 'vocabulary') closely resembles that of Rorty in defending the deconstruction of lay, philosophically influenced discourses offered by edifying theory. While Rosenberg may well have been right to attack specific critical arguments for the narrow formalism influential at that time, he does so only by subordinating important material and formal dimensions and qualities *tout court* to psychological and social considerations. One problem with this move is that the specific achievements of the art and artists which Rosenberg supports are seen to exemplify values which may be found in art but might equally well occur elsewhere. Thus, for example, in his essays on the painter de Kooning (1964, 1985) the exemplary artist is presented as one who, standing in the openness of a present freed from faith, the firm guidance of a tradition or certainties of any kind, responds with courage and resolution:

> Both art and artist lack identity and define themselves only through their encounter with one another. They are suspended one upon the other and are held aloft only through their interaction. The artist's high-wire act is the model of the efforts of individuals to give shape to their experience within a continuing condition of social and cultural disorder... De Kooning discards the traditional image of the artist in order to begin with himself as he is; he discards all definitions of art in order to begin with art as it might become through him. By their mutual indetermination art and artist support each other's openness to the multiplicity of experience... 'No

style' is a proclamation of release for the painter which presupposes a liberationist philosophy of the self. (Rosenberg, 1985, pp. 154–5)

In the last analysis the works testify and are subordinated to the life of the artist as an existential hero. For Rosenberg, the alternative to arid formalism must be sought in realities and values beyond art, in particular in an authentic existence lived in the face of the 'absurdities' of modernity or perhaps of life itself. The dichotomy between form and value inevitably leads, however, to a certain thinness when Rosenberg comes to discuss particular works. The movement from a naked confrontation with experience to creative practice must involve compromising the purity of existential resolve; the 'mutual indetermination' of work and artist, and the maxim of 'no style', logically culminate in 'no work'. The actual paintings become tokens for the vanguard culture which, on quasi-philosophical grounds, the critic seeks to justify.

It might be argued that Rorty's more philosophically sophisticated theorising does not in reality privilege the fact of agreement over its content, that it gives full weight to the features and achievements of specific practices, in particular through its assertion that there can be no universal philosophical or metaphysical yardstick for evaluating them one against another. Nevertheless, the social relationship practiced by this style of theorising in its interaction with lay discourses should be considered more closely. Insofar as edifying theory emphasises the fact of agreement it displays its remoteness from the interests and feelings of participants, who usually care considerably, even passionately, about what exactly is being proposed or accepted. Yet, for the pragmatist, any agreement, any criterion of judgement 'is a criterion because some particular social practice needs to block the road of inquiry, halt the regress of interpretations, in order to get something done' (Rorty, 1982, p. xli). In order to get the conversation going again edifying discourse must dissolve the obstacles presented by mundane settlements, and the best way to do this is to demonstrate polemically not that there are superior reasons (in the old sense) for change but that all transcendental continuities and everyday realities are an intolerable restriction of freedom, itself perhaps a reason of sorts in a more modern idiom. Edifying theory must, therefore, ignore or belittle the practical concerns of members, and it does so by invoking 'higher' considerations of human freedom.

Cladis, a Durkheimian critic generally sympathetic to pragmatism, suggests that Rorty is insufficiently 'sociological' here.[6] For Cladis, Durkheim and Goodman are preferable to Rorty because, as 'mild

mannered pragmatists' they balance, within an overall view of the
productive and self-productive sociality of human beings, 'making' and
'finding', by recognising that all cultural production depends upon a
pre-given context into which individuals and groups are, in Heidegger's
phrase, 'thrown'. Rorty is criticised for giving insufficient weight to what
must be discovered culturally in order for anything to be made. He
simultaneously devalues the normality – more specifically the historicity
and sociality – upon which critical edification depends, and so inevitably
entrenches criticism and innovation in subjectivity. That is, if edifying
discourse must inevitably weaken members' confidence in and commit-
ment to their community's language and transactions it is difficult to see
why this would not also apply to the community of edifying conversa-
tionalists.[7] Through the project of unlimited deconstruction edifying
theorists impose exile and subjectivity upon themselves. Equally, if
avant-garde modernist art is as radically negative as Rosenberg and
others have claimed then its works, like those of radical pragmatic
theorising, could not be the products of a community, nor could they
address a community and, being deeply entrenched in this asocial
condition, avant-garde artists would be condemned not so much to
freedom but rather to acute isolation, almost amounting to a kind of
solipsism, the delusion of being able to speak a private language.[8]

Pragmatism and context

If forms of argumentation employing 'essentialist' notions are
misleading or unhelpful in the achievement of the 'useful' outcomes
members desire, the question arises of what would happen when,
enlightened by pragmatism, members abandoned the old philosophical
vocabulary and with it questions like that of aesthetic quality, of the
integrity and importance of artistic problems, of the specificity of
expressive practice. What would this speech, purged of all mention of
'fundamentals', sound like? Does Rorty take us any further than Becker
on this question? Although a great variety of responses might be
imagined the result in general would surely be a preference for a more
instrumental terminology. Thus, for example, the work of art would
become just another semiotic artefact. The experience of the work, and
particularly questions of its quality, would be translated into a consider-
ation of its 'effect' upon some specific audience. Anything difficult or
strange in art would be treated either as the result of poor communica-
tive practice ('noise'), or as complexities to be unravelled only by
qualified experts and technologists of the signifier. Talk about art would

be rationalised, it would have to have some clearly defined goal, an achievable target, and would be judged a success if participants felt it had taken them a measurable step further towards their specified and agreed goal.

Of course, pressures for this kind of reform are already widespread, and spring in part from economic and political circumstances, in particular from pressures to commercialise and privatise, organise and exploit, the semiotic economy.[9] It may also have deeper roots. At least since Weber some theorists have related these processes to Western culture's 'rationalising' or 'instrumentalising' drives. Rorty discusses this issue in his essay 'Habermas and Lyotard on Postmodernity'.[10] For Rorty, Habermas takes too seriously Hegel's response to Kant's division of human experience into the theoretical, the practical and the aesthetic. Hegel saw the task of philosophy as the reunification of the three domains separated by critique. Habermas inherits this task, but locates the ground for reunification not in the theoretical self-realisation of *Geist*, but in the logical structure of undistorted communicative practice. Rorty, however, sees no need to take either Kant or Hegel as seriously as this, nor to go transcendental. Once what Weber calls the 'stubborn differentiation of value-spheres' is accepted as the characteristic problem of modernity then philosophers

> are condemned to an endless series of reductionist and anti-reductionist moves. Reductionists will try to make everything scientific, or political (Lenin), or aesthetic (Baudelaire, Nietzsche). Antireductionists will show what such attempts leave out. (Rorty, 1985, pp. 167–8)

Rorty believes all such efforts are 'scratching where it does not itch'. These philosophers characteristically overestimate the importance of metaphysical or epistemological speculations to real life. The concrete achievements of modern science, politics and art, and what they might achieve in the future, do not depend nearly as much as theorists like Habermas want to believe on a philosophical grounding of their inter-relationship. Rorty is apparently content to let these spheres and their characteristic practices exist happily side by side. Their relationship does not need regulating so as to form what older traditions of social thought understood as a culture, which might then underpin or express a society. This is because the culture we have now – which can only be specified as the accumulated results of what scientists, scholars, artists and critics do – springs from a social order which is best understood, and which is increasingly understanding itself, as deeply pragmatic.

Languages and individuation

Rorty does not take language and its social context seriously enough. For him, what guides everyday language use[11] is a consensus of interests. The hand directing everyday interaction from behind the scenes is the pre-given community of interests of a secure liberal society.[12] If left to themselves, free from the mystifications of philosophy and embracing the contingency of their beginnings, language communities will guide themselves towards the realisation of their worldly ends. In the theory of culture, therefore, language as such is seen as an enormously powerful cultural form, and this awareness is also manifested in the self-understanding of particular discourses.

This fails to recognise the significance of an important aspect of modernity: the peculiar objectification of language, a self-conscious or reflective relationship of discourses with themselves – as constitutive or poetic practices – and with other kinds of discourses. It is necessary, here, to introduce this complex topic. Later chapters develop the idea further and discuss some of its implications, particularly for the social theory of art.

The modern objectification of language has many profound repercussions. Of interest in this context is the question it provokes about the relationship between different kinds of language, different modes of representation. Kant introduced the idea – perhaps responding to an emergent feature of modernity – that such vital human realities as science, ethics and art require distinctive concepts, notions, images employed in different ways. The different languages used when human experience is articulated in terms of scientific knowledge, ethical deliberation and artistic creation come to be seen as intimately related to the distinctive characteristics of these domains. From the point of view of social theory it is important that these areas of experience are closely related to a wide range of social phenomena; they appear in institutions, and institutional structures and procedures, in cultural forms jostling for prestige and influence, and they provide avenues for individual self-definition and development.[13]

There are, of course, a variety of ways in which the relationship between these languages and the types of experience to which they relate have been understood. For some, the language of science is uniquely important in its capacity – via theories, models, experiments and data – to reveal facts about the real world; for realists in ethics and art their respective languages must also have this capacity for discovering and conveying truths about independent realities of some kind.

At least since Kant and the Romantic movement, however, other thinkers have argued that, while scientific language may be uniquely connected to public, verifiable, reliable knowledge, ethics and art are not to do with cognition in this sense, but with values, or the imagination, or truths of a very different kind. Consequently, their languages must differ fundamentally. Truth, as correspondence with an external and independent reality is ruled out if, as many have thought, in these areas there are no facts, only opinions or aesthetic constructions. More recently, following Nietzsche, theorists of postmodernism have argued for the essentially rhetorical character of science and more generally for the essentially poetic or constructive nature of all discourses.[14]

I do not propose to describe in detail or evaluate these approaches directly. What is important here is that issues relating to the cultural and social dimensions of important public discourses have formed, and continue to form, part of the background to recent debates within social and cultural theory. Any attempt to understand, let alone explain, important cultural and social phenomena must take account of these languages, of how they articulate different forms of individual and collective experience and of how the problem of their interrelationship constitutes a significant aspect of the question of culture.

It would, perhaps, be desirable if discourses like science, ethics and art could not only coexist, but complement one another, their separate voices blending chorally together. It will be part of my argument, however, that there are chronic tensions in their relationship which make coexistence or polyphonic harmony difficult to achieve and maintain. These tensions might usefully be understood as stages in a process whereby these languages, and those who use them, struggle to establish and consolidate their position relative to one another.[15] The first stage, during which a discourse tries to determine and assert its identity and validity in relation to other discourses, is referred to here as *individuation*; the second stage, during which a discourse attempts to secure its position by bestowing upon other discourses places in its world, is here called *totalisation*.

A sketch of the development of art, specifically visual art, as a language and cultural practice is necessary. It has been widely argued[16] that the objectification of nature and then of the human world has set the scene for any systematic understanding of modern society, and that within this process divisions between cognitive, normative, and aesthetic domains emerged and have found institutional expression. Science and technologies of various kinds, including social technologies, have come to occupy leading positions with respect to modernity's

need for knowledge which can be employed for productive or control purposes. Other dimensions of human experience, ignored or occluded by science, needed to develop different kinds of language in order to be heard. A classic example is the way in which Romanticism seized upon and elevated the notions of expressive totality and a benign, spiritualised nature over what it took to be the alienated abstractions of Enlightenment positivism.[17] This is not to imply that the socio-cultural phenomena – types of 'experience', ideas and practices of the self, new notions of art and so forth – associated with Romanticism came *before* the language in that it could be expressed, although it can happen that the stirrings of a new sensibility, of a new view of things, often begin in forms that seem barely comprehensible from the point of view of more familiar and entrenched discourses.

Not only did these languages develop their distinctive characters, but they were compelled to provide insiders and outsiders with 'reasons' that explained why they were as they were. Their significance and value as ways of apprehending and representing the world had to be discursively represented and established by and for those who articulated them; in modernity, the poetics or constructive cultural powers of languages must eventually be justified.[18] This often occurs in the form of a philosophical, theoretical or critical meta-language or commentary which places and frames the discourse *vis-à-vis* other languages.

Individuation and public justification occur in different ways for different languages. In the case of art, various movements since the late eighteenth century were not only attempts to explore and understand new styles or outlooks *within* art, but were also individuation strategies aimed at asserting the integrity and importance of art within the wider culture; I have in mind such things as the belief in the centrality of 'feeling' and the 'sublime' (Romanticism), 'significant form' (Clive Bell), embodied vision (Merleau-Ponty), dreams and the unconscious (Dada and Surrealism), formal materiality (Greenberg) and transgression and radical novelty (Rosenberg and many others). These ideas have typically been contrasted with other ideas and values, supposedly characteristic of science, practical affairs, bourgeois life and so forth: reason, immediately comprehensible public meanings, calculation, the conceptual, universals.[19]

Totalisation

Turning now to the totalising phase of this process, it may be seen that in order to understand itself each language must have an idea or image

of a whole context within which it is related to other languages. If this idea of a context is not given externally – perhaps in the form of a religious, metaphysical or moral belief in a given, meaningful order – then it too must be constructed. In this move a discourse must shape around itself a sympathetic environment, a world which suits its form of life. The reflexive turn of late modernity[20] includes not only a dawning recognition of the implications of the constructive imperative *within* the sphere of life to which a particular discourse relates but also of the pressures to place or incorporate other languages, other spheres of experience.

Thus, as modernisation develops, spheres like science and art begin, as Weber suggests, to unfold their own distinctive inner logics, and this is complemented socially and economically by the intensification of the division of labour, and specialised markets and institutions.[21] Each seems to offer the possibility of a complete experience of things within their scope. As different worlds, they also come to seem not just different but opposed, contradictory, incommensurable. Not only that however; self-justification requires that they develop and deploy sub-cultural realities. This means that in practice they must assert not only their distinctiveness but their *validity* against the claims of other spheres, and this often means attempting to influence or re-shape the language in which public ideas and images about different cultural practices is carried out. John O'Neill has described this process as follows:

> As Weber saw, our reason has divided once and for all into the subrational-ities of science, art and ethics. But we have not experienced any detotal-izing settlement in the process. On the contrary, our science tries to rule our politics and our economy, while our economy largely dominates our art and morality, if not our science. At the extreme edge, our art and morality try to impose their rule upon our science and political economy. (O'Neill, 1995, p. 22)

This view of competing, antagonistic efforts to construct totalities, competing images of culture, within which particular languages can assert themselves, is somewhat at odds with the view that late-modern societies are increasingly characterised by, on the one hand, a prolifer-ation of subsystems of expert knowledge contributing to the technical resolution of practical problems, and a proliferation of expressive lifestyle options on the other, and thus an obsolescence in the very idea of a common culture capable of exercising upon individuals some kind of binding or constraining force. Citing Niklas Luhman, Bauman argues that

with the adoption of functional differentiation individual persons can no
longer be firmly located in one single subsystem of society, but rather must
be regarded a priori as socially displaced'. That is, the individual is a
'displaced person' by definition: it is the very fact that he cannot be fully
subsumed under any of the numerous functional subsystems which only in
their combination constitute the fullness of his life process... that makes
him an individual. (Bauman, 1993, p. 95)

The individuation of languages and their corresponding social
subsystems leads to a new universality of 'homelessness', for which
'culture' is now merely the indefinite and contested setting. Yet the
question of culture, the problem of understanding and articulating the
place of one language in relation to others, does not disappear for
culturally mobile individuals, for groupings and institutions promoting
different spheres, and particularly for cultural theorists. The question of
a reflexive social theory is important here because it offers the possibility
of inquiry into, and discussion of, the social relationships of different
languages which together constitute the question of culture, which
would include of course the question of social theory itself.

The popular and purportedly theoretically informed view that truth or,
failing that, reliable, useful knowledge is closely related to limited aims
and a defined community,[22] reflects a recognition of the unavoidability of
the kind of cultural differentiation discussed above. On the basis of recent
debates within social theory about late-modernity and social reflexivity it
becomes possible to recognise not only individuation but also the efforts
by various languages to place themselves relative to one another, and it is
in the drive to construct an hospitable community – a culture in its own
image – that a language community may deny its bounded character
completely, thus becoming total in its ambitions.

Paradoxically, in the climate established by the popularisation of
postmodernist cultural theory any impulse to moderate the totalising
imperative, perhaps through the idea of a larger moral order, has
become vulnerable to the Nietzschean critique that it is merely a failure
of nerve,[23] or to the charge that any such interest is inherently conserv-
ative. Combined with intellectual specialisation this has meant that
much cultural theory has become increasingly technical and narrowly
focused, often disinterested in the social as such.

As totalising individuation gathers force so also do ways of thinking
and speaking which are at root strategic. Incommensurable languages
come to resemble one another insofar as the demands of rhetorical
campaigning restructure them internally. Different practices are flattened

by the need for totalising self-assertion. Thus, Rorty's pragmatism may be seen to reflect a particular state of affairs in the social relationship of languages. In seeking to clear out philosophical or doctrinal fundamentals, Rorty recognises the need for strategic thinking, but also seeks to respond to and promote 'conversation' between languages.

Returning to the question of how art might be discussed in Rorty's post-philosophical culture, I have suggested above, *pace* Rorty, that fruitful practical agreements have often been arrived at via 'philosophical' distinctions, between how things really are and what they seem to be, between individual interests and wider interests of a practice or community, between the abiding values of a practice and distortions or distractions caused by fashions, fads, commercial and political pressures, between genuine individuality and mere perversity, and so forth. A reflexive social theory of culture would certainly not exclude these possibilities. Yet it must also take seriously, particularly in its own case, the ways in which language-specific descriptions of other discourses and of their interrelationships – the 'theories' of culture and society which languages reflectively develop – may be linked to expansionist interests. Here the question would be whether a non-metaphysical, edifying theory of languages, or specific languages freed of metaphysical and epistemological pseudo-worries, would be capable of addressing the problem of the *limits* of languages, and of their nature and influence. It is difficult to imagine how this might be possible without invoking ideas about wider goods like truth, justice, and beauty, and about a wider cultural community which is more than the aggregation of sub-cultural interests, that is, without employing traditional, supposedly metaphysical ideas. A Durkheimian like Cladis, for example, would rightly argue, from a position within classical social theory, that if a language is to respond and shape the community of a practice it must convey to members the idea of a normative reality beyond the calculation of both self and mutual interest.

To summarise, Rorty can be seen to radicalise themes in Becker's *Art Worlds*, in particular that of a fully fledged pragmatic theory of truth. Rorty's approach serves as an occasion on which to raise a series of issues relevant to a range of approaches to a critical, reflexive social theory of art. These issues relate to: first, a rejection of traditional, so-called essentialist approaches to practical, critical and theoretical accounts of art; second, an attempt, influenced by Wittgenstein, to tie all cultural phenomena, including the deeper values and concerns of particular language communities, to specific concerns and language games of these contingent historical social groups; third, an effort to justify a mode of theorising

in terms of its practical contribution to an ethical end, the furtherance of a liberal, pluralist society. The questions raised at the beginning were: What does all this make of art? What does all this make of theorising?

I have argued that avant-garde modernism, as described by Rosenberg, has the kind of cultural role that Rorty has in mind for edifying theory. But Rosenberg does not just describe avant-garde modernism; he seeks to justify it, sometimes on the grounds of an optimistic or progressive view of modernity and sometimes as an heroic, existential reconciliation with the absurdity of the human condition. The philosophically more sophisticated Rorty seeks to justify edifying deconstruction by logically undermining the so-called metaphysical objections to his position, and by linking his outlook to an image, which he believes will have wide appeal, of the good, liberal society. The juxtaposition of Rorty and Rosenberg reveals that what post-philosophical edifying discourse and avant-garde modernism sometimes share is a common drive towards radical novelty via the relentless deconstruction of specific practical agreements which, when viewed from the point of view of the logic of pure possibility, appear to be merely arbitrary or unjustifiable interruptions in the endless and unlimited conversation which is Rorty's favourite metaphor for the good society, the modern *polis*.

Is edifying discourse capable of attending non-reductively to the specific languages and worlds which, presumably, the modern city must not only tolerate but also nourish? Could avant-garde modernism be a model here? Rosenberg's treatment of the material, formal, and semantic specificity of modern works is not encouraging; perceptively and honestly he observes that what matters about many transgressive modernist works, and more specifically to the critical theory behind them, is their sheer arbitrariness in relation to art's past, and to one another. If they were not radically arbitrary then how could they be radically new? Rosenberg is driven to argue for the radical high formalism of mere contingency. Similarly, for edifying discourse any agreement is, methodologically, a blockage to be removed; the achievements and successes, points of agreement and mutual understanding for languages and their communities are less important, in Rorty's vocabulary less 'interesting', than 'disagreements'. More accurately, Rorty, like many with an avant-garde outlook, is not interested in the conflict between different practices but is mesmerised by that between practice as such and the idea of a pristine language, at a point before it becomes tainted with use. What he calls the 'contingent' is a symbol of pure possibility, of freedom understood as spontaneous action governed only by the radical heterogeneity of desire. Yet, insofar as avant-garde

modernism or deconstructive edification have become coherent, intelligible, institutionally secure and socially reproduced practices, they trade on agreements, criteria, and mutual understandings.[24]

Cladis is right to suggest that there is a need here for a social theory with a capacity to respond hermeneutically to languages and practices, and to the kind of practical conversations in which assumptions, procedures, techniques, metaphors, values and criteria are at stake. Such a theory would not assume, as does the sociologically naïve Rorty, that the critical language of a practice is incapable of development because it sometimes employs 'metaphysical' or 'essentialist' concepts. It would also have good reasons for critically interrogating the high formalism that legitimates the cult of novelty and edifying deconstruction.

I have suggested that cultural individuation commences when a language begins to articulate experience in different ways, a process that always has formal, semantic and social dimensions. Totalisation begins when a language and its speakers begin explicitly to recognise its constructive potential, but also encounter the different representational constructs of others. Totalisation is not necessarily a pathological condition caused by deliberate discursive imperialism; languages must try to regulate and place others in a framework that legitimates and secures even limited claims on their own behalf. Inevitably, each fashions a world, within which it is at home, out of its own resources, using its own methods; and it extends the boundaries of its world so as to place the practices and worlds of others. Seen in this way, totalisation is the tragic side of individuation. The popularisation of the Wittgensteinian view that different kinds of truths and values are closely related to specific language games and related forms of life, and the Nietzschean view that the strong, creative individuals who devise dominant belief systems only do so by vanquishing others, both reflect and help to realise a specific social and historical possibility in the development of modern cultural forms. The conviction sets in that there is no point trying to 'discover' the shape or grounds of a 'settlement' between different languages, and that the only alternative to metaphysical futility, once the need to justify one's language comes up, is to combat all objections, all counter-claims, by rhetorical aggression of one kind or another. This influence is critically examined in subsequent chapters.

Excursus: a visible city

San Gimignano is an Italian hill town not far from Siena, popular with tourists and well known for its wine. On approach it appears as a group

of curiously modern looking, unornamented towers on a distant hilltop. Publicity photographs and drawings reproduced, for example, on wine labels, show a similar view; a compact walled town set among vineyards from within which rises a clutch of plain, rectangular towers. This seems to be the very image of a sturdy, independent community united internally but ready to defend itself against external enemies. The architecture might seem to reflect and symbolise the active assertion of internal social and political cohesion.

The history of north Italian towns like San Gimignano shows something different. By the beginning of the thirteenth century most towns and cities in northern Italy had at least two contending parties. Leading families, friends and supporters struggled for dominance, often violently.

> These parties were, of course, in the first place, alliances of men seeking control over government. Yet the climate of murderous hatred in which they fought out their differences had other origins; the parties were not simply political groups, they were also the coming-together of men united in blood feud. (Larner, 1980, p. 106)

Conflicts were extended and exacerbated by the prolonged struggle between the Papacy (Guelfs) and the Empire of Frederick II (Ghibellines) which began with the latter's excommunication in 1239. In San Gimignano the principal struggle was between the Guelf Ardinghelli clan and the Ghibelline Salvucci. Much of the surviving medieval architecture, including the main piazzas and the 13 or 14 surviving towers, was built during this ultimately disastrous conflict. By 1352 the town was financially exhausted, and after a heated public debate decided, by one vote, to relinquish its independence and place itself under the protection of Florence. Thus, much of what we see today testifies not to internal cohesion but suggests circumstances and dispositions leading to ruinous civil strife; reckless self-assertion, an absence of civic judgement on the part of leading citizens, a lack of confidence in the machinery of justice for the settling of disputes, unbridgeable ideological differences. The towers, which are today the most impressive feature of this apparent image of independence and unity, spring from a context in which

> prestige, wealth and boastful aggressiveness were driving powers that made it imperative for every noble family to be the owner of these threatening symbols of superiority... San Gimignano was not a town of burghers but a town of nobles, not of aristocrats of the spirit and the soul but of warriors

embracing force and violence, cunning, passion and hatred. (Gutkind, 1969, pp. 340–2)

Perhaps the image of the troubles of art and the social theory of art as a city beset by external foes presented in the Introduction could be redrawn? Modernity provides for the reflectivity of art, requiring it to find and follow its own paths. Yet modernity also requires art to assert, to explain and justify itself publicly *vis-à-vis* other discourses, initially science and technology, which enforce a separation between perceptual experience and warrantable truth claims. This inevitably means engaging in a struggle over which discourse is adequate to the terms and demands of public debate, a debate which, however, can only be given shape by the discourses between whose claims it must adjudicate. Somewhat later, art becomes an object for social and cultural theory. It is a truism that the era of modernism in the arts has witnessed a relentless drive to experimentation and innovation, but it has also seen a series of practical and critical efforts to define the practice of art afresh as a specific kind of language; this has encouraged some artists and critics to overlook the crucial difference between these discursive strategies and the real practice, and to launch art and theories of art into totalising strategies of their own, the most well-known and influential of which has been that associated with Nietzsche.

For other artists and thinkers, in order to follow its own paths, art has had to steer clear of the dominant ways in which a language could be explained and justified. The centre, the question of culture, is seen to have become the scene of the struggle between highly institutionalised languages for individuation and realisation, and the predominately calculative and technical vocabulary in which this struggle increasingly takes place is not seen as the kind of language in which art can authentically assert itself. It follows that art must actively seek out a position on the margins.[25] Thus, the notion of the city of art with which this essay began is perhaps misleading if it fails to take into account how a certain image of the classical or Renaissance city state is inappropriate, not only to an idea of the modern *polis* as composed of differences, but also to the question of culture, of a positive social and moral framework for different languages, insofar as that is discussed in terms of an instrumentalised, technical image of language.

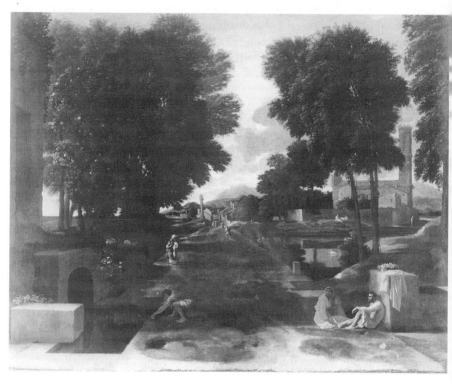

Plate 5. Nicolas Poussin, *A Roman Road*, c.1648,
Dulwich Picture Gallery, London.

Chapter 5

Fields, Movements and Histories

Languages, social worlds and theoretical reflection

One of the main practical consequences of a heightened awareness of language and modes of representation in general in the twentieth century has been to encourage a greater sensitivity to communication, not just to what is said overtly but to what is connoted or implied, not just to the content of representations but to their form and context. As well as focusing critically on the representations of others – in what has been referred to as a 'critique of representation' – this awareness also raises the question of the responsibility of each speaker for his or her own language. To see a language, like that of sociology, as constructive, not only in its descriptive but also its analytical and critical forms, is to intensify the discipline's sense of social and ethical responsibility beyond the usual ways in which this is thought about and practiced, that is, in terms of the background commitments, the ideology or prejudices of individual researchers, or the explicit purposes served by research projects. Sociology and social theory are understood not just to report upon social action or to shape it, but to *be* forms of social action.

As James Boyd White notes[1], to consider language use as social action is to face two questions: What kind of relationship does a writer establish with the language? and What kind of relationship does the writer establish with the audience or reader? I would add to these two questions a third: What kind of relationship does the writer establish between different ways of writing – or more generally, of representing – and in particular, between the author's way of writing and those of significant others, within the world he or she assembles? I have interrogated works by Becker, Wolff, Bürger and Rorty with these questions in mind.

In suggesting that their views tend towards an intellectual weakening of art, which would have adverse practical effects if art world members came to accept them, I have sought to illuminate an aspect of their character as social action; the ways in which reflection might also weaken knowledge are considered in more detail below. I have also suggested, along the lines of the *tu quoque* argument, that the consequences of their critique could be equally damaging for social theory itself, unless it were able to make a convincing exception in its own case.

We have seen that each writer has some particular interest or angle of vision on the topic. Becker aspires to provide an adequate description of and to draw appropriate conclusions from the real organisational complexity of art worlds, Wolff seeks a critical analysis capable of preserving its object, and Bürger a practice with a sure sense of its own historicity. The discussions above have at one level sought to describe tensions or problems in their accounts which, with Wolff and Bürger, are at odds with some of their stated intentions. Yet my argument, like theirs, is necessarily also constructive. I am seeking to understand the shape of a relationship between visual art and social theory which preserves the integrity of both but which also raises questions about individuation and reductive appropriation.

I have assumed that readers care about the integrity and viability of art or sociology (perhaps both) but have not tried to suggest *why* anyone should do so. How indeed would this done? If the experiences which languages provide for exist fully only for those who speak and live, at least partially, within them how could their intimate texture and value be demonstrated to outsiders? Defenders of scientific and technical activities often point to their widespread social benefits, some perceptible or measurable in practical and economic terms. While visual art often gives pleasure directly and is sometimes economically profitable, what really matters here is the possibility of an account that is based on its distinctiveness and intrinsic value; the same goes for sociology. It is important to the kind of social theory I am proposing that it takes seriously intrinsic justifications for social practices like art and sociology. With the latter, this entails the idea that knowledge, clarification or critique are to be desired for their own sake, whether or not they are practically useful.

I have discussed some implications of accounts by social theorists of art and art worlds offered by leading sociologists aligned with three theoretical traditions. Some of these implications only represent difficulties from particular points of view, one of which would be that

of (some) art world members, whose key ideas about their own practices have been subjected to a corrosive process of theoretical reflection. But I have argued that they might also bother the kind of social theorist who either cares about art or about the reflexivity of his or her discipline. I have also tried to demonstrate that these difficulties are not necessarily due to a lack of sympathy or technical mistakes. The wish to ameliorate or remove such problems relates to a broadly political or ethical interest in understanding the relationship between theory and practice, between sociology and visual art; it presupposes a commitment to art – or rather, to a broad approach to art – and to theory, again of a certain broad kind.

Political language, like other practical discourses, must take some things for granted, or must try to persuade its audience that a range of goals or circumstances or contexts of action can or should simply be accepted as desirable or factual without the need for further investigation. National economic performance and wellbeing of citizens and their families, social justice, national destiny, and the rights of the individual have all operated in this way at different times. Ideas like these, and an interest in getting things done, sometimes in response to urgent problems, have often been seen as antithetical to a traditional view of the foundational, disinterested orientation of theory. Since the Enlightenment, some thinkers have insisted on a distinction between genuine theory, which has for them an intrinsically practical character, and the fruitless musings of merely speculative reason. For others again, a different type of theory was important, one not chained to the needs of scientific discovery or instrumental action, and thus able to represent the possibility of radical criticism of existing arrangements, practical concerns and political languages. More recently, for deconstructionists and, as we have seen, for postmodern pragmatists like Rorty, the politics of theory springs from its alignment with the value of innovation and change.

This suggests various distinctions between different types of theory and the social worlds which host them in terms of the ways in which they conceive of the nature of theorising and of its limits. One might construct, for example, a continuum with, at one pole, a social world that has no explicit reflection on its practices and, at the other, a social world that submits all its practices, including theorising itself, to sustained theoretical reflection. It is important not to assume, however, that reflection *per se* must be theoretical in character; this is an assumption that it is easy for theorists to make and which reflects their professional ideology. Atheoretical reflection would be practical (in the broad

sense of oriented to action, although not necessarily restricted to means–ends rationality), strongly marked by a specific context, and expressed in a 'local' language. A third distinction could be made between reflection which is primarily goal-directed or practical in the narrow sense and that which is pursued primarily as an end in itself; reflection here would be an intrinsic good.

This would suggest a description of languages and social worlds according to the extent, levels, and types of reflection, where the latter is split into two sub-distinctions: theoretical and atheoretical reflection, and extrinsic and intrinsic reflection. A number of points need to be made here. First, within modern culture theoretical reflection is so important and ingrained that the ideal–type position of zero theoretical reflection – which Bernard Williams calls that of the 'hypertraditional society'[2] – is not a real option; reduced reflection, or more significantly reflection that takes non-theoretical forms, will inevitably experience pressure within the public sphere to develop a legitimating position[3] with respect to more theorised and self-theorising languages. Third, and related to this second point, the languages and worlds to which these distinctions might apply are not in reality hermetically sealed-off from one another; they constitute locations within the field of modern culture, although describing them, and the shared cultural space within which they exist, is highly problematic. Yet it would tend to be theoretically reflective discourses that produce such maps; as we shall see Bauman argue, the idea of culture itself can be seen as one of the most important weapons so far produced by social theorists in their struggle for power and position during the early modern period. There is here, as elsewhere, a close connection between accurate, comprehensive cartography and imperial expansion.

The metaphor of reflection inevitably suggests a moment of vision, a turning back to examine something pertinent to thought or action, something already present but overlooked. It might also suggest, more literally, seeing this 'something' not directly but by turning a reflective surface towards it. Both of these imply, to reintroduce Rorty's term, 'finding', inspecting something already there. But reflection, particularly once connected to the power of language,[4] is also conceived of as a more active process, not so much passive reception but as bringing something to light which would otherwise be hidden or even non-existent. This is the notion of reflection as 'dis-covery' or, pushed a little further, 'making visible'. So another distinction, but this time applying to theoretical modes of reflection,[5] would be between those that consider themselves to be aimed at discovery and those that take

themselves as significantly constitutive. It is proposed here that social theory as such is not only inevitably constitutive in fashioning and proposing representations of social phenomena, but also that it is inevitably faced with political or ethical questions about how its meaningful constructions relate to the meaningful constructions of those it studies, and in particular how theory is deployed to legitimate its constructions in the face of alternatives.[6] I am suggesting that social theory becomes reflexive – here a kind of reflection that includes itself as object and the other as subject – when it attends to this ethical dimension of its own constructive activity, particularly in terms of its language and practices.

One way of approaching this issue is by considering how social relationships between languages have been constructed, debated and contested in general and, in particular, between art and social theory itself. This would form something like a history of discourses and practices at the level of culture; inevitably, social theorists have been major influences in this changing field, but writers, artists and critics have also contributed, often as much through new forms of creative and critical practice as through explicit theory.

Enlightenment, Romanticism, modernism, and beyond

I turn, then, to the idea of a history of the field of relationships between languages which give accounts of themselves and of other languages; of particular interest are the languages of science, ethics, and art. Each has had a long and complex history of meaning–construction, each has been subject to internal and external struggles to define its character, and each has periodically attempted to provide a comprehensive context for itself and other languages.

This is, of course, an enormous, complex topic, spanning the history of ideas, the history of cultural formations, and the history of social structures. My approach here is the more limited one of a critical reflection on the implications for social theory when the question of the ethical dimensions of its constructive character is recognised. In order to radicalise this reflection I suggest that art, with its traditional emphasis on making, is a good place from which to pose reflexive questions *to* social theory.

In order to launch this reflection I outline below the pre-history of modern cultural forms provided by Charles Taylor in his *Hegel* (1975) and *Sources of the Self* (1989). I do not mean to suggest that his history is simply to be accepted as the whole, true story, or that the philosoph-

ical approach to ethics which frames it is to be accepted without question, or that the two projects fit together in a completely satisfactory way. On the other hand, much of what Taylor says about 'disengaged reason', 'expressivity', the 'epiphanies' of Romantic and modernist art and so forth do seem to me exceptionally informative. His accounts are useful for their breadth, but also because they are animated by a strong sense of the social and cultural questions posed by the historical tensions between individuating discourses such as metaphysics, epistemology, ethics, theology, and aesthetics. They raise, in other words, the question of the ethical dimensions (or resources) of cultural formations; indeed, this is one of his central concerns.[7]

I juxtapose Taylor's account to Zygmunt Bauman's (1987) history of the modern intellectual, or rather of the intellectual operating in the fields of social science and the humanities. Bauman has sought to provide what might be called a critical social history of modern social and cultural theory. He is particularly concerned with the social origins of rationalistic, 'legislative' theory, designed specifically to influence the new absolutist powers of the emerging modern nation state in seventeenth- and eighteenth-century Europe. He is interested in this body of theory not simply as knowledge but also as a rhetoric through which intellectuals tried to gain positions of power and security; in other words, he considers social theory as social action. He also inquires into the social conditions of what he sees as the contemporary demise of the legislative role and the rise of the interpretative alternative. Along the way he reviews the relationship between practices of art and of theory in the modern and postmodern periods.

The best known example of an explicit rethinking of art in the context of a critique of scientific rationalism and the Enlightenment is Romanticism. The results of what Taylor calls the 'expressivist' revolution, a wider and deeper movement than artistic Romanticism, include a reconfiguration not only of artistic practices and of the meaning of art in the wider culture but also of the relationship between art and theoretically directed disciplines aimed at the production of reliable knowledge.

Taylor describes with admirable clarity in the first chapter of his *Hegel* how Enlightenment thinkers crucially re-defined (or, arguably, invented) the idea of human subjectivity. Human beings could not determine the ultimate purpose of their lives on the basis of a pre-existing cosmic order invested with meaning. Rather, concepts of meaning and order belonged exclusively to the subject. To understand nature correctly and fully, human beings had to free themselves from

sentimental, anthropomorphic projections and begin to observe, soberly and systematically, the contingent, mechanical relationships between things, in particular the objects of organic and inorganic nature. The Enlightenment's view of man, its anthropology, emphasised a mechanistic, atomistic view of human corporeality, of the various different faculties which human beings possess, and stressed particularly contrasts between mind and body, feeling and will, imagination and intellect. Thus, a distinctively human reality was identified, and contrasted with the divine on the one hand and the natural on the other. A process of splitting began, the individuation of spheres of human experience, of kinds of being, which, once separated, could not then return to any immediate or simple unity or wholeness.[8]

The Romantic critique, notably in the work of Herder, opposed this view of the subject confronted by a disenchanted, objectified nature with the concept of 'expression'. The subject was seen to possess a unique, self-defined goal which it must strive to realise during the course of its life. This restored the centrality of *telos* to human existence. However, this purpose, the very meaning of human life, was not simply to be derived from a revelation of man's 'place' within the cosmos – this was not a return to Aristotle – but resided in or was linked to the uniqueness of the individual. The realisation of this purpose, which simultaneously made the purpose apparent, against all obstacles and constraints the world might throw in its way, was the one vital task of the subject, be the subject an individual person, a social group or a nation. This new definition of man as an essentially expressive, creative being clearly places great importance on those decisive actions that clarify our real nature:

> This clarification awaits recognition by a subject, and man a conscious being achieves his highest point when he recognizes his own life as an adequate, a true expression of what he potentially is – just as an artist or writer reaches his goal in recognizing his work as a fully adequate expression of what he wanted to say. (Taylor, 1975, p. 17)

The practice of the artist became a model for human action as such. However, the concepts of art and artist – dominated as they were at this time by views that stressed didactic, moral or pleasure-giving functions for art – themselves needed redefinition. The new view 'needed a theory of art as expressive, and a theory of meaning in which linguistic meaning, the meaning of signs, was not sharply marked off from other forms of meaning, but was rather continuous with the expressive meaning of art' (ibid., p. 18). Language and art were privileged media

through which expression occurred. Art became 'the paradigm human activity. The human centre of gravity is on the point of shifting from *logos* to *poiesis*' (ibid.). The still popular notion of expression in art, as simply an outpouring of emotion, an unbridled externalisation of feeling, is a gross corruption of the original Romantic conception. For Goethe, Wordsworth and others, expression in art was not simply a question of finding a suitable vehicle for some feeling one might happen to have, but the transformation of feelings into truths more fundamental than those of science or mere subjectivity.[9] The notion of the artist as genius has its roots in this period, and has suffered a similar fate. For Romantic metaphysics, the genius is simply a person who successfully pursues the demanding task of self-expression. This need not imply self-obsession, extreme arrogance, an artistic practice as divinely inspired creative frenzy, or any of the other caricature attributes and behaviour by which the idea of artistic genius is routinely discredited today.

Thus a new vision of art came into being with a critique of the Enlightenment's disengaged subject and its disenchanted, objectified world. For Romanticism, the artist and artistic practice became models for the understanding of the nature, the *purpose*, of human life. An imbalance in the relative status of art and science was thus redressed. The new importance of the 'making' practices of art as opposed to the 'finding' procedures of science might even seem to make art the pre-eminent discourse. As Taylor notes (ibid., p. 21), we have here the origins of a cult of art, sometimes threatening to replace established religion.

To summarise, leading Romantics felt a need to reconstruct relationships between different aspects of human life and experience, to re-collect into a new settlement the discordant languages which the heritage of the Enlightenment and contemporary society tended to produce. As this wholeness could not be found – it was not divinely or naturally given – it had to be made. The concept of art swung decisively away from the idea of mimesis, and art became a model for human self-productive activity in general.

With the Romantic period and on into the era of modernism the work of art becomes what Taylor calls an 'epiphany':

> the locus of a manifestation which brings us into the presence of something which is otherwise inaccessible, and which is of the highest moral or spiritual significance; a manifestation, moreover, which also defines or completes something, even as it reveals. (Taylor, 1989, p. 419)

The epiphanic work could still be seen to possess a representational dimension in depicting the appearance of those objects or events with which a numinous reality had somehow fused; but, in the twentieth century in particular, it often shed almost all vestiges of representation in order to achieve a heightened self-sufficiency.[10] Taylor also points out[11] that epiphanic art has often been connected to a criticism of bourgeois, commercial, industrial, capitalist society, and in particular to a rejection of mechanistic, instrumental thinking and its disengaged stance.

Art and the formation of modern culture

Sources of the Self is a book of moral philosophy in a historical context. Its author is particularly concerned with the moral sources opened by expressivism, and his view is that, despite important differences between the artists and thinkers operating in its wake, all accept, as must we, that the 'moral or spiritual order of things must come to us indexed to a personal vision' (ibid., p. 428). In the case of scientific knowledge our experience is crucially mediated by concepts and theories, while aesthetic and moral experience of a spiritual reality is inescapably marked by a personal dimension. Both conditions amount to the unavailability of unmediated orders and thus lead towards radical reflexivity, but in distinctive ways; the first through public, theoretical discourse and the second through particularity, inwardness and creativity.

In the immediate post-Romantic period the idea of expression and its implications for the visual arts were subject to important changes. Taylor identifies three types of epiphanic art, all of which break, or attempt to break, with the Romantic notion of a spiritualised, benevolent nature: a Realist art preoccupied with a despiritualised nature and the nobility of man;[12] an art concerned with anti-natural concentrations of experience and form, which he discusses mainly in relation to Baudelaire; an art focused on the uncontrolled energy of an amoral nature, whose most important philosophical source was Schopenhauer. Viewed as moral sources, all these important nineteenth-century artistic and philosophical movements give considerable emphasis to the powers of creative imagination:

> In different but parallel ways, they emphasize that the epiphanies of art involve a *transmutation* of what is there: despiritualized reality, or fallen nature, or the amoral will; rather than the revelation of a good which is ontically independent of us – even if it needs us to come to an epiphany. (ibid., p. 446)

For Taylor, modernism aims at the same targets as Romanticism: the mechanistic world view, instrumentalism, bourgeois society, the vulgarity of mass culture and so forth. But there are important differences, in particular an intensified rejection of the ideas of benign nature and human innocence. Leading modernists saw the Romantic cults of nature and subjective feeling as having become convenient compensations for the persistent or intensifying miseries and decadence of contemporary bourgeois life. Paradoxically, this often went along with an intensification of the turn inward; in Bergson, Hulme, Husserl, Heidegger and Merleau-Ponty we find a new, radical drive towards lived experience. The most important difference here is, however, the rejection of the idea of a unitary self, including both the Enlightenment ideal of the disengaged, controlling rational agent and the Romantic expressive self forged from a new higher unity of reason and feeling. The new inner life explored by modernist artists and thinkers is one of fragmentation, disturbance, flux. This often went along with critiques of the ways in which a scientific and technological culture empties and 'spacialises' time, and of two tropes central to contemporary narratives: disengaged reason's myth of progress and the Romantic counter-trope of dialectical or organic growth. Postmodernism has more recently taken up and extended these themes.

The attempt to return to lived experience, experience before knowledge, was made problematic by a widespread awareness, across the natural and human sciences, of the inevitability of mediating structures of one kind or another as conditions for intelligibility or representation. If experience unmediated by form was impossible then the task was to distinguish between good and bad, strong or weak, formation processes. Taylor argues that in Ezra Pound's work one can discern a new mode of epiphanic art – the 'interspacial'[13] – which breaks decisively from expressivism. The work of art does not express anything but is a point of concentrated energy in a field of shifting forces; we do not see the meaning 'behind' or 'shining through' the work. The modernist 'refusal of depth' is precisely this negation of reference, the identity of meaning with the object.[14]

In sum, for Taylor three kinds of 'spiritual profile' emerge from modernism. The first indulges in a further celebration of the powers of unrestricted human freedom and the creative imagination, the second leads to new, post-Romantic forms of epiphanic art, while the third – through an 'austere discipline of the imagination' – seeks to find a language capable of expressing uncomfortable, difficult truths of contemporary experience. Severely critical of the first, Taylor also

criticises fashionable theorists like Derrida, Foucault and Lyotard whose postmodern theories provide fertile ground for this kind of nihilistic outlook.

This historical sketch provides an outline for placing the contemporary relationship between social theory and the practice of visual art, as this is reflected in the works of Becker, Wolff, and Bürger, in a wider hermeneutical context. Of particular interest is the picture it gives of individuating and totalising moves in the development of modern cultural practices like science and art. The Enlightenment's establishing of science as the pre-eminent discourse was never a simple, uncontested, unproblematic hegemony of course,[15] yet in securing a uniquely persuasive claim to the production of rational and useful knowledge the representations of art were pushed towards other human phenomena such as belief, value, desire, feeling, imagination, which were required to find a place in a cultural world within which scientific knowledge occupied a predominant position. Discovery, albeit mediated by the concepts and methods of theory, now itself modelled and controlled by the requirements of explanation in the natural sciences, became the prevalent metaphor for the relationship with truth.

Romanticism's counter-totality was based upon a new, spiritualised conception of truth and a new conception of making rooted in the creative imagination. Nature was seen as a vital, benign spiritual reality which must be realised in the creative activity of the subject; through the artistic act, attending to and articulating an inner voice, the subject became an expressive totality reconciling human and natural orders. A profound cultural reconfiguration occurred; now art was the pre-eminent discourse, and science was either relegated to serving the lower human functions, merely material needs or, as with Schiller, dialectically raised to a higher level, but only in the expressive fulfilment of human existence as whole. Hegel took a similar position, although he conceived of the dialectical *telos* somewhat differently.

In the context of the rapid developments of industrial, bourgeois capitalism during the nineteenth century – within which science and technology were deepening and extending their cultural position and influence – the radical promise of Romanticism became less convincing. Avant-garde artists came to see it as a coopted, compensatory fantasy, and as leading in artistic practice to cloying, inauthentic sentiments and inexact, corpulent forms. Some of the origins of modernism lie in this next bout of critical individuation, aimed at reducing the hold of sentimental delusions in favour of a new rigor in practice and expression. The new, post-Romantic totality – whose

influence is still widely felt in contemporary culture – is best expressed by Nietzsche in his well-known attack on the will-to-truth and his valorisation of art.[16] In the turbulent period towards the end of the nineteenth century and the beginning of the twentieth, so fertile in the formation of modern culture, modernists abandoned key Romantic and expressivist ideas. Leading artists sought to confront or embrace the heterogeneous, disjunctive experiences of living on a variety of levels within a variety of social spheres.[17] This was accompanied by an intensified turn inwards, towards the depths and margins of consciousness, through which the artist sought the fullest possible exposure to the flux of experience, to its ecstatic and painful intensities, to the *now*, and by a new interest in language, a mysterious, demanding source for creativity beyond the transparent or used-up tokens which words become in theoretical or everyday public discourses. This seems to be an extreme form of individuation, in making difficult or impossible the question of art's wider cultural implications; this is not perhaps in itself a totalising move, but more a kind of voluntary or aristocratic exile from the public realm.[18]

With postmodernism the aspiration to produce epiphanic works has been widely abandoned, and while varieties of theory provide artistic nihilism with a bizarre rationale of sorts it is not one that could, consistently, have wider social or ethical aspirations. On the other hand, behind postmodernism in some of its forms is the important influence of Nietzsche's astringent deconstruction and ranking of cultural languages and forms from an aesthetic point of view, perhaps the most radical counter-totalisation yet offered on behalf of art.

Bauman, intellectuals and modernity

Alongside this outline of a history of cultural formations, informed by Taylor's philosophical history of moral ideas, it would be useful to set a social history of social theory and social theorists provided by Bauman. Themes and arguments from Taylor's work, and from the sketch of cultural or discursive history I have linked to it, will return several times below. Bauman's history – perhaps deliberately polemical and oversimplified in places – is nevertheless salutary in trying to place social theory within a social-historical context.[19]

He approaches the problem of analysing the social category of the intellectual by treating it as a shifting 'spot' or 'territory' within a larger arena consisting of other similar locations:

> We will treat the category of the intellectual as a structural element within the societal figuration, an element not defined by its intrinsic qualities, but by the place it occupies within the system of dependencies which such a figuration represents, and by the role it performs in the reproduction and development of the figuration. We assume that the sociological meaning of the category can be obtained only through the study of the figuration as a totality. (Bauman, 1987, p. 19)

The idea of a 'societal figuration' is close to that of a social field composed of different languages or cultural forms and practices, and of their interrelationships outlined above.[20]

Bauman goes on to argue that intellectuals, particularly theorists of human life and society, were largely responsible for the modern notion of culture. The theorists' ideology of culture is 'that narrative representing the world as man made, guided by man made values and norms and reproduced through the ongoing process of learning and teaching' (Bauman, 1992, p. 2). This ideology became necessary in the context of a breakdown in traditional patterns of social reproduction in late seventeenth- and early eighteenth-century Europe, but also served to legitimate the role of intellectuals as those with the ability and right to legislate social reconstruction on the basis of knowledge. The connection with Enlightenment ideas of a rationally ordered and directed society are apparent, and the legislating agent, which intellectuals sought with some success to influence, was the modern state.

If human beings were essentially what they were taught, theorists could readily account for different ways of life, values and outlooks both within and between societies. But the ideology of culture established not just a hierarchy of forms of life – a familiar feature of traditional societies – but the hegemony of learning and legislating, which was distinctively modern and, unsurprisingly, the form of life of intellectuals themselves: 'Theorists typically viewed other ways of life as products of the wrong kind of teaching, of malice or error, of ignorance at best' (ibid., p. 9). Not only this, however:

> Whether the dominated are construed as primitive, traditional, or uncivilised; whether the category construed is that of non-European cultures, non-white races, the lower classes, women, the insane, the sick, or the criminal – inferiority of mental capability in general, and inferior grasp of moral principles or the absence of self-reflection and rational self-analysis in particular, are almost invariably salient in the definition. The overall effect of such a universality is the enthronement of knowledge, the feature pertaining strongly to the intellectual mode of praxis. (Bauman, 1987, pp. 17–18)

I have suggested that this kind of discovery of profound flaws in the self-consciousness of artists, particularly with respect to 'moral principles' and 'rational self-analysis' has been a regular feature in many recent sociologically inspired critiques of art, including those of Becker, Wolff, and Bürger.

Bauman notes that the invention of the concept of ideology has played a prominent role in the social history of social theory. What is needed is a position from which the theorists could sit in judgement on all perspectives, a perspective which, in its universality, is not a perspective, 'which is confined to no localised routine practice and so reveals all routine practices as parochial and founded solely by their own respective pasts' (ibid., p. 108). Ideology critique is founded on the need of intellectuals to evaluate and rank all other representations:

> This feature anointed the intellectual with a mission, and the right, to adjudicate between ideologies, to reveal them as ideologies, as partial and prejudiced world-views, to disclose their lack of universal foundation and hence their invalidity outside their own homeground, their essential 'untransferability', and inadequacy of credentials when confronted with universal standards of truth. (ibid.)

Again, given the fact that many recent sociological studies of art have conceived of themselves principally as ideology critiques it is no surprise that they display these features. Theorists have, through general conceptions of the relationship between representations and socio-political structures, not only tried to disclose deeper truths about culture but also acted on their own behalf. For example, an important social–scientific idea like the 'primitive' is best understood as a 'by-product of the self-constitution of the intellectuals... coined by those who are, or see themselves as being, outside the space it denotes' (ibid., p. 17).

In Bauman's view, the role of the theorist-legislator is now in terminal decline. Belief in the planned perfectibility of society has waned, there is widespread antipathy to the intellectual and legislative ideal of universal values and cultural uniformity (although not human rights), and the modern state seems disinclined to take the grand schemes of theorists too seriously. To be set against this loss of power are, however, the modest comforts, security and status usually enjoyed by contemporary theorists and experts. The expert is one of the new roles available to those who would once have aspired to be theorist-legislators. Compared with the latter, the expert has a narrow, pragmatic, technical range of competencies, carefully avoids specula-

tion (visionary invocations of a new social order and so on) and, in Bauman's phrase, follows Weber in 'keeping the poetry of values away from the prose of bureaucratically useful expertise' (1992, p. 16). In common with artists, theorists find that political impotence is accompanied by a degree of professional freedom:

> Having reached the nadir of their political relevance, modern intellectuals enjoy freedom of thought and expression they could not dream of at the time that words mattered politically. This is an autonomy of no practical consequence outside the self-enclosed world of intellectual discourse; and yet this is an autonomy just the same, a most precious and cherished consolation for the eviction from the house of power. (ibid.)

The final defeat for the modern theorist-legislator has been the state's substantial abandonment of culture, in the sense of popular representations and values, to the market. Their hegemonic dreams now gone for good most theorists have, Bauman believes, abandoned the old aspiration of their trade to uniformity and order in favour of a diametrically opposed view of culture, now seen as 'the ground of perpetual, irreducible (and in most cases desirable and worth conscious preservation) diversity of human kind' (ibid., p. 18). The theorist is re-born as interpreter.

What does Bauman make of art within the historical and social context he outlines? Overall, his view is that modernism – more or less innovative art in the modern period – has been significantly constructed by, and has thus suffered from, rationalistic theory, an expression and instrument of the will-to-power of theorists. Postmod-ernism in the arts represents a critical rejection of and a liberation from theoretical expropriation. He approvingly quotes Lewin's argument that artistic modernism (here restricted to the visual arts) was overwhelmingly 'scientific' in being experimental, concerned with objective truth, and committed to the goal of progress.[21] For Bauman 'modernist artists broadcast on the same wavelength as their intellec-tual critics' (1987, p. 134); aestheticians and critics remained firmly in control of modernism conferring the status of 'art' on some things, denying it to others, interpreting works to the wider public, and judging between them in terms of quality and importance.

> In the case of aesthetics the power of intellectuals seemed particularly unchallenged, virtually monopolistic. In the West, at least, no other sites of power attempted to interfere with the verdicts proffered by those 'in the know'. (ibid.)

Yet Bauman is also aware of the argument that part of the thrust behind modernist practice and criticism was a drive to wrest control of the aesthetic from the arbitrary taste or ideological prescriptions of absolutist rulers,[22] to make the arts more open to all – this was after all the period during which many of the great, free, public art galleries, museums and libraries were set up – and to give the arts some independent status and autonomy. Faced with the evidence of constant argument, debate, innovation and modification of practices and values throughout the modernist period he argues that none of this really mattered, in that what survived unchallenged was 'elitist judgement'. Thus, critics in the modern period, often passionately committed to art, who supported the idea of artistic freedom, who tried to widen artistic and evaluative categories when they were clearly unable to cope with new work of quality, and who sought to devise new interpretations in order to remedy the deficiencies of older ones (which were often rightly seen as excessively rationalistic) and to cope with new developments in practice were merely preserving their own position as monopoly providers of knowledge.[23] Citing Becker's attack on the view that the elevated status of some art works may reflect their evident qualities, and the dedication, talents and insights of their producers, Bauman notes that the 'theory of reputations' requires 'the concepts of "beauty", "depth", "values" etc., all of which assume the monopolistic competence of the theorists' (ibid., p. 138).

The reality is not so simple. I have argued above that ideas like these 'assume' no such thing, that they belong instead to the usually heterogeneous vocabulary, some of whose terms are derived from traditional or current philosophical or aesthetic debates, in which art worlds struggle to develop, to piece together usually temporary yet important practical understandings and evaluations.[24] It is an entirely contingent matter which ideas exercise most influence at any one time. There have been episodes during the modern period when much of practice and criticism has been strongly influenced by theories of one kind or another,[25] and periods where the prestige of certain theories has done much to raise the status of art works and artists who have adopted them, sometimes exaggerating their real artistic importance; the current vogue for postmodernism is a case in point. There have also been episodes when artists have produced works that have exceeded the explanatory and evaluative grasp of all existing theories.[26] To depict artistic practice and criticism in the modernist period as one effectively ruled by the aesthetic theories of rationalist critics is absurd; *pace* Bauman, it would, however, be possible to argue, without much

polemical exaggeration, for the almost complete theory-dependence of much postmodernism. There is also an enormous difference between a theory that shapes the general critical climate for a certain kind of work[27] and a theory that influences how artists actually practice or what art world members believe that works should look like,[28] and the modern period has seen examples of both.

Turning from the socio-historical to the conceptual, Bauman remarks that 'the institutional theory of art (as an institutional theory of any other value domain) sounds the death knell to the philosopher's dream of control' (ibid., p. 139). Leaving aside the point that, even if philosophers were not responsible for the institutional theory in the first place, (some have been among its most vigorous proponents) it is clear that a strong version of the theory entirely disconnects the language and consciousness of a particular social group from what its practice is said to bring about: art world members may naïvely think they are capable of taking into account talent, training, depth of thought, visible features of the work and so on, in deciding about works, when all they can really do is operate a scheme of rationally arbitrary classification devised by legislative aestheticians in their own concrete interests.

How would this look with respect to Bauman's discipline? He discusses Richard J. Bernstein's proposal that within their community theorists should continue to be guided by and to enforce the rules of reason, yet when it comes to conflicts or difficulties between communities then they must act as interpreters.

> Inside the community, philosophers have the right, and the duty, to spell out the rules which decide who are rational discussants and who are not; their role is to assess the justification and objectivity of views, and to supply the criteria for criticism which will be binding because of those criteria. (ibid., p. 145)

As Bauman says, this kind of shared outlook makes what is meant to be the experience of the seminar possible. Members must feel confidence in certain shared assumptions, vocabulary, and meanings. There are, in addition, rules which must be accepted, for example the authority of evidence or findings, and of arguments conducted in a broadly logical way. There is a problem of demarcating between different contexts, which Bauman rightly raises; he does not, however, discuss the problem of the ways in which the institutional theory makes any 'inside', including the academic one represented by the seminar, into another 'outside'; it sounds the 'death knell' not only for

the theorist's 'dream of control' but also for the 'rules of reason'. One does not feel that, in the last analysis, Bauman belongs to those who believe that these are same thing.

In sum, I have argued above that social theorising is also social action, not just in terms of its results – knowledge, understanding, insights – but also through what it is as a constitutive social practice. The metaphor of reflection is a common way of trying to understand the nature of theorising, and this inevitably suggests 'seeing', either for the first time or more clearly, something that was previously obscure or overlooked. While reflection in some cases gives birth to theorising, it is important not to jump to the conclusion that reflection and theorising amount to the same thing, or that theorising is simply reflection put on a proper, organised, self-conscious basis; this may well be a professional prejudice. If the primary purpose of theorising is thought to be explanation then what reflection brings to light – usually organised and focused by methodology – is a fact or condition which is causally significant. If theorising is conceived of as primarily to do with understanding then reflection is meant to reveal implicit or suppressed meanings. In both cases the impulse to reflect implies that ordinary assumptions, accounts and meanings are somehow inadequate or insufficient; a more sceptical view would reveal that, on occasions, theorists create a demand for their wares by actively weakening members' confidence in their everyday under-standings and explanations.

We can think of reflection as a feature of forms of life (or language communities or discourses) and distinguish between the latter according to differences in the extent, depth and nature of the reflec-tion that occurs within them. We could ask in each case what areas are 'off limits' for reflection, either because they are proscribed, or because it never occurs to anyone that the area could be or needs to be a topic for reflection. We could consider how profound or superficial is the level of reflection, although the metaphor of depth may prove to be problematic, and again it is important not to assume too quickly that 'deep' equals 'theorised'. Finally, we could ask whether reflection is conceived of as discovery or creation. It seems clear that social theory cannot avoid classifying and ranking different languages, practices and communities according to what it conceives to be the character and quality of the reflection which goes on within them, yet this has been, and continues to be, an important feature of the ways in which social relations between different languages and communities are fought out, negotiated or imposed.

The period since the Enlightenment has seen, initially in Europe and then more widely, a complex process of discursive and cultural division and change. In science, morality, and art there have occurred a series of internal changes and external reconfigurations, a succession of struggles over the self-understanding of these languages, over their under-standing and accounts of other, competitor languages, and over their respective socio-cultural-political positions. It is not that the construc-tions of cognitive, moral or aesthetic practices *always* constitute moves in the relationships between discourses; this is an empirical question. Sometimes they are weapons of war from the start, but sometimes they are no more than resources for or background features of such moves.

A key feature of art's self-understanding, which entered deeply into some of its most important achievements, but which also constituted an important element in its struggles to achieve and then hang on to some independence and integrity, has been the development – during the Romantic period – of a distinctive type of representational value. What Taylor calls epiphanic works of art were claimed, uniquely, to possess dimensions of human depth, spiritual truth and particularity. These have been seen as characteristic features of artistic truth, as opposed to the scientific truths of reliability, accuracy, utility and universality. Despite important changes in the period of modernism, in particular the rejection of a pre-given, benign natural order, of original human innocence, of the unity of expressive identity, and even of an aspiration to a higher, dialectical synthesis of different modes of experi-ence and expression, the practices of most important modernist artists were directed towards the production of the epiphanic work.

Bauman provides the outline of a social history of social theory. A central episode in the modern period, in part defining it, is the rational-istic legislative campaign by intellectuals pursuing a place in the sun, that is, in the upper echelons of the modern nation state. The difficulty that Bauman formulates is that one cannot be a modern intellectual without acting in this way; indeed, the inner practices of the seminar are like this – a microcosm of the 'republic of letters'. Even the produc-tion of an historically grounded, logically persuasive critique of the legislative intellectual trades upon and contributes to the vitality of this historically aggressive principality.

Bauman is perhaps a bit too eager to make the arts serve his case against the modern theorist. He vividly demonstrates how intellectuals have fought on behalf of their community, but he also assumes, perhaps because as an intellectual he is over-impressed by the power of analytical and critical rhetoric, that they have always triumphed. He

makes his case by depicting the arts in the modern period as a totally legislated domain:

> in no other sphere of social life has the non-interference of the non-intellectual authorities been so traditionally low, and in consequence, the authority of intellectuals so complete and indubitable. (ibid., p. 140)

Given the history of art in the nineteenth and early twentieth centuries this is simply unconvincing. In the modern period the arts in general, and the visual arts in particular, have sometimes managed constructively to ignore, to fend off, to incorporate, to learn from, to work alongside, creatively to misunderstand rationalistic theories of different kinds. On the other hand, with the slow death of modern legislative reason and the rise of interpretative and postmodern intellectual styles the arts face new challenges in their relationships with social and cultural theory.

Chapter 6

Varieties of Theory and Practice

Critical theories and critical resources

Much of the argument above has been concerned with the character of social theory, particularly as some influential theorists have tried to apply it to visual art. These accounts have been read not just as social theory but also from what I take to be a position close to that of practitioners and art lovers. I cannot, of course, claim that this position represents that of all practitioners or spectators; it would be absurd and presumptuous to claim to speak with the full authority of the 'community'. On the other hand, it is reasonable, and sometimes necessary, to try to speak for a social world as one sees it, making no secret of the partiality of one's position, yet trying to explicate and defend widely shared ideas, values and practices which may be crucial to the good which that world is capable of representing. I have argued that the implications of recent social theory for art worlds, in particular for social processes of creation and appreciation, make necessary this act of hermeneutical self-defence.

The self-understanding of art worlds is influenced, however, not only by social theory, philosophy and what has come to be known as 'art theory' but also by art criticism, and the theories it sometimes employs. Clearly, criticism is an everyday, constitutive feature of art worlds in that those who fashion and those who encounter works make innumerable, complex, situated interpretative and evaluative acts on a routine basis, many of which are voiced and discussed. The influence of criticism which is more institutionalised, and thus often more powerful, is another important force with which art worlds must contend; it is frequently capable of making or breaking reputations,

careers, market value, and helping to shape whole climates of curator, practitioner, purchaser and spectator opinion.

Modern mass media provide powerful tools for the formation of critical opinion. For example, aspects of visual art have been the subject of widely seen British television series since the 1960s: Kenneth Clark, *Civilisation* (1969), John Berger, *Ways of Seeing* (1972), Robert Hughes, *The Shock of the New* (1980), Sandy Nairn, *State of the Art* (1987), and more recently Wendy Beckett, *The Story of Painting* (1994), Simon Schama, *Landscape and Memory* (1995), Andrew Graham-Dixon, *The Story of British Art* (1996). Broadsheet newspapers carry regular reviews of exhibitions, and stories about the doings of more notorious artists appear in the tabloids and glossy magazines. 'Blockbuster' exhibitions, often attracting huge crowds and big financial returns, have been staged in capital cities and regional centres throughout the world, but particularly in Europe, North America, and the developed nations of the Pacific. The permanent collections of major galleries have enormous numbers of visitors, and constitute exceptionally important resources for the international tourist industry. In and through all these areas critical opinion operates to shape not only contemporary taste and fashion, but also the historical canon, and deeper assumptions and values.

Rather than attempting to survey the totality of contemporary criticism in its relationship with the self-understanding of visual art – an ambitious and probably hopeless task – I propose to examine some of the ideological resources for a range of critical practices. I mean by resources the deeper models and values which, by suggesting what visual art might be about at various levels,[1] what kind of formal and semantic processes are going on in works, help to shape practical perception, interpretation and criteria of judgement. These resources are related to philosophical and other kinds of theory, including social theory, and I am particularly concerned with the ways in which shifts in theoretical preferences may affect the practical, critical environment.

The resources of criticism, these deeper models and values, are in part a historical residue. That is, they belong to philosophies, critical theories or practical reflections which have been important in the past. Yet, when an artist or interpreter (who may of course be the same person) seeks to break free of a deadening convention, to do something different and more pertinent to his or her experience, an older and apparently superseded outlook, belief, technique or argument is often taken up again, and put to use for new purposes in a new context. Resuscitated critical or philosophical theories in this way often become

part of the critical resources for a contemporary practice. Critical resources may also, however, be influenced by new theoretical or practical outlooks, sometimes imported from other areas.

By the practice of criticism I mean the process of coming to right judgements of the meaning and quality of particular works of art.[2] This process is not just a matter of 'intuition', of simply 'seeing' the quality of something. But neither is it a matter of comparing the work one sees with a theorised ideal or paradigm, nor is it the result of following a methodology of taste. There are limits to the extent that the practice of criticism can be governed by abstract theoretical procedures. Yet the critical act needs to be guided by some idea of what a piece is trying to do, what its fundamental artistic intentions might be.[3] It is at this point that critical practice connects with broad theoretical views of what an art work might be 'about'.[4]

In *The Mirror and the Lamp* (1953) M. H. Abrams identifies four fundamental historical approaches to art as such: mimetic, pragmatic (or didactic), expressive, and objective (or formal). In order to take account of movements like Dadaism one needs to include another category: transgressive art. I want to suggest that these approaches – all represented in philosophies and theories of visual art (as well as of litera-ture, which is Abrams' first concern) but also broadly and practically understood by artists and spectators – have been shaped within the cultural and ideological history outlined in the previous chapter. That is, the complex interaction between theories and practices oriented by ideas and metaphors of mirroring, teaching, expressing, forming, and transgressing, and the successive impact of movements and cultural shifts like the Enlightenment, expressivism, modernism and postmod-ernism have shaped the resources for contemporary criticism. Below I begin an exploration of this interaction, particularly from the point of view of contemporary possibilities for criticism.

A brief resume of Abrams' categories would be useful. By 'mimetic' he means art that tries to reflect or represent phenomena of the perceived or known world. It is typically concerned with the 'truth' of its representations, understood as either an adequate description of the evanescent appearance of things or of an underlying structure or form beneath appearances.

By 'didactic' art Abrams refers to works that try to teach some truth of faith or doctrine. The approach frequently employs striking shapes and colours, and emotionally compelling imagery, usually yoked together in vivid storytelling, to make more comprehensible and attractive a religious, ethical or political ideology. Perhaps the best

example available is medieval religious art and craft, but one might also want to include official art patronised by modern totalitarian regimes of different political persuasions, and even, perhaps, modern avant-garde works intended to expose and criticise social injustice or the pretensions of high art.

'Expressive' art has its roots in Romanticism. The artist tries to find ways in which his or her vision of the world, typically a response informed by feelings as much as intellect, may be brought into material form. As both Abrams and Charles Taylor note,[5] expressive approaches often contain a claim not just to present the contingent emotions or singularity of a particular person but to truth. The best Romantic art is meant to reveal something essential about human experience of the world.

It is necessary to be precise regarding 'formalism' because it has been much caricatured recently. Formalist approaches typically affirm that there are specific methods, materials or material practices which should be at the centre of the art form in question. The identification and exploration of these basic possibilities is, for Greenberg and Fried,[6] the core of the modernist achievement. There is, however, another view often associated with formalism but distinct from the views of Greenberg in which, for each kind of art, there are certain unique qualities to the ways in which it realises and forms its meanings. Here semantic (in another theoretical dialect 'ideological') possibilities are not necessarily abandoned in favour of empty abstractions but restated in the context of the particular ways (including material processes) in which the practice can engender and orchestrate them.[7]

Finally, with transgressive or negating art we confront those approaches whose primary purpose is to violate norms, break rules and ignore conventions, to disturb and subvert any established consensus or orthodoxy, usually upsetting parts of the art world or the general public in the process. In some cases it is very difficult to disentangle this interest from didactic art. For example, some Dadaists and Surrealists subscribed to more or less clearly defined political programmes while others (Duchamp in particular) appear to have been more concerned with negation as an element in a complex philosophical–critical game, or perhaps even as an end in itself.[8]

Previous chapters have examined the impact of various kinds of theory, particularly recent social theory, on the practical self-understanding of art worlds. Critical theories are often closer to the self-understanding of art worlds than social theory proper, but critical theories are not the same thing as critical resources. I mean to suggest

by this distinction that the everyday resources for authentic critical judgements are of necessity too qualified by the particularities of works and their contexts, and by the possibility of unexpected, indeed sometimes unprecedented, aesthetic phenomena occurring and needing to be acknowledged, to be part of a clearly formulated and widely understood theory. Critical resources are composed of ideas, values, metaphors as well as perceptual practices – habits and skills of seeing and understanding – but they are much more like materials and tools of *bricolage*, of contextual response and improvisation, than the articulated, logically linked, discursively defensible elements of a theoretical discourse. Nevertheless, critical theories do often influence the formation and employment of critical resources, and in this way the practical self-understanding of art worlds. It would be appropriate, therefore, to examine the impact on critical theories of shifts in the social relationships of those important public discourses relating to truth, knowledge and art which have been outlined above.

Mimesis

Beginning with the idea of mimesis, there is no doubt that this has been historically, and still is, an enormously important kind of artistic intention. From the Renaissance onwards many painters and sculptors have been preoccupied with the imitation of nature, although it is important not to oversimplify the variety of approaches adopted. For example, leading Renaissance artists and thinkers saw nature as worthy of imitation but believed that the artist's task was to reshape it, restoring its flawed features to perfection. It was because there was an essential coherence between nature and the form-bestowing activity of human beings that observation was so important; the mind of the artist had to be guided towards a vision of what the perfected thing should look like by perceiving the form or reason which was within it as a natural object. As Dupré suggests:

> In Leonardo's notebooks we find the ideal, familiar from literary humanism, of art completing and perfecting what nature initiates. But he insists that artistic form must be discovered in and extracted from nature. Observation of nature precedes artistic expression. Being the one who most intensely experiences nature, the artist penetrates its inner secretes. Still, if observation reveals the forms of nature, experience alone does not convey its essence. That essence the mind must find in itself. (Dupré, 1993, p. 51)

Yet this position, which established a strong connection between an exploratory, even scientific, view of nature and artistic theory and practice, did not survive the decisive shift already afoot in physics and astronomy to a much more mathematical view of nature's underlying forms or structures:

> Galileo expressed the idea of natural form predominantly in geometrical or mathematical terms, thereby loosening the union between physical essence and artistic ideal. The natural models that guide the artist are now assumed to be taken from the more superficial realm of experience while the essence of nature lies hidden in its mathematical core. (ibid.)

It was of course this predominantly mathematical approach to scientific explanation and modelling that was eventually to triumph, disconnecting direct observation from strong claims to fundamental truth. By the time of Kant it had been widely accepted that science was uniquely capable of producing valid accounts of the nature of physical processes, and that the key to its successes did not reside primarily or simply in painstaking observation of the visible world; direct observation might be a necessary but was not a sufficient condition for reliable, systematic knowledge.

If the mimetic impulse was to be justified it had to be understood and defended in terms other than those that made sense to Leonardo and his contemporaries.[9] By the eighteenth century Jeremy Bentham was able to argue that while art may be of some use – in providing the discerning few with a unique form of pleasure – in this function it was no more significant than any other pastime,[10] and it had the profound drawback of encouraging the perversion of truth; precisely in seeking to give pleasure through its representations artists tended to distort the facts. As Abrams puts it, Bentham's aphorism 'All poetry is misrepresentation' means that 'poetic pleasure is grounded on falsehoods in narration, description, allusion, and moral judgement – all with the end of inciting the emotion against reason' (Abrams, 1953, p. 301). It is important not to underestimate the sophistication and complexity of eighteenth- and nineteenth-century critical theory in its arguments about the relationship between science, art, and truth. And while Bentham should not be taken as expressing a simple consensus, nonetheless the natural sciences, at this time rapidly gaining in institutional power and cultural standing, were becoming widely seen as providing a unique mode of access to knowledge, which art could either merely ornament or distort. Against this, the rise of Romantic and subsequently modernist theory and practice, particularly in their efforts

to restore to artistic representations a dimension of a non-mimetic yet fundamental truth,[11] constituted an important development in the ways in which art as a language, practice and social world could assert its validity and importance within the wider culture, and begin explicitly to explore its own inner possibilities.

Important artists throughout the modern period continued to be passionately committed to representing the visible world. The start of a new period is often seen as marked by Cézanne's effort to 'paint from nature' without the apparatus of pictorial representation developed since the Renaissance, a paradigmatic and still challenging moment in the development of modern art.[12] The insistence on 'beginning again' is not only a refusal of technical rules for the production of semiotically successful or conventionally useful representations but a drive to reconstruct art itself around the demands of particularity. The contemporary critical neglect of this impulse, strengthened by the distaste in much postmodern theory of any serious discussion of representation and truth, has meant that the work of artists operating in this way is often seen as 'outmoded', a strange departure from postmodernism's founding principle of 'parachronism', which Lyotard formulates as a time's lack of synchronicity with itself.[13] It is not done to appear 'untimely'.

Pragmatics, expression and form

Pragmatic and expressive approaches must first be considered separately. A pragmatic view that art's only purpose and justification is to impart some doctrine or ideology, or to motivate its audience to act in ways an ideology deems proper, runs up against the obvious difficulty that an art designed according to these ideas would be indistinguishable from propaganda, advertising or public relations. The artist would be replaced by the expert with images, someone who, by talent or training, was able to understand and deploy an effective rhetoric of visual signs. The ultimate test of professional competence, of the quality of visual artefacts, would be the influence exerted on the thinking or behaviour of spectators. The idea of artistic or aesthetic qualities beyond this functional dimension would be an unnecessary mystification, as would any idea of artistic autonomy. Art could have no ends, no integrity, no practice of its own. Those with no liking for art might not be displeased with this conclusion; if all that one found in art were untruth or mystification, or a craven or unconscious contribution to the perpetuation of social injustice, then such hostility would be understandable. Yet, while few would deny that images are often

connected in many complex ways to political and social power, there are good reasons for questioning the assumption that, in the last analysis, all that matters about visual art and visual culture is whether they support or challenge a supposed status quo, or whether they are commercially or technically successful.

From the 1970s onwards, however, this kind of assumption about the social role and effects of the visual arts, along with a connected series of implications for practice, have been popular. Initially in the rise of a neo-Marxist social history of art, particularly in the work of T. J. Clark, and then in the struggles by Left and feminist intellectuals to assess and release the radical potential of structuralism, semiology, post-structuralism and Lacanian psychoanalysis, the question of the political dimensions of art was central.[14] While I cannot enter into these arguments here, several points could be made which indicate some outstanding difficulties for this instrumental approach. First, many artists, simply as late-modern individuals working in this sector, demand more freedom of expression than a strong version of pragmatics would allow; the view of the process of artistic production as a technology of the signifier in the service of political ideology, perhaps with a special ingredient added by sheer talent, has understandably not proved widely or enduringly popular with either artists or spectators.[15] Second, on this strong version of pragmatics it is difficult to see why much theoretical or critical attention to high art could be justified, as *prima facie* it exercises far less influence on contemporary societies than the popular culture disseminated by mass media and the semiotic economy in general. Intensive study of high art is made more difficult by a persistent uneasiness among ultra-radical critics with the supposed elitism entailed in any notion of a hierarchy of cultural practices and artefacts.[16] Third, the politics of critical pragmatism have often been – despite its insistent criticisms of modernism – actively avant-garde and culturalist in outlook, anticipating or hoping that rapid and significant social change would follow from attacks on the thinking and taste of the enemy, be it capitalism, the middle class, patriarchy or whatever. This is strikingly at odds with the developed, sophisticated political theory and, more importantly, the political *programme* one would expect, particularly in the light of frequent critiques of the political naïveté of modernism in general and the early avant-garde in particular. In many cases it is difficult not to see the supposed critical content – usually supplied by the artist or friendly critic as commentary, and then arbitrarily added to works which would otherwise be indistinguishable from exercises in 'formalism', 'aesthetics' or postmodern ironical chic –

as political posturing, happy with its distance from the unglamorous grind and difficult facts confronting any genuine political process. Fourth, there has been little evidence so far in many of these political 'interventions' of a specific and theorised ethical dimension, despite the fact that theoretical and political assaults on art are often framed in ethical terms. This may be due, in part, to the influence of Marxist-Leninism, the ethical attitudes and theories of which are notoriously weak and contradictory;[17] it is also due to the prevailing scientistic influence of structuralism and semiotics in the 1970s and the avant-gardist theoreticism of deconstruction in the 1980s.

Yet an important strand of nineteenth-century social thought, part of its expressivist heritage, sought a reunification of areas of human experience separated by the Enlightenment and modernity, areas designated then and now by dichotomies of intellect and emotion, fact and value, prose and poetry, objectivity and subjectivity, politics and ethics, disengagement and expression, and particularly significant here, of pragmatics and aesthetics. In other words, within its theoretical and political framework was an anticipation that aesthetic, cognitive and ethical phenomena would not, or need not, be set against one another. Art and politics need not be mutually exclusive.

While Kant was preoccupied by the need to establish within his system a series of clear distinctions, for example between pure and practical reason, analytic and synthetic concepts, fact and value, other aspects of his work, notably in the areas of ethics and aesthetics, represented for thinkers of Hegel's generation an advance in understanding ideas such as moral responsibility and human freedom. This gave rise, eventually, to new definitions of the pragmatic and the expressive, and their fusion in Schiller's proposal of aesthetic education, in the historical unfolding of *Geist* of Hegel's speculative dialectic or, for Marx, in human praxis, a developing interrelationship between technology, social and political organisation, and knowledge. The utopian, dialectical ideal of a reunification of languages and social worlds separated by the Enlightenment, or perhaps by the whole course of Western culture, has, of course, been of great historical importance. Fichte, Hegel and Marx played leading roles in developing the philosophical, social, and political theory of this project, despite their important differences. This tradition of thought was centred, however, around an emancipating dialectic in which mutually alienated fragments of life, masquerading as social wholes, were to be dialectically recollected into a new, higher-order corpus, a genuine community, existing through constant self-assertion, through dynamic, purposive

social action directed towards its freely chosen goals. Different versions of this project of expressive social reconstruction constitute a major utopian theme in classical sociology.

By the middle of the nineteenth century leading thinkers had become increasingly sceptical of this outlook. Nietzsche's powerful critique of morality and historical teleology as disguised forms of the will-to-power[18] is well known. Even where Nietzsche's teaching is rejected in its details, the attack on historical metaphysics, on utopian 'meta-narratives', on humanism and any politics of the subject – including dialectics – has been widely influential on postmodernism. Beyond mere theory, the Marxist version of the convergence of fact and value, or critique and expression, in proletarian revolutionary praxis seems to have been damaged beyond repair by its moral and political failures in the very field it claimed as its own: history. In Western capitalist democracies the widening and deepening of institutional and cultural differentiation of specialised languages and social worlds, as well as an economic and political system which places the atomised individual in a central position, also work strongly against the ideal of social dialectics. Behind the theme of dialectical reconciliation and emancipation postmodernists have detected a totalitarian threat to level and expropriate differences of languages and social worlds, or more straightforwardly, a survival of sociology's nineteenth-century metaphysical–political past, an embarrassment to today's experts and sophisticated cultural critics.

How has critical theory been affected by the eclipse of emancipating, utopian dialectics, as well as by the increasing social force exerted by individualism and technical reason? The first consequence is to confirm the narrower sense of the pragmatic noted above. Here then, art would be simply the means towards an externally determined end: instrumental semiotic action in the highly politicised, or commercialised, field of culture. The second consequence is a version of expression which, when divorced from any wider social or ethical purpose, becomes the assertion of radical difference – the pristine otherness of the individual act – from any community or tradition.[19] This theme within art theory is also vulnerable to instrumentalism. In the context of a culture that values authenticity highly, art has, of course, often become a struggle to assert difference or personal originality, against the constraints imposed externally by social rules, conventions, obligations and the like. Genuine artistic individuality – the result, both infrequent and mysterious, of a successful effort to create something of significance and beauty – is confused with solipsistic self-promotion through the

minor talents of stylistic variation. The third consequence is a kind of new formalism in which aspects of art, taken to be wholly unique to it, are declared to be the only valid content that works can have.

Pragmatism as politicised cultural instrumentalism has already been discussed. The second alternative – stylistic manipulation – raises another issue of considerable importance and difficulty for contemporary art. Older ideas that made profound insights, acute sensitivity, spiritual vision, extraordinary skills and so forth conditions for artistic success were all compatible with the idea that the creative act required an intention and the deliberate employment of appropriate means. Action was seen as guided by individual intentions but also, insofar as it occurred within a *practice*, by a pattern of concerted activity distributed historically and socially. Individual intention was framed by the artist's understanding and reproduction of a range of means, methods, precedents, models and criteria which belonged to the historical practice of visual art. For the informed spectator, the identity and quality of the individual's activity related to the methods, language and evaluative criteria of the practice, which had existence and life beyond that of the individual artist, even if new ideas and approaches sometimes extended or modified the practice. Variations could occur between individuals in their understanding of the nature of the practice, and in their actions in the light of this understanding; sometimes differences were relatively trivial, sometimes more important.

A broad grasp of the practice would, by definition, embrace major variants as different approaches to fine art, and this might suggest the possibility of debate between and about these rival understandings of practice. Differences between understandings might, however, be so profound as to exclude the possibility of discussion; for example, it might be doubted that rival camps really had common ground that could be debated, or that they could agree on the evidence or criteria that, when revealed, would resolve their disagreement. Arrival at this point might suggest that there was more than one practice going on, or that one position had come to regard itself as uniquely valid *vis-à-vis* others.

It will be evident that I mean by the practice of visual art more than simply a predominantly technical process with a social and historical dimension. Bound up with and available through a practice are goods specific to visual art: the qualities of a distinctive range of objects, and the individual experiences and social exchanges associated with them. A practice in this sense is distinct from a technique, in that it has a value dimension in its own right, a dimension that outcrops historically and socially. It would follow that the modern practice of visual art – and I

believe that this can indeed be identified – is close to a tradition, albeit a dynamic and changing one. Most of the artists worth taking seriously during the modern period, most *good* artists, have sought to *exemplify* or *emulate* art in their work. That is, they have seen art as being important (even as all-important), as having a definite character, even if this was difficult or impossible to pin down, as something that, because it mattered, was worth arguing about and contesting, and as something that could be lost from view or corrupted, but that might be recovered and restored by those who were sufficiently gifted, dedicated or uncompromising. They regarded art as a practice and sought to live up to its demands. They did not so much strive to make concrete or visible a philosophical or theoretical *concept* of art but exerted themselves to achieve a particular goal within the framework provided by a tradition of practice which, as moderns, they had to rediscover or reproduce for themselves. This framework should not be seen, then, as merely passively received or handed down, but rather as actively constructed along with the vital concrete details of particular works. In this way, the imitation of the paradigm of art in, as one might say, its *spirit* but not its *appearance*, provided the conditions for successful, innovating practice. If postmodernism, whatever else it means, implies that artists have transcended the need to practice, and the need *for* practice to emulate and exemplify the spirit of art then, in my view, postmodernism as an ideology is deeply antithetical to the possibility of art itself.

For some theorists and critics influenced by postmodernism, contemporary art practice has indeed gone beyond not only the practice represented by modernism, but the notions of tradition and practice altogether. The idea that important lessons may be learned by trying to come to grips with the expressive possibilities of given media, and that standards and criteria and an historical canon are bound up in the living reality of a practice, has for some been deprived of any historical or social justification. A practice of visual art is seen not only as obsolete and implicated in a metaphysical, moralising meta-narrative of the goodness of art, but also, more concretely, as an impediment to self-expression.[20] A practice becomes, in popular sub-Nietzschean vein, no more than the accumulated results of other individuals asserting their will, their social privileges or fictive identity over others. One response might be to seek to invent a new art game, but in order to avoid repetition and metaphysics the game would have to be free of the intentionality and constraints of a practice. The new regime would supply a way of acting that *seems* artistic and a way of producing things that *appear* to be art. The activity of the artist is directed by an image of what the

practice is meant to achieve: acts and works that *look individual*. In other words, when the result of successful expressive activity – the realisation of an individual vision – becomes a technical aim then a concrete image of individuality, of singularity, comes to dominate the process of production. The look of the work becomes a *style*, a place is created within the highly defined field of contemporary styles – a 'system of differences' if ever there was one – which then constitutes the individuality of the artist; the core of the practice is stylistic manipulation, and its aim the construction of a stylistic difference which is recognisable as such in the context of an established array of styles. The novelty of the style as style provides its 'impact' within the system. This is a capitulation to a reduced sense of identity; the ceaseless search for the new, the marginal, the idiosyncratic reveals a profound dependency upon whatever happens to be central and established. It participates fully and efficiently in the demands of the fashion sector of the semiotic economy, providing novelty, recognition and approval.

The third alternative, that of 'formalism', is also important to contemporary art. The emergence of the explicit recognition of artistic form – by which I mean the material and syntactic dimensions of the work, organised and orchestrated by the artist, which contribute to its appearance and meaning, as worthy of attention in their own right – is a complex phenomenon with an equally complex history. This is not what I mean here by formalism.[21] What then does this critical term suggest?

Initially and simply it refers to an approach excessively or exclusively concerned with material processes and organising devices, to the detriment of, or as a substitute for, meaning. But this can come about in at least two different ways. First, form can be foregrounded as a consequence of the failure of a piece at the level of meaning, particularly in those cases where reasonably well-informed spectators are not directly aware that what they are seeing *is* a failure at this level. For example, suppose an artist working with the religious and mystical aspirations of Rouault, but where the image does not rise above cliché and sentimentality,[22] thus failing to attain the kind of elusive but potent meaning achieved by better work. Here, a failure of meaning occludes or displaces a failure of form. If, however, the meaning of the piece is less prominent, in a sense less literary and thus more immediately enmeshed with its form, then form may sometimes replace a failed meaning. It is almost as if form rushes in to occupy the semantic vacuum. As an example, again suppose an artist with religious, mystical and tragic aspirations for his or her work, but this time operating with the painterly vocabulary of Rothko or Barnett Newman. Providing a

failure of meaning is not simply due to formal incompetence, to wit technical failure with methods and materials,[23] relative semantic weakness may operate to make formal dimensions predominant.[24]

A second way in which form can be foregrounded is, paradoxically, when it ceases to be a dimension of meaning and becomes instead a means to a negative aesthetic, semantic or stylistic effect. Initially this might seem an implausible suggestion; if the signifier merely serves the full representational presence of the signified then surely it suffers an eclipse, it is used up and overlooked? This is typically the case with many text-based representations. Yet with a lot of postmodern work there is a tendency to make the piece seem as if it were replete with meaning, and in such a way that it is something like a text; the piece is a kind of visual equivalent for a piece of writing. The structure of the piece competently suggests that the form does not matter, except as a conveyance of the quasi-textual meaning. Yet the quasi-textual signified is not really present either, rather we see traces or incomplete fragments, the result of a refusal or failure by the postmodern artist to engage rigorously with meaning. Thus, attention rebounds on the object itself which, although remaining a subservient and essentially technical device, is now thrown into prominence. This process leads to the artistic inertness and indifference of many postmodern works, often mistaken for their cool, ironical stance.

The rejection of Romanticism and expressivism by early modernists in the nineteenth century was connected to a new emphasis on form. For the classical modernism outlined by Taylor, a cult of subjective feeling and sentimentality about human innocence and a benign nature was seen to have debilitated artistic imagination and weakened the intensity of the work itself. The new concentration on form was part of an effort to rescue the epiphanic work from warm feelings and tired images.[25] The facile rejection of this demand, sometimes called the 'aesthetic', along with narrative, instruction, and dialectics leaves the postmodern artist with no option but political posturing or the terminal formalism of pastiche.

Art theory beyond art history?

It is now necessary to look at approaches to visual art that do not strictly belong to social or critical theory but sometimes draw upon social theory, or upon discussions in which social theorists have participated. I have in mind in particular the approaches sometimes collected under the title of 'art theory'.

What is art theory as it applies to the visual arts? Art theory has to some extent replaced the older disciplines of art history, the philosophy of art (aesthetics), and art criticism. Institutionally, it is often closer to practice than the social theory of art proper, often being taught to students of creative practice. It is also capable of influencing the outlook and responses of critics, art journalists and curators. Intellectually it draws on different theoretical sources: the so-called New Art History, feminisms, Lacanian psychoanalysis, deconstruction and postmodernism.

There is no agreed programme or single paradigm tying these disparate sources closely together; for example, the hostility of the remaining New Art Historians to what they see as the relativism, elitism and conservatism of deconstruction is well known. Yet there are some attitudes that proponents of much recent art theory often have in common, despite their differences. These are: a hostility to modernism, particularly to what is seen as a modernist canon of works and a modernist pantheon of artists; a hostility to modernist theory, meaning by this a current of argument and practice which stressed the modernising impulse of movements like Constructivism, the Bauhaus and de Stijl,[26] and the so-called formalist criticism of Fry, Bell, and Greenberg; a desire to develop new concepts and specialised languages designed to put theorising about art on a firm critical basis and raise it above older, more widely understood – but supposedly deeply ideological – types of criticism;[27] finally, a tendency to approve of the kind of art work, either historical or contemporary, on which this kind of theory can find a purchase, and this naturally tends to be work in which literary or quasi-theoretical elements predominate. Supposedly 'disaffirmative' or 'issue-based' works have been particularly popular. Within these approaches and sharing these attitudes is a subset of theories, strongly influenced by postmodernism and deconstruction, particularly influential in recent years, and for many representing the leading edge of art theory.

Art theory, whether understood as either the larger, heterogeneous group or as the subset influenced by postmodernism, has generated over the last twenty or so years a large and complex literature, which cannot be reviewed as a whole here. Donald Preziosi's *Rethinking Art History* (1989) is an ambitious attempt to criticise contemporary art history – and the various theoretical camps it now contains – on the basis of postmodernist and poststructuralist theory, to reconceptualise art history from the point of view of art theory. As such it will allow some of the more important arguments emanating from this influential body

of thought to be summarised and examined with reference to the kind of reflexive social theorising I am attempting to develop and defend.

This work aspires to a high degree of sophisticated theoretical self-reflection. Preziosi has taken on board many postmodern, deconstructive, Foucauldian ideas and, so armed, sets out against the whole of current art history and, although he does not explicitly distinguish between the old art history and the new paradigm by calling the latter 'art theory', this would be possible and in some ways useful. In his theory, works are not treated as expressive of their epoch, of social structure, of the vision of individual artists, of class formations, ethnicity or gender, or as self-dissolving, quasi-linguistic artefacts; it is rather a theory of art history *as a theory*, in part at least a meta-theory of art history: 'After more than a decade of debate and discussion of disciplinary crisis, it is perfectly clear that art history knows what it does. And it frequently knows why it does what it does. What it knows less well, however, is what *what it does* does' (Preziosi, 1989, p. 53). In other words, the problem Preziosi raises and tries to resolve is that of art history's chronic insensitivity to its constructive or performative dimensions. This appears to bring his approach close to the kind of questions I have been asking about the social theory of visual art as socio-cultural construction.

The instrumentalist metaphor

A discussion of the film *Lust For Life* allows Preziosi to make some points about the role of the art historian and the theoretical framework of the discipline. Despite widespread worries within and about the discipline, he argues that art history is not in crisis because it is being torn apart by contradictory or incommensurable approaches: Marxist social history, feminisms, Foucauldian genealogy, semiotics, post-structuralism, Lacanianism. Its deeper crisis springs from the fact that it incorporates at its roots (and cutting across other ideological differences) a view of the work of art – its 'obscure object of desire' – as either an ineffable, spiritual epiphany or as an essentially simple, homogeneous (if encoded) 'meaning' which just happens to be encountered initially in a visual form. The former has been widely rejected in recent decades as 'metaphysical', 'essentialist', 'elitist', as 'bourgeois ideology' or complicit with 'masculine myths of genius' and so forth. The latter view has spawned a clutch of approaches that have tried to construct supposedly more scientific, or at least systematic, theories; ideas about social structure and socio-cultural change have

been imported into the field of art historical enquiry, and in the area of semiotic analysis what were widely taken to be improved concepts and methodological advances provided by new theories of language and signification were employed. What both share, argues Preziosi, is a view of the work of art as in essence a quasi-linguistic text, an artefact of language, a carrier of meaning.

In both cases the work of art is seen as clearly different from all other artefacts, being internally unified and economically organised[28] (everything contributes to the meaning); this bounded, homogeneous unity reflects the bounded, homogeneous unity of the Subject (capitalised so as to indicate an ideological construct). The basic effort of art history has been to provide a quasi-scientific analysis (the 'disciplinary science') of a metaphysical, ideological entity; art history is, in this way, theological in a pejorative sense; its object is an imaginary projection serving ideological functions.[29]

The supposed disciplinary science of art history seeks, in the different works forming an artist's oeuvre, those common stylistic features which can be detected by an expert; the most tell-tale signs are often details. The formal and semantic elements constituting individual works are treated as unified compositionally, or through narrative structures, or by the orchestration of colours and marks, or in some other way. The entire business of art history 'hinges on one major assumption: an isomorphism of the significative elements of the entire system, code or oeuvre of an artist (and, by extension, of a time or place), which is grounded in a deeper belief in a homogeneity of Selfhood on the part of the artist' (ibid., p. 31). Or again, the disciplinary framework which constructs the art of art history requires that 'each artwork, both in its totality and in all its details, is a trace or testimony of an organic wholeness, a constant self-identity of the Subject through all its transformations' (ibid.). Within this system art historians and critics are 'sacerdotal semioticians or diviners of intentionality on behalf of a lay congregation' (ibid.).

Preziosi does not like loose ends. The theological, divinatory role of the art historian is ultimately and conveniently also eminently practical: 'The discipline is grounded in a deep concern for juridico-legal rectification of what is proper(ty) to an artist and is thereby involved with the solidity of the bases for the circulation of artistic commodities within the gallery–museum–marketplace system' (ibid., p. 33). And we surely do not need reminding what a sinister historical role this unity of the subject stuff has played in a 'century increasingly obsessed with ethnic self-identity and national statism' (ibid.). One feels compelled to add

here that the century has also witnessed concern, now and then, with individual human rights, social justice, expanding socio-cultural avenues for expressive individuation in lifestyle, sexuality and so on, all of which seem to assume that the identifiable individual person is rather important, being the subject and sometimes the agent of change.

Preziosi is concerned with the disciplinary 'machinery', the rhetorics of art historical discourse, which constitute both its object and its subject. The social identity of the art historian derives from an 'epistemological scenography' which justifies some ways of speaking but not others; if, in a pluralist period, there is no overall agreement about paradigms, methods and so on, then prevailing dialects must enable specialists to carve out their self-contained territories. Beneath the surface pluralism (or relativist crisis, which depends on one's temperament) lies a deeper agreement on a key metaphor. Preziosi calls this the 'instrumentalist metaphor'; it is in essence the notion that the art work is an instrument of linguistic meaning. This trope is deeply 'scientistic', by which he seems to mean that it entails a realist epistemology: 'This binary, subject-object topology serves to reify the phenomenon in question [art], investing it with a pregiven ontological status, an otherness that is and must be autonomous of the analyst–subject' (ibid., p. 35). He quotes H. I. Brown, who makes the point more clearly: 'We must understand that scientists are trying to understand a reality which is objective in the sense that it exists independently of their theories' (ibid.). This, apparently, inevitably severs the object from its context, 'its modes of production and reception and social determinations' (ibid.). In fact, of course, it *necessarily* does no such thing, and if the supposed metaphysics of art history and criticism is to be replaced with the sociology and semiology of systems of visual culture, a move Preziosi seems to favour, then this would presumably be because the latter are seen to offer genuine knowledge and not reductive prejudices. This seems to amount to replacing what is, for Preziosi, one reifying, realist epistemology with another equally as reifying.

In order to reinforce his critique, Preziosi now trundles out, to much conceptual clanking and grinding, the new disciplinary siege engine designed to shatter the last defences of the old history: the Bentham/Foucault Panopticon. This formidable contraption is too well known to require lengthy description, but the uses to which Preziosi puts it in the context of art history are worth considering. There is a good deal about how each cell, as viewed from the central viewpoint (the position of the Subject, of vision, knowledge and power), is displayed according to Albertian single-point perspective, and how

anamorphosis[30] might disturb this kind of organisation by representing something that makes sense only from a spatially different viewpoint; anamorphosis 'deconstructs', but does not imply a negation or transcendence of perspectival representation as such. In this way it might be said to 'represent' deconstructionist theory. At a more mundane level, the panoptic system, as a social technology, renders its captured phenomena 'legible', and therefore controllable, by removing them from their living contexts and making them available for scrutiny, classification, and organisation on the basis of their visible, surface, and in this sense, formal features. This argument against panoptic epistemology begins to sound very like the ancient complaint of the Platonist philosopher that it is wrong to make classifications and judgements on the basis of appearances, the raw material available to the mind through our embodied, flawed senses. It replays the theorists' traditional 'scandal of the optical', the transgressive assertion of the significance of the visual, through a refusal of legibility.[31]

Preziosi repeats the familiar argument that to seek after the original idea or vision or feeling of the artist in order to determine a work's meaning is to commit an intentional or affective fallacy; but he also has objections to the search for an original meaning of the work as defined by its original historical context;[32] here, the text or voice of the work is really that of History, usually understood as the struggles of some favoured, mythological agent, for example *Geist*, an ethnic group, the working class or women. While formalism and iconology determine the meaning of works by placing them in a diachronic series of forms or images,[33] strictly historical approaches achieve the same end by locating the work in a socio-historical grand narrative of oppression, ignorance, education, emancipating struggle and freedom.

To summarise Preziosi's critique, the instrumentalist metaphor governs a family of disciplinary perspectives: formalist, iconographic, social–historical, structural–semiotic. The discipline in all its forms is inherently totalising and reifying, compelling the historian to render semiologically and functionally complex artefacts into the 'texts' of history, of the artist as Subject, or of language; the work and the oeuvre are routinely rendered internally consistent and mutually coherent. Ambiguity, incoherence or contradiction are gradually eliminated. One part of a complex totality is selected – be it form, iconic image, ideology, structural or supposedly grammatical features of communication or signification – and required to explain or determine everything else; what have thus become contextual elements are viewed in terms of their relative contribution to the work's meaning. The underlying

paradigm is logocentric, privileging the Voice over its 'representations or material traces' (ibid., p. 48).

What does all this amount to? What purpose is to be served by a supposed liberation from the old art history? Preziosi raises the flag of enlightenment: 'If the "history" of art's history has too often been to history as Disneyland is to the history of the United States, it may be because, like the latter, it has worked to engender and maintain a heterotopic vision of what it might be comforting to believe about ourselves and our history' (ibid., pp. 43–4). This sounds very like the traditional call of enlightening human sciences that we should be rid of illusion, steeling ourselves to face the rigors of uncomfortable truths; it is impossible not to hear in this sentence two false histories being adversely compared with two true ones. Not so:

> this is not to oppose the history of art history's art to some truer history… At issue is the question as to whether any history articulated within a discursive framework based upon centrality, homogeneity, or the continuity of self-identity can be other than oppressive. (ibid., p. 44)

Where does this idea of 'oppression' come from? Is it not simply *ad hoc* liberal–radical moralising dragged into what Preziosi initially sets up as an epistemological argument? In discussing the supposed 'isomorphism' of the work and the self Preziosi writes that we confront 'what is surely an ethical praxis, dependent upon very particular notions of Selfhood inherited from certain areas of Western theology' (ibid., p. 43). As there is no expansion of this idea it is difficult to know quite what he means by an 'ethical praxis', or even 'very particular' ideas about the self, let alone 'certain areas' in theology. Clearly, he is implying that there is something wrong with isomorphism, but whether this is because it imports extraneous ethical considerations into what is properly epistemology, or because it proposes the wrong sort of ethics, or because there is something objectionable about this (or conceivably any) idea of the homogeneous self, or because of its supposed provenance in some type of theology is not clear. Yet these are very important and pertinent questions.

The new metaphor: reckoning with the world

The position beyond the discursive space defined by the ruling instrumentalist metaphor is not just a reversal privileging the interpreter over the original maker or sender of the text–artefact, inviting free, creative play with the message. This would be just a 'negative theology' and

would do nothing to return objects to their contexts. Rather, we need a metaphor that allows attention to

> processes whereby artefacts used as artworks are produced and reckoned with in the engenderment and sustenance of individual and collective realities (that is, ideologies), if we are to (1) see the logocentrist and instrumentalist paradigms in a clearer and more enhanced light; (2) reverse the parochialism of focus so endemic in the modern academic discipline; and (3) reconnect the contemporary discipline with its pre-war engagement in important philosophical, cognitive, and psychological issues. (ibid., p. 51)

A prolonged discussion of artefacts from the upper Palaeolithic period in the light of the structuralist theory of Leroi-Gourhan and the later work of Marshack is intended to take us closer towards this idea of cultural 'reckoning', and thus towards an art history beyond its modern form, in particular towards the 'poststructuralist critique of verbocentrist structuralism' (ibid., p. 142).

While acknowledging Leroi-Gourhan's structuralist innovations, his account of Palaeolithic art as representing a mythic world order suffers from a 'static or monolithic perspective'.[34] Marshack's approach, on the other hand, is seen to have the advantage of attempting to replace individual images or artefacts in their cultural context: 'his findings foregrounded the situational context of usage and function and focused attention on the nature of the subject–object relationship' (ibid., p. 136). Gombrich is quoted with approval: 'The test of an image is not in its lifelikeness but in its efficacy within a context of action' (ibid., p. 133). At one level this move sounds anything but revolutionary, being perfectly familiar to anthropology, entirely natural to palaeo-anthropology and seemingly endorsed by Gombrich. Preziosi believes, however, that Marshack's approach represents an advance because he does not treat Palaeolithic representations and artefacts as autonomous works of art, but rather as functional, in the pragmatic sense of being one of the ways in which human beings 'cope' or 'reckon with' the world in an everyday, practical fashion. He also opens up the possibility of these artefacts having more than one meaning as they participated in wider systems of cultural signification. For example, it is hypothesised that after around 70 000BC the 'stylistic' features of representational or decorative artefacts came to play a functional role in socio-cultural differentiation and identification.[35] All semiotic activity could thus be seen to possess contextual dimensions, as well as being 'multimodal and multifunctional'.

> Artistic activity may, at certain times and places, constitute an institution. But to consider art as a kind of thing distinct from other things in the sociocultural world may constitute an unwarranted reification and an impoverishment of our understanding of the roles played by visual practices in individual and collective life, both at present and in the past. (ibid., p. 152)

The 'artifactual environment' – to which what has been called the work of art belongs – can no longer be thought of as a text 'in any ordinary sense of that term' (ibid., p. 153). So if not an ordinary old text then perhaps a new one? The new text in fact turns out to be the reassuringly familiar postmodern Word, 'irreducibly plural', not one to be read – in the normal sense – but written, 'a performance or actualisation on the part of users' (ibid., pp. 153–4). This would seem to be a form of pragmatism, and as users we confront questions which could be raised with respect to Rorty: what is or should be our way of reckoning, which will in turn determine (or write) the texts constituting our knowledge of Palaeolithic art and culture?; that is, how are we to understand – or reckon – our own ways of reckoning?

It is not clear that it is in any way sensible for palaeo-anthropology to treat these markings and artefacts as works of art in the first place, not just because of the risk of anachronism but also because the fact that it is compelled to hypothesise about cultural forms on the basis of very little surviving evidence means that a social phenomenon as complex as art, itself a part of other complex cultural forms and practices, is beyond its descriptive and explanatory power. If this is the case, then for palaeo-anthropology to desist from speculations about art is not of much significance with respect to the problems of recent historical or contemporary study. Second, either there are knowledge claims being made here – in which case we seem to be in some version of the instrumentalist or panoptic paradigm – or there are not; this is another instance of the way in which throughout this work Preziosi shifts uneasily from knowledge claims to largely unargued quasi-ethical appeals. Third, in endorsing Marshack's determination of the meaning of surviving Palaeolithic artefacts by the text of a whole culture, however 'complex', 'ongoing' and so on, we are surely confronted by another instance of the logo-centric reductionism and its instrumentalist metaphor he earlier condemns at such length?

As a whole Preziosi's work promises much but is in reality deeply frustrating, presenting arguments which often seem on the edge of insights but which culminate in contradictions, obscurity or vagueness.[36] Having fought through to the end there was, for this

reader at least, a strong feeling that a ponderous edifice of postmodern, deconstructionist, Foucauldian machinery had given birth to little of substance. What is produced is an attitude to art history (as a discipline) and to the history of art (a set of works, artists and so on) that oscillates between being predominantly technical–epistemological and, when this line of argument runs into trouble, reverts to nebulous but rhetorically forceful liberal moralising. Unlike many important European postmodern offerings, the tone is predominantly 'conversational' rather than 'tragic'.[37] Whether conversation is, in the last analysis, meant to lead to improvements in knowledge or in how human beings act towards one another, or whether 'ironising' conversation is good in itself, is again unclear.

To summarise, this chapter has been concerned with the exploration and application of some of the theoretical and historical ideas introduced previously. In particular, it has looked at how theory has influenced criticism. Contemporary critical practice has been approached through the idea of critical resources, the deeper models and values which, by suggesting what an art work might be trying to achieve, shape evaluative and interpretative outlooks. The resources represented by notions of mimetic, didactic, expressive, formal, and transgressive approaches have in the past influenced and been influenced by philosophical, social and other types of theory. Today they are affected by an outlook – art theory – which includes or trades upon philosophical and social theories. As resources for critical practice these notions constitute a sphere distinct from concrete acts and works, and the meta-theory and specific constructions of theory proper. They look both ways, towards broader theoretical debates but also towards highly localised and specified interpretations and evaluations.

The idea of mimesis, or more specifically of representation, has had to cope with the strength of the connection between scientific knowledge and abstract, conceptual models, ultimately mathematical in nature. Artists pursuing this ideal have had to fashion new ideas of the connection between appearance and truth, a theme neglected by much contemporary theory.

A modern version of didactics has been very popular with many theorists since the late 1960s, and probably because of this the influence of fashionable theories on artists and critics interested in this approach has often been profound. Its more significant problems relate to its imposition on art and artists of a choice between instrumental semiotic artefacts or the illustration of theory. Unsurprisingly, this has proved unpopular with many intelligent and independent artists. Older

expressive theories often contained the promise of a dialectical reconcil-
iation of art and politics, but widespread rejection of dialectics by
contemporary theory often leads to aesthetic ineptitude and political
vacuity, despite the supposedly radical gloss.

The rejection of dialectics, as well as the widening and increasing
potency of instrumentalised consumption and lifestyle individualism,
has also affected contemporary critical resources for the pursuit of
expression and aesthetic form. In the arts and criticism influenced by
postmodernist theory this has related to a rejection of the idea of
practice, of a way of working which, historically and socially, precedes
the individual, and which contains ways of doing things, goals and
values capable of providing a constraining and enabling context for
individuals operating within it. The result is often a pursuit of expres-
sion which degenerates into the manufacture of a style, the 'look' of
individuality and novelty, but within an already familiar and conven-
tionally effective system of differences.

There is a connection between the manipulation of style and
formalism in that the construction of an aesthetic or cultural identity
through stylistic variation – even if finally seen as a 'mask'– is a highly
formal, in fact mechanical, procedure. First, it is dependent upon
existing conventions, whether of subject matter, materials and conven-
tions or values. Second, flouting norms elicits an immediate response,
whether they have been rejected in an effort to say something new or
merely to attract attention.[38]

This kind of inversion is at one level entirely formal, although, of
course, it may take some wit or insight to identify the move beforehand
and to make it in the right sort of way. On the other hand, given the
diversity of individual efforts in the arts across Europe and America, at
any one moment there are always plenty of natural mutations from
which the critical–fashion system may select according to its needs and
hunches about shifts in fashion in consumer preferences. The system
nominates particular artists, and then those fortunate individuals – now
rich and famous – are attributed with the talent and intelligence which
must have been required in order to make the move for which they have
become known, and which, in retrospect, seems part of an inner logic.
Such operations provoke widespread and, one would have to admit,
justified scepticism about art.

The contemporary pursuit of form goes wrong in one of two ways:
when there is a failure of meaning in the context of technical
competence, and when there is a withdrawal from meaning. Except
for the ways in which it generally discourages an interest in coherent

meaning, the former cannot really be laid at the door of contemporary art theory. With the latter, however, the connection is much closer; artists influenced by postmodernist critical theory typically produce works which are merely conveyances of quasi-textual but fragmentary or incoherent meanings; the theory gives artists and audience a way of being satisfied with failure.

In emphasising the constructive or performative aspects of art history Preziosi proposes an approach that seems close to the kind of reflection on the social character of social theory outlined in previous chapters. His attempt to step beyond existing disciplinary frameworks – perhaps a product of the modernity whose cultural dimensions they try to explain – into postmodern art theory is an attempt to establish a position from which these questions may be posed. But the new post-disciplinary position turns out to be less than satisfactory. He is right to argue that approaches within contemporary art history, particularly those influenced by semiology, structuralism and post-structuralism, have tended to construct the work of art as a quasi-linguistic artefact; they have acted on the view that the supposed semiotic self-sufficiency of the work of art, often its first line of defence against the incursions of theoretical rhetoric, must be deconstructed as a preliminary to uncovering any legibility it may possess. From this point of view, if deconstruction leaves nothing but the insubstantial remains of a doomed resistance to theory, so much the better; if the work survives the process, what is uncovered can only be the traces of the self-deconstructing, pre-theoretical artefact, in other words, dumb theory in a visual form. He is also right to point out the ways in which socio-historical approaches may render the individual work and the artist's oeuvre as small carriers of some larger, external non-artistic meaning, whether this is understood as the functional demands of social structure, of the self-development of *Geist*, or the formation of some privileged historical agent.

There are, however, many problems for Preziosi's postmodern theory of art, perhaps the most important of which is the oscillation between a set of epistemological proposals for conceptual and methodological reform and an invocation of a new aesthetic or moral tone in our commerce with works of art. It is difficult not to hear in Preziosi's arguments attempts to promote art theory in two different ways; if the audience does not buy the first it will surely accept the second. He implies that the exposure of the meta-theoretical or epistemological failures of art history (the instrumentalist metaphor, the power–knowledge machinery of the disciplinary science and so on) somehow

validate the epistemological implications of the post-disciplinary system; yet, knowing that the new approach could not consistently claim to provide better history, its real claims must be somehow moral or political. It escapes the 'oppressive' character of the instrumentalist metaphor, the Subject, the aggressive imperialism of the Word and so on. Yet this moral or political dimension is simply invoked as if it represented a point of resolution, a new, self-identical position from which theoretically mediated accounts of art could be produced. It is precisely because this dimension is unavoidable for a reflexive theory that it cannot be employed in this way.

Chapter 7

Reflection, Theory and Language

I now wish to consider how the problem of the social relationship of major discourses, in particular of cognitive, ethical, and aesthetic languages and the domains they shape, has been approached by social theorists and philosophers. I will argue that the classical sociological tradition of Weber and Durkheim may be tentatively read in the light of the emergence of this problem. This discussion is followed by a critical review of more recent and direct approaches in works by Oakeshott and Lyotard.

Every way of addressing this problem belongs to one or other of the languages in question. My approach here, for example, belongs in many of its features to social theory. On the other hand, as a theory it is ethically rather than cognitively or aesthetically or meta-theoretically reflective. While, in raising again the question of the possibility of the social, it is intended to connect strongly with the classical sociological tradition, it nevertheless departs from the drive within that tradition towards objectification and connected epistemological and method-ological issues. It emphasises sociological hermeneutics and poetics, and in particular the language of sociological practice. The question raised in the later parts of the chapter is what difference might it make to the practice of social theory for language to be treated as an historical, normative context, a source, limit and value for cognitive, ethical and aesthetic practices. The question of language is, in this sense, closely related to the question of the social.

My approach, which seeks to take the question of language as a normative context and limit seriously, is informed by the hermeneutics of the later Heidegger and particularly by Gadamer's philosophical hermeneutics. The latter is considered directly and at some length in

the next chapter. Here, I wish rather to argue, in a preliminary way that some questions confronted by the classical sociological tradition – in particular in works by Weber and Durkheim – when reformulated reflexively, demonstrate the possibility of a connection between this approach to language and ethical questions about the practice of social theory itself. It would be a mistake to suggest that works by Weber and Durkheim show the kind of hypersensitivity to questions of language and representation with which we are familiar today. Yet, in important passages it is possible to identify tensions and emergent questions about the social character of social theory.

Weber: science, politics, and aesthetics

In various works Weber attempts to understand the possibility of and relationship between social science and politics in the context of an analysis of what he calls 'value spheres'.[1] He is anxious to understand a characteristically modern 'polytheism of values', not just as a theoretical or philosophical problem but in a definite historical and sociological context, which he famously calls 'rationalisation'. His recognition that social science is itself historically and socially situated exceeds the usual ritual observance. In a well-known passage of 'Science as a Vocation' he writes:

> The fate of our times is characterised by rationalisations and intellectualisation and above all, by the 'disenchantment of the world'. Precisely the ultimate and most sublime values have retreated from public life either into the transcendental realm of mystic life or into the brotherliness of direct and personal human relations. (in Weber, 1948, p. 155)

These 'ultimate and most sublime values', sometimes described 'new gods for our time', are often in open conflict with one another. To devote oneself to a life organised by one value requires that others be rejected. Even if the individual does not make a single, overall commitment, but rather multiple, successive ones in respect to different aspects of life, the results are much the same.

Just how, then, do different commitments, different aspects of life, different languages and practices relate to one another?[2] Weber denies that there is any way of judging rationally between these values, precisely because the possibility of judgement is created by the acceptance of one value rather than another. Even science cannot decide between gods. Its role is restricted to a clarification of the value to which an individual, an institution or a society commits itself, and a rational elucidation of the consequences.

This discussion springs, in 'Science as a Vocation', from a meditation on the meaning of science. In the contemporary West, and increasingly on a global scale, science represents, on the one hand, just a particular value (or perhaps complex of values), one way of life among others, but, on the other, it exercises a profound shaping force upon every other way of life. Science is the most important part of a process of rationalisation which has been going on within Occidental societies since classical antiquity. The inner significance of this process, beyond its contribution to man's practical affairs is, for Weber, that we have come to accept, as a fundamental presupposition of our culture, that the world is in principle rationally intelligible, 'that one can, in principle, master all things by calculation' (ibid., p. 139).

Weber asks what this process of objectification and disenchantment *means*. The answer seems to be *nothing*, or rather that science, having eventually suffered the same fate as the ancient religious myths it replaced, has become silent about its own significance. The old illusions that science is a way to 'true being', 'true art', 'true nature', 'true God', or 'true happiness' are no longer acceptable. Here, as Weber tries to understand science and politics afresh in this new context, he anticipates issues developed subsequently in debates about of post or late-modernity.[3]

Western societies are locked into rationalising or modernising processes, partially controlling and partially being controlled by them, but because rationalisation is necessarily silent about its own significance the relationship between different, competing cultural forms, ways of life or practices, organised around different values, is marked by a fundamental arbitrariness. However, although science cannot resolve questions of value it can enable clarity about available choices. Of course, self-clarification and a sense of responsibility are themselves values, and as such cannot find legitimacy outside the forms of life they organise. The decision to opt for clarity or responsibility is no less arbitrary at root than opting for confusion and irresponsibility.

There would appear to be little here that would help one to imagine how the social relationships between discourses like art and social science might be arranged more positively, at least in a traditional sense. Social science may offer the possibility of greater clarity but, as we have already noted, no binding reason can be offered as to why clarity is something we should want. Looking more specifically at the place of art within this context, Weber suggests that, as rationalisation gathers pace and force

art becomes a cosmos of more and more consciously grasped independent values which exist in their own right. Art takes over the function of this-worldly salvation, no matter how this may be interpreted. It provided a salvation from the routines of everyday life, and especially from the increasing pressures of theoretical and practical rationalism. (ibid., p. 342)

He goes on the observe that

the refusal of modern men to assume responsibility for moral judgements tends to transform moral intent into judgements of taste ('in poor taste' instead of 'reprehensible'). The inaccessibility of appeal from aesthetic judgements excludes discussion. (ibid.)

As there are no rational grounds for choice between ultimate moral values the transformation of ethical judgements into judgements of taste is inevitable. This does not constitute a refusal to accept responsibility for judgement, but is simply an acknowledgement of what is, for Weber, its real context. That is, the aestheticisation of morality is not the consequence of a failure to exercise proper responsibility but simply a logical consequence of the circumstances under which it occurs. Weber's own preferred aesthetic–moral stance was what he took to be a sober, undeluded, humane individualism; yet, all that can be said about this commitment, this approach to life, is that it was to his taste.

The implication of Weber's argument is thus not simply that, through a dialectical twist, the importance of art grows as an escape from and compensation for the rigidities of rationalisation, but also that to choose one fundamental value rather than another is an aesthetic act. In this way, the relationship between science and art is ironically inverted. While science, technology and bureaucracy influence more and more aspects of human life, fundamental values are only available as creative or aesthetic acts and judgements of taste.[4] The difficulty is that the aesthetic now seems to be just another name for an arbitrary act of choice and, as we have seen Weber himself note, the aestheticisation of a discourse effectively renders it silent about itself; there can be no dispute, no discourse, no theory, no real reflection about matters of taste.

What do Weber's views imply for the ethical or political mediation of the relationship between different languages and practices in modernity? In 'Politics as a Vocation' politics is famously defined as the 'leadership, or the influencing of the leadership, of a political association, hence today of the state' (ibid., p. 77). What is most important here is Weber's connection of politics with the institution of the state. The state is not to be understood in terms of its ends, but rather in

terms of the characteristic means it employs. Hence, 'a state is a human community that (successfully) claims the monopoly of the legitimate use of physical force within a given territory' (ibid. p. 78). Citizens accept that only the state has the legitimate right to employ violence, either internally or externally. Politics is then 'striving to share power or striving to influence' (ibid.).[5]

Weber also wants to suggest, however, that politics, perhaps now politics in a broader, more authentic sense, does have a strong connection with an 'ethics of ultimate ends'.

> What calling can politics fulfil quite independently of its goals within the total ethical economy of human conduct which is, so to speak, the ethical locus where politics is at home? Here, to be sure, ultimate *Weltanschauungen* clash, world views among which in the end one has to make a choice. (ibid., p. 117)

Yet, somewhat confusingly, there is for Weber a profound gulf between an 'ethic of absolute ends' and an 'ethic of responsibility'.[6] Modern politics, the politics Weber advocates, differs from an older politics of belief in belonging to this world and not the next. A secular and moderate process of decision-making accepts the inevitability of negotiating between conflicting demands and interests, and rejects authoritarianism and the divisive, uncompromising pursuit of a single vision. It must recognise the violence of its means and the unpredictability of its results. It should soberly review the likely consequences of actions, and be prepared to own up to unanticipated or unwanted consequences. In particular, it faces up to the fact that good ends may sometimes require dubious or even wicked means. Intractable moral paradoxes constitute fundamental features of authentic political life and thus demand personal maturity in those who face them. In this way an 'ethic of ultimate ends and an ethic of responsibility are not absolute contrasts but rather supplements, which only in unison constitute a genuine man – a man who can have the "calling for politics"' (ibid., p. 127).

The ethic of responsibility is not just an attempt to rationalise Weber's preferred form of secular, democratic politics; it is also a response to the significance of science in modernity, and in particular to its silence about ultimate values, which tends to precipitate the ethical and (insofar as it is ethically determined) politics into a condition of interminable, intractable conflict. A modern political outlook is thus not confined to struggles for influence over the state but touches social theory itself. It would follow that Weber's politics of

social theory is based not only on the existence but also the recognition or acceptance of different values, ways of life, individuated projects, languages and practices, and that this recognition cannot turn for support to either science or the ethical domain of pure value. The ethics of responsibility is not so much another ethical domain but an ethical response to modernity.[7]

While Weber is, of course, famous for his emphasis on the objectivity and value freedom of social science he nevertheless does identify and respond to an important challenge for the modern theorist: the recognition of distinct value spheres, languages, and practices already embarked on the exploration and realisation of the ways in which their languages and representational practices are poetically constitutive; these are practices embarked on paths of individuation. Yet, if there is no substantive content to the ethical which can be rationally established,[8] then the domain of value becomes a battlefield, and ethics and politics are in reality warfare which only superior force can temporarily resolve; this is where charismatic authority appears of course. Therefore, the ethics of responsibility is both a particular ethical position and a more pervasive outlook, a tragic vision of modernity, a sense of ambivalence and complexity which suffuses the reflexive dimension of Weber's theorising.

Durkheim and collective representations

I have argued that elements of the classical sociological tradition – as represented in particular by aspects of Weber's work – might be read so as to expose their reflexive dimensions, that is, their sense of the problematic character and place of social–theoretical practice alongside the individuated value-spheres and languages of modernity. I now want to suggest that, in a rather different way, this kind of reflexive dimension is also present in works of Durkheim.[9]

Lukes distinguishes two distinct emphases in Durkheim's use of the notion of 'representation': the cognitive and the expressive. Through religious ideas people may gain a conception of their society, albeit in a mythological form. The function of religious ideas in traditional societies parallels, more vividly and concretely, the role of sociological ideas in modern societies; in visual, dramatic, symbolic or ritualistic representations aspects of underlying social structure are brought to life. Rituals and symbols are the outcome of an imaginative elaboration of an experience of the world which has an important social function.[10] He finds, within the expressive power of symbolism, a force that creates

and renews the social world,[11] an idea forcibly expressed in the following passage which, although drawn from a review (written with Marcel Mauss), surely comes close to Durkheim's own beliefs:

> this interpretation of religion appears, above all, to be consistent with a system of action aimed at making and perpetually remaking the soul of the collectivity and of the individual. Although it has a speculative part to play, its principal function is dynamogenic. It gives the individual the strength which enables him to surpass himself, to rise above his nature and keep it under control. The only moral forces which the individual qua individual has at his command are those issuing from individuals in association. That is why religious forces are and can only be collective forces. (Durkheim, 1975, p. 180)

In modern societies religion is compelled to cede its cognitive or speculative claims to science, but the social function once performed by religious ideas is still necessary to the health of society.[12] What is 'eternal' or socially necessary in religion is 'the cult and the faith' (Durkheim, 1971, p. 430). The contemporary or modern period is transitional between religious belief and a new, secular moral order,[13] and the tasks of constructing compelling images of the social are large and perplexing.

In *The Elementary Forms of the Religious Life* Durkheim sometimes veers towards, but seems finally to reject, a positivist religion of science. In a scientific age any new 'cult and faith' of the social will need to give reasons for assent.[14] Yet, obviously, a cult which justifies itself rationally is no longer simply cultic. Science and its demand for reasons is central to modernity, yet weak in terms of the creation of solidarity: 'faith is before all else an impetus to action, while science, no matter how far it may be pushed, always remains at a distance from this' (Durkheim, 1971, p. 431).[15]

Elsewhere, Durkheim famously provides an optimistic view of the development of modern societies towards ever closer integration; as the division of labour intensifies so too does the degree of organic solidarity. However, he also recognises historical forces that exert a countervailing influence. While, at the level of social structure, individuals within modern societies may actually be more integrated, they tend not to recognise this desirable state of affairs. They regularly fail to give enough weight and attention to their collective life. A gross individualism[16] encourages a monadic self-consciousness. Enlightenment individualism tends to deify the person as a self-sufficient entity, a reality *sui generis*. The individual becomes the object of his or her own

cult, unable to perceive or accept the reality and claims of any larger collective context.[17] The modern state – devised largely to regulate the economic and legal behaviour of individuals and of parties (alliances between individuals with similar interests) – cannot be expected to provide a new morality and symbolism. Hence, for Durkheim, the characteristic problems of contemporary societies: anomie, egotistic suicide, industrial disturbances and so forth.

Durkheim's proposal of small-scale, collective organisations capable of mediating between individuals and the society as a whole is well known. But his work might also be read in a way that brings out some curious parallels between what was for him the most primitive society then known – that of the aboriginal Australian tribes – and his own, advanced society. This is one of the places in which the reflexive tensions of his work become visible.

For much of the time Australian tribal populations are broken up into small, self-sufficient family groups which wander in search of food. Durkheim depicts this routine as largely 'economic activity... of a very mediocre intensity' (ibid., p. 215). However, from time to time this drab, secular existence is punctuated by periods during which scattered groups come together into larger tribal units. These occasions are characterised by intense, emotional involvement in rituals of various kinds, which often centre around sacred objects upon which the emblem of the clan or phratry is inscribed. The totem is the 'species of things which serves to designate the clan collectively' (ibid., p. 102), and he describes in great detail the ways in which these objects, upon which the totem is depicted, are uniquely important in Australian tribal life.

If anomic problems and gross individualism are common in modern societies, despite the development at the level of social structure of the conditions for organic solidarity, then perhaps this image of atomised, shifting, isolated social units engaged for the most part in routine economic activity and with little sense of the larger society beyond them in some ways resembles the moral difficulties of modernity? And if the totem, the sacred representation of the greater collectivity[18] does not just express the *conscience collective* but creates and sustains it, it would be reasonable to expect that Durkheim's intermediate corporate groupings would require representations capable of performing a similar social function.[19]

Durkheim is also well known for his views on an 'ethic of humanity', a secular ethic of equality and mutual respect, which the destruction of mechanical solidarity and its social exclusions makes possible. In *Suicide* this is expressed as follows:

This cult of man is something…very different from… egoistic individualism… Far from detaching individuals from society and from every aim beyond themselves, it unites them in one thought, and makes them servants of one work. For man, as thus suggested to collective affection and respect, is not the sensual, experiential individual that each one of us represented, but man in general, ideal humanity as conceived by each people at each moment of its history… So we have, not to concentrate each separate person upon himself and his own interests, but to subordinate him to the general interests of humanity. (Durkheim, 1970, pp. 336 – 7)[20]

Paradoxically then, the appearance of the modern individual who is 'detraditionalised', not defined and determined by the social groups to which he or she is attached, provides the conditions for the development of an ethic of humanity. The individual and the cultural differentiations poetically constituted by individuated languages and practices within modern societies belong to the sacred.

What, for Durkheim, is social theorising in its relationship with other languages and practices, the results and means of characteristically modern forms of individuation? If these forms are 'sacred' how can there be a social world above and beyond their diversity? The task of social theory would not just be to report on individuated subcultures, that is, on cultural practices which have forgotten or which ignore their larger context; this would be social theory in its positive or cognitive configuration. Rather, in its ethical or poetic form, social theory invokes or expresses the image of a greater and higher 'humanity'. It is performative in seeking to sustain, or even bring into being, the social as a normative claim on individuals and individuated practices, it is dedicated to cultivating the goods of humanity, the highest achievements of which human practices – within an ethics of humanity – are capable.

Thus, one important challenge for Durkheimian social theory, in its ethical and reflexive dimensions, is how to develop criteria for distinguishing legitimate individual and cultural diversity from new tribalisms and forms of gross individualism. A second challenge, connected to the first, is the development of a compelling rhetoric for the ethic of humanity. The sheer abstractness of 'humanity' runs up against the need for expressive, concrete images of the social; certainly, any image could not be a mechanically produced mirror image, it could not be an image in which a person or group directly recognised a representation of its identity. Rather, its force would be connected with its rejection or transcendence of resemblance in this sense.

Modernity, reflection, reflexion

I turn now to the question of what difference it might make to the practice of social theory for language to be treated as an historical, normative context, a source, limit and value for cognitive, ethical and aesthetic practices. Put another way, what difference would it make to social theory for language to be treated as a metaphor for the social?

I want to propose for consideration two broadly 'political' relationships between socially and culturally productive languages and practices like science, ethics, and art. Both seek to recover or reassert, against profound differences in the ways in which these languages shape their domains of experience and social worlds, a notion of the social as such. In the first, the problem is resolved by the development of a 'fourth' language which, it is anticipated, will respect and preserve irreducible differences while also persuasively demonstrating the larger social reality to which particular languages and practices belong. The second seeks mediation between languages directly, that is from within spheres of experience, value and practice, and without recourse to a fourth language.[21]

The modern development of discourses provides eventually for the possibility of self-consciousness. The distinctive ways in which languages like science, ethics, and art articulate experience come to include the possibility of reflection on the relationship between the language and its products, an awareness of how language operates, and what is made available through that operation.[22] To have a reflective understanding of a theorem in physics or a historical account is, in this context, to see the ways in which they are immanent to their parent discourses; it is to accept that the authority of their accounts is in part provided by the language and practices to which they belong.

Reflection in this sense involves the development of the language so as to provide for: first, a view of its own history, standards, achievements and boundaries; second, recognition that it articulates experience in certain characteristic ways; third, awareness that it is related to other discourses which are also capable of representing and acting in distinctive ways. This has been mentioned above[23] in terms of individuation.

The emergence of discourses in a modern form has been widely discussed in recent years, principally in terms of the development of science. The setting up of a disenchanted, objective world by subjects engaged in projects of knowledge and control exerts a powerful historical influence on the structures of human experience, and the rank order of languages and practices within the wider culture; profound

divisions appear between, for example, the natural and the human, the intellect and the emotions, facts (with which action must deal) and values (which might guide action), the real and the imaginary.[24]

I have suggested that individuation is intimately linked to totalisation. In developing its sense of identity a language must distinguish itself from other languages, it must provide accounts and images of the things which define it negatively, but to which it is still related in various ways.[25] Discourses like science, ethics, and art now come equipped with meta-discursive commentaries which seek to describe not only their distinctive features and what grounds their legitimacy, but also how they differ from other languages. A traditional tactic here, employed by Aristotle and others, was ontological; a language or practice was argued to be legitimate insofar as it was appropriate to the nature of a particular sphere of being. More recently, in the wake of Romanticism and the 'linguistic turn', it is often argued that differences between socio-cultural worlds are related to differences between the languages employed; languages are given a more constructive or constitutive role in relation to the spheres of experience and action they address.

It might seem to follow from this outlook that a language's understanding of itself and others is necessarily 'perspectival' or incomplete. Yet the requirement of completeness is itself problematic, in that it suggests the possibility or desirability of a comprehensive point of view beyond any specific language or practice. If such a position is not available, because of the historicity and socio-cultural specificity of human beings,[26] then one must return to the discourses themselves.

I have argued above that in the case of the sociology of art – treating this as an example of how a discourse producing knowledge-based accounts operates on another discourse – leading theorists of different ideological and methodological persuasions operate in broadly similar ways. First, they demolish members' everyday opinions and understandings; second, they attack rival knowledge-based explanations and accounts, particularly insofar as these are influential among members or in important sectors of public opinion; third, they construct an order of forces, pressures, causalities and norms which social theory is uniquely able to understand, and within which the local phenomena of art worlds – including widespread members' beliefs – can be either explained causally or condemned (or occasionally validated) on moral or political grounds. This has been described above as reductive and totalising.

I am not suggesting that sociological accounts can proceed in a substantially different way; this is indeed a central point. Nor is it that they are somehow sociologically mistaken *because* this is how they

proceed, although of course they may be wrong in lots of others ways: about facts, in their reasoning and so on. I am suggesting, however, that awareness of these features of sociological practice may precipitate a change in self-understanding, and that it might then be reasonable to speak of a shift from *reflection* to *reflexion*. By the reflexive turn[27] I mean a deepening awareness that theories and their products are always socially determinate in three ways: first, they belong to a specific language practice; second, the specific ways in which they are shaped historically and culturally always transcends current capacity for theoretical reflection; third, they constitute a specific political or ethical relationship with other languages and their constructions. Put slightly differently, it is a sign of a reflexive dimension in a discourse when it recognises that its accounts are inevitably both illuminating and projective, both revealing and reductive, explanatory but also in need of explanation.

Some of these ideas can be usefully discussed in the context of the works of two somewhat unlikely bedfellows: Michael Oakeshott and Jean-Francois Lyotard. Despite dramatic differences in many areas, both share a lively sense of the importance and challenge of different major socio-cultural forms and practices – in particular science, ethics or politics, and art – and both raise questions about the politics of these languages and the character of theoretical language itself.

Oakeshott and the conversation of mankind

Oakeshott's defence of poetry [28] recommends participation in what he calls the 'conversation of mankind'. Throughout history the archetypal characters have been the scientist, the practical man, and the artist. While an individual might occupy more than one of these roles, shifting from the perspectives and values of one to those of another as contexts change, each character speaks from and for a distinct and irreducible form of 'imagining'. By 'imagining' Oakeshott means the fundamental activity of the individual mind: 'making and recognizing images, and moving about amongst them in manners appropriate to their characters and with various degrees of aptitude' (Oakeshott, 1962, p. 204), Scientific imagining (or language) shapes what we have come to think of as genuine knowledge, while practical speech and activity, characterised by desire and aversion, aims to maximise pleasure and avoid pain. Artistic imagining is nothing to do with either pure or applied knowledge, or physical gratification, but is rather a 'contemplating' of, or 'delighting' in, images for their own sake. As to the relationship between them:

> Every mode of imagining is an activity in partnership with images of a specific character which cannot appear in any other universe of discourse; that is, each mode begins and ends within itself. Consequently, it is an error... to speak of a manner of imagining as the 'conversion', or 'transformation', or 'reconstruction' either of a supposed unspecified image or of an image belonging to a different universe of discourse. An unspecified image is only another name for a nonentity; and the images of one universe of discourse are not available (even as raw materials) to a different mode of imagining. (ibid., p. 222)

This passage clearly states Oakeshott's view of the incommensurability of the worlds articulated by different discourses, and the dependence of their characteristic and unique phenomena upon the specific use of language associated with them.

Oakeshott provides a description, almost a phenomenology, of aesthetic experience. For 'contemplation', images are just images; they have no descriptive or prescriptive relationship with any reality beyond them, either real or ideal. They are 'merely present', that is, the question of their origins or conditions – psychological, historical or social – is unimportant. Contemplation is disinterested; the image is an object neither of aversion nor desire. Nor is contemplation goal-directed. It occurs when an image *qua* image 'becomes the focus of attention and the nucleus of an activity in which it is allowed to proliferate, to call up other images and be joined with them and to take its place in a more extended composition' (ibid., p. 221). Movement within this 'labyrinth of images' is thus 'playful... free from care and released from both logical necessity and pragmatic requirement' (ibid.).

However, the relationship between the discourses corresponding to science, practice and art – the 'conversation of mankind' – has, of late, become unbalanced:

> In recent centuries the conversation, both public and within ourselves, has become boring because it has been engrossed by two voices, the voice of practical activity and the voice of 'science': to know and to contrive are our pre-eminent occupations. (ibid., p. 202)

Given the force and extent of this ill-mannered monopoly, it is difficult to see how art gets a word in edgeways at all. Certainly, it cannot contribute to the determination of natural or historical facts; nor can it contribute much to calculations of utility. Unlike both science and pragmatic practice, art's language is not 'symbolic'; its images are purely self-referential. This not only sets the language of art

aside from the ways in which science and practice communicate, but also seems further to reinforce art's irrelevance to life.

For Oakeshott, art has the chance of a hearing only insofar as practical man is capable of seeing that there are aspects of life that are not wholly practical, for example friendship, love, spontaneous moral goodness, fond recollections of childhood. These experiences may be sufficient to awaken a taste for the impractical dreaming characteristic of art. The place of art within life is not, for Oakeshott, upon some commanding vantage point, from which it confers direction and wholeness. It is certainly possible to imagine a life lived without it. To have developed a taste for art is to be able to enjoy a brief moment of respite from an 'endless struggle' for 'illusory ends', and also, perhaps, to ameliorate the brutishness of everyday practice by discerning its limits.

Beyond this, however, in a moment that recalls some of Rorty's concerns, art can be seen as an image of conversation as such. The conversation of mankind is clearly an ideal for Oakeshott. The interplay between reason, desire and the poetic does not of itself serve the ends of science, practice or art. Rather, it constitutes an image of a civilised, cultured human being and of the life lived with others which he or she would wish to lead. Artistic images coexist happily and, like art, conversation does not drive towards a conclusion; in authentic, civilised conversations, speakers do not strive to eliminate or silence one another. The language of art is not a mere means to the ends of science or practice but an image of the whole: the conversation of mankind. Language, here, is not an instrument but rather a 'non-labourious activity' without external ends, allowing or encouraging an increase in the complexity and richness of the human world.

In Oakeshott may be seen some of the consequences for the understanding of art following changes in the relationships between discourses initiated by the Enlightenment. In a generally Kantian manner, art is not seen as primarily about the objective world, over which science has decisively established its rights. Neither is it properly associated with technical or instrumental problems. Rather, its very pointlessness, the weightless complexity of its language, invokes dimensions of experience which may soften and cultivate, but probably only at the margins and for the few, modernity's increasingly barbaric obsession with control, power and gratification.[29] Yet the marginality of art cannot be denied; modernity is seen as irresistible, and there is little sense in Oakeshott of how the margin might become socially significant. Art is preserved by withdrawing itself from a contest with science and practice which it can only lose, but its worldly

ineffectuality is thereby confirmed. There no indication of how resistance, or a politics of languages, might be either necessary or possible, or of the problems and paradoxes this would involve. Resignation and nostalgia pervade Oakeshott's essay; this kind of conservatism – unlike the crusading moralism of Leavis for example – does not seek or anticipate many victories against the Philistines on behalf of art and culture. The possibilities for an alternative to reduction and totalisation remain unexplored, and a refined but enervated nostalgia fills the vacuum thus created.

'What does language want of me?': Lyotard, legitimisation and postmodernity

In the work of Jean-Francois Lyotard can be found a rethinking of the relationship between the prominent public discourses of modernity. He is particularly concerned with the shifting configuration formed between science, technology, politics, art and philosophy. Indeed, 'the postmodern condition' is famously defined as 'the state of our culture following the transformations which, since the end of the nineteenth century, have altered the game rules for science, literature and the arts' (Lyotard, 1984b, p. xxiii).

The metaphor of the game is of particular importance to Lyotard. Drawing on a reading of Wittgenstein, he sees languages as self-contained and internally organised ways of speaking with which individuals must learn and engage if they are to make sense of the world and express themselves intelligibly. The raw materials, the constituent elements, of a modern society at a cultural level are a plurality of incommensurable language games. Language games are incommensurable in the sense that they are only coherent from within; specific realities can only be approached through the games which constitute them. For Lyotard, there can be no 'language-less' mode of cognition, expression or practice, nor any universal meta-language allowing different games and their worlds to be understood and evaluated against one another.

Different types of society can be understood as different configurations of language games. It was not until the advent of the game called science – the moment at which modernity appears, at least as a philosophical possibility – that societies were able and required to confront the question of their own social character. The capacity of societies to enquire into their own character emerged along with their capacity to act consciously upon themselves, that is, to use technical and political power to achieve articulated social goals.

Lyotard argues that, in the traditional narratives of pre-modern societies, a given pattern of social relations is immediately specified. In dispensing with the traditional narrative form, science releases a subject, an object and the problematic relations between them carried by denotative statements requiring legitimisation. The new social bond – scientific consensus – is the goal of discourse, and not its condition. The nature of scientific discourse is such that it cannot avoid, whatever the sentiments of individual scientists, rejecting the claims of all other discourses to speak the truth. This 'unequal relationship [between discourses]… is the entire history of cultural imperialism from the dawn of Western civilization' (ibid., p. 27).

The power for action is intimately linked to the possibility of knowledge. If it could not regard itself as an object among other objects, the modern subject could neither know nor act upon itself and its environment. The question of legitimacy arises because traditional reproduction of social identities and bonds has been shattered; detraditionalised moderns do not know immediately who is speaking, who is being addressed, or why the speaker has the right to speak in the way he or she does. Hence, the roles and procedures of the game of knowledge must be established by or within the game. As they are not given, identities must be constructed and justified.

Lyotard seems happy for science to legitimate itself, and indeed for all games to enjoy this privilege. 'Delegitimisation' – the hallmark of the postmodern period – refers to an increasingly widespread acceptance of the view that any attempt to ground the plurality of discourses in some larger meta-discourse is doomed to be fruitless or totalitarian or both. Postmodernity is essentially a crisis of those great narratives by which science, politics and philosophy have sought, in different ways, but always imperialistically, a legitimisation both for themselves and for the kinds of relationship they chose to enjoy with other games. In particular, the dominant nineteenth-century narratives – speculative idealism, ontologies, philosophies or sciences of history, emancipatory humanist politics – have shown themselves to be, variously, tedious, incredible or horrifying. The fading appeal of these once popular fables need not, however, cause despondency. Lyotard believes he can discern even within contemporary science – once the heartland of positivist modernity – an irresistible 'search for instabilities', a drive for new moves and new games, which he calls 'parology'. Postmodern science thus begins to catch up with twentieth-century avant-garde art in its relentless destruction and reinvention of the game, or games, of art.

This is an important point for Lyotard, because he needs the authority of science to stand up against the negative side of postmodernity, which he calls 'legitimisation by performativity'. The vacuum left by the withering away of the old grand narratives is increasingly filled not by the aesthetic gaming, the 'general agonistics' he approves of, but by a vulgarised will-to-efficiency; every move and every game is to be judged by the universal criterion of its contribution to the accumulation of power:

> This is how legitimisation by power takes shape. Power is not only good performativity, but also effective verification and good verdicts. It legitimates science and law on the basis of their efficiency, and legitimates this efficiency on the basis of science and law. (ibid., p. 47)

Against this stands the 'open system' of science, the main goal of which is to generate new ideas.

> Science possesses no general metalanguage in which all other languages can be transcribed or evaluated. This is what prevents its identification with the system and, all things considered, with terror. (ibid., p. 64)

In this way, authentic art and science are seen as distinctive games or practices. Both are decisively postmodern insofar as they seek neither a legitimisation beyond themselves nor to legitimise (or delegitimise) others. Given this position, the central question is that of the social bond, the political relationship between discourses. Within the postmodern political context, art and science stand together for a new openness, a new vigour, a new responsibility; they stand against a new, systematic, totalising (and perhaps totalitarian) imperialism – the unshackled discourse of power.

In *Just Gaming* (1985) Lyotard and Thébaud focus on the problems of discursive politics directly. There can be no discourse of discourses in the sense of a rational, legislative ethics or political science: 'One cannot put oneself in a position of holding a discourse on the society; there are contingencies; the social web is made up of a multitude of encounters between interlocutors caught up in different pragmatics' (Lyotard and Thébaud, 1985, p. 73). As the Sophists and Aristotle understood, judgement here can only be case by case. However, to shed the possibility of knowledge of the political, to resist the invasion of prescriptive discourse by denotative discourse, seems likely to produce a new tyranny – the rule of opinion. A conventionalism that equates justice with whatever happens to be the consensus on justice

would not allow us to condemn even the most palpable evil, for example Nazism. This leads Lyotard to a consideration of a Kantian Idea of justice. By 'Idea' Lyotard means 'a reflective use of judgement, that is, a maximisation of concepts outside of any knowledge of reality' (ibid., p. 75). For Kant

> an idea signifies a concept of reason, and an ideal the representation of an individual existence as adequate to an idea. Hence this archetype of taste – which rests, indeed, upon reason's indeterminate idea of a maximum, but is not, however, capable of being represented by means of concepts, but is only an individual presentation – may more appropriately be called the ideal of the beautiful. (Kant, 1928, p. 76)

At issue here is the reflective use of judgement, that is, acts of judgement where only the particular is given and the universal must be found. The use of this notion in Kant's work is notoriously complex and difficult.[30] Lyotard's employment is somewhat clearer. Politics, here the relationships between languages, would be regulated by the idea of justice. For Kant, the idea of justice is linked to that of a totality of reasonable beings, of a free society encompassing all of humanity. Particular ethical or political acts would be judged by their compatibility with this totality. According to Lyotard, this idea of justice refers not to what has been established or is fixed by opinion but to what might be achieved, to possibility not actuality. A particular prescription is not to be judged against established opinion; rather, 'it is weighed from a capacity that exceeds it and that can be in a wholly paradoxical position with respect to the data of custom' (Lyotard and Thébaud, 1985, p. 82). However, Lyotard believes that Kant's idea of a society of reasonable beings is in fact the notion of a totality, a plurality tyrannically ruled by one language, re-shaped as a single order. Kant's writings on politics and history show that the association of justice with finality implies that underlying history and human affairs in general is a movement from multiplicity and division towards convergence and unity.[31] In the last analysis, it does not matter if this movement is not expected ever to reach a conclusion, a state of 'perpetual peace'; even as asymptotic it remains regulation by means of totality.

For Lyotard, postmodern politics can only be regulated by the idea of diversity. Political proposals and acts are to be judged according to their compatibility with the idea of multiplicity. Yet the defence of multiplicity may disguise yet another version of totality, and 'one should be on one's guard... against the totalitarian character of the idea

of justice, even a pluralistic one' (ibid., p. 96). The problem seems to lie with the 'impurity' of language games; if one remains within the character, the logic, of non-prescriptive discourses the appearance within them of the idea of justice should not intrude. Or rather, and more paradoxically, the idea of justice should regulate discourses to exclude questions of justice from non-prescriptive discourses.

> It is by means of plurality that it regulates them; it says, 'Careful! There is *pléonexia* here, there is excess, there is abuse.' The person holding this discourse of knowledge, or the person playing this narrative game, is exceeding the authority granted to him or her by the rules of the game and is not abiding by the pragmatics 'proper' to the game played... But the Idea of justice resides precisely in keeping prescription in its 'proper' order, just as it does in keeping narration and description in the order that is respectively 'proper' to them. (ibid., p. 97)

This idea of justice as multiplicity derives from the view that postmodernity amounts to the revelation of the multiplicity of language itself. Language provides for the different language games that articulate the manifoldness, the complexity, the richness of our worlds. To acknowledge, to respect language is to abide by the diversity of its gifts. It would be disrespectful, hubristic or unwise to attempt a universal legislation, a body of law, for the regulation of discourses. As Thébaud puts it:

> language cannot be mastered. It is something that I do not manipulate; in a way it comes to me from elsewhere... I have the impression that their [the Hassidim] question is always: what does language want of me? (ibid., p. 98)

There are then many kinds of justice, each provided for by the rules of particular games. Within every game the idea of justice is an injunction to extend, enliven, enrich the world the game brings into being. But this creative, paralogical 'violence of the imagination' does not extend to the rules of the game within which it is exercised, nor to other games.

> The idea of justice as multiplicity prescribes the observance of the singular justice of each game such as it has just been situated: formalism of the rules and imagination in the moves. It authorises the 'violence' that accompanies the work of the imagination. It prohibits terror, that is, the blackmail of death toward one's partners. (ibid., p. 100)

As Sam Weber points out in his Afterword to *Just Gaming*, this position is not without its paradoxes. If justice is the self-imposed

restriction of games to their own particular spheres, and respect for the constitutive rules which provide for their particularity, this is precisely a universal prescription, and one which is absolute because it is seen as not belonging to any particular game.

Crucial here is the relationship between discourses and language. If there is a radical difference between language as such and particular language games it is difficult to see how a politics of languages could be possible. Ethical or political speech must be determinate, capable of specifying what is to be done, what may be done, and what may not. But if it is determinate then it belongs to a language game and not to language as such. Language, in this sense, cannot regulate relationships between discourses; it does not provide for a 'body' of law. Heidegger's turn away from a positive project of fundamental ontology towards an elliptical, poetic invocation of the otherness of Being, the inaccessibility of language, is entirely consistent with this view; fatally, however, it threatens to consign the politics of languages into either the mutual indifference of sub-cultural practices or a 'general agonistics' within which speakers contest, not within a framework of rules, but over what game is to be played by all, a situation indistinguishable from total war.

As reformulated in line with Lyotard's views, social theory would attempt to avoid expropriating violence, and to live within its proper limits, yet poetically to multiply ideas and images of the social. It would recognise its constitutive power and its legitimate interest in individuation, but also its tendency towards totalisation. Yet social theory must also, because of the very nature of its subject matter, represent and place particular phenomena within a larger social context, a social totality that 'hangs together' in some way. At this point it faces unique problems as a discourse; given its task of accounting for the social *per se* it inevitably traffics in reduction, expropriation and totalisation.

An alternative would be to abandon the question of the social *per se*, perhaps in favour of modest contributions to the solution of problems designated by governments and other agencies with an interest in expert help (and with the funds to pay for it) or, on the other hand, to become engrossed in sub-cultural hermeneutics and politics. While understandable, both responses abandon the challenge of classical sociology. The resultant postmodern mood, which sets in after the exuberance induced by the new paralogical freedom from controlling metaphysical narratives and traditional serious questions has waned, is likely to be one of irony and ambivalence or, more negatively, indifference and cynicism.

To summarise, in Romanticism and in the works of Oakeshott and Weber, there is explicit debate about the place of art in human life as a whole. Both Oakeshott and Weber accept the growing historical dominance of science and rationalising, practical activity but also affirm, albeit in different ways, a significant role for art. For Oakeshott, art is a respite from the rigors of practical existence on the one hand and the abstractions of science on the other.[32] For Weber, however, art, along with the erotic, comes to stand for, collects together and articulates, aspects of human experience irrelevant to or disruptive of the fateful project of rationalisation and disenchantment.[33]

I have also argued that, beyond what Oakeshott and Weber actually say directly about the place of art in modernity, there are ways in which the nature and functions of art are very significant for their work. That is, art seems to play a more important role in their ideas than they allow for explicitly. Thus, for the former, the experience of art may keep alive the whole idea of conversation; although only a weak force when compared with the power of practice and science – and many would find Oakeshott's sharp distinction between the two unconvincing – it is the very pragmatic pointlessness and inwardness of art, combined with its emotional poignancy, that stands in the way of an uncivilised homogenisation of life by knowledge and instrumental practice. For Weber, surely influenced at this point by Nietzsche, the impossibility of rational choice between contradictory or competing values makes this inevitable decision a matter of aesthetic judgement. The 'inaccessibility of appeal from aesthetic judgements' places the issue at the very margins of Weber's social philosophy, at a point close to which coherent, useful, rational theorising is impossible. Nevertheless, the significance of this limit for rationality is important, and marks a transition to value-politics proper.

The question of the political mediation of the relationship of languages, in particular between science and ethics, has been raised in relation to Weber, and extended towards that between discourses and language as such in relation to works by Lyotard. Weber's illuminating troubles with an ethics of responsibility result in what is, at one level, a particular ethical position, but a position which is also driven towards a tragic vision of modern sociality; at this point can be glimpsed a genuinely reflexive dimension of Weber's theorising. For Lyotard, the idea of multiplicity guides a concept of justice, which might be capable of guiding or regulating the relationships between the array of incommensurable differences released and articulated by language games. It is language as such that provides for this multiplicity, and to

preserve it is to recognise and respect the unspeakable, unfathomable transcendence of language. Language is not to be 'manipulated', it comes 'from elsewhere'. The question is always 'What does language want of me?' Yet the perplexities and difficulties of this position, and in particular of the indeterminacy (or formalism) of these notions of multiplicity and language, suggest the need for another approach.

Chapter 8

Hermeneutics, Aesthetics and Art:
Gadamer and Modernism

Gadamer has written extensively on the problems facing cultural practices like art, science, and ethics in the context of a particular relationship between them which includes, as one of its most important features, a drive towards scientific knowledge and technical control. For Gadamer, Kant's differentiation of aesthetic from moral and cognitive experience grants art a domain of its own within which it may develop its intrinsic possibilities, but also makes the participation of art, together with science and ethics, in a larger human culture highly problematic. As Lyotard might put it, once modernity replaces tradition, the idea of a *polis*, a city, of a whole society becomes an abstraction or, at best, a problematic ideal.

In the first third of *Truth and Method* Gadamer explores some implications for our understanding of art which flow from this position. He is specifically concerned with the impact of the work of Kant on experience of and thought about art.[1] Also, in this part of *Truth and Method*, Gadamer sets against what he considers to be an aesthetics dominated by subjectivism a view of art which rests upon a particular approach to language. Hence, via the work of Gadamer, a view of the relationship between art and language, which began to emerge in the discussion of Oakeshott and Lyotard above, may be developed.

Gadamer's approach to the relationship between particular language practices and language itself is, of course, closely related to the philosophy of his teacher, Heidegger. Both raise the question of the particular kind of truth which belongs to art as a language of a specific kind. To separate art from truth is, for Gadamer, to consign it to a subjectivist aesthetics and thereby necessarily to diminish and devalue it. The inability of traditional aesthetics to raise the question of the truth

of art is discussed below in the context of what Gadamer calls 'aesthetic differentiation'.

Given my concerns here, there are two principal questions for Gadamer's hermeneutics: is this view sensitive to the character, achievements and value of art?,[2] and what are its implications for the politics of languages?; that is, can thinking about a politics of discourses – within an ethically reflexive social theory of cultural forms and practices, one aware of the social poetics of its own practice – be guided by an ontology of language? These questions may be briefly recapitulated using Lyotard's terminology. For Lyotard's postmodern theorist, it would be modern to believe that art has been overcome by philosophy or science, that art is an arbitrary activity, or perhaps one whose self-consciousness is undeveloped in certain ways, but about which philosophy or science tells the truth. Against this, it would be postmodern to see all these discourses as forms of play, as games. Following Nietzsche and Weber, questions about choices between games, or about their relationships, become 'playful' or 'aesthetic'. Thus, the way in which we understand play – perhaps by treating art as a paradigm of serious agonistics – becomes crucial to a deeper understanding of major cultural forms and possibilities. An inadequate or reduced sense of art may then have serious consequences for any understanding of these issues.

For Heidegger and Gadamer, what gives rise to modernity's distinctive articulations of human life and experience by specific language practices, into such things as scientific evidence, ethical and legal rules, notions of right conduct, beautiful works of art and so forth, is language. From this point of view, these discourses and their cultural spheres are parts of a life together in language, although, of course, what 'together' might mean is initially far from clear. Ideally, recognition of language would enable us to understand the possibility of a positive, enriching, humane social relationship of discourses, that is, of a wider culture, capable of making claims on the self-understanding and practices of these constituent languages. Crucial here, is what Gadamer sees as the continuity of human understanding. Understanding cannot or should not rest with the 'fact' of incommensurable discourses, nor with relativism, indifference and cynicism about the question of the social itself, but must press on to what this problematic situation means more widely. For Heidegger, the challenge for thought *contra* modernity is to remember that language in this sense has been forgotten. We can examine what this means for Gadamer by following his arguments about the ways in which contemporary thought confronts art and history.

The distinctiveness of art: play

Gadamer's discussion of art does not belong to conventional social theory or aesthetics. It is a phenomenology or hermeneutical ontology of art. Leaving to one side questions of the exact nature and status of such accounts, of interest here is Gadamer's sustained attempt to interpret the distinctiveness of art.[3] He begins this effort with a discussion of the relationship between art and play. Play is removed from means–ends rationality, a pervasive feature of everyday life. It involves a 'to and fro movement', but does not have a practical aim beyond the playing of the game itself.[4] However, reason of a kind is involved; for play to occur rules, procedures and aims are determined which constitute the particular 'game'. This is a 'non-purposive rationality'; the play is in this way not thoughtless but intended. One cannot play fully without attending to the hermeneutical identity of the game. Play is thus 'the self-representation of its own movement' (Gadamer, 1986, p. 23), a 'pure autonomous regulation of movement' (ibid., p. 24) which comes close to communication. It is not a great step to art, in particular to drama, theatre, spectacle – play which becomes 'representing for someone'. In being meant for others the closed world of play opens itself up. A religious rite or a drama does not just represent contingently but refers essentially to an audience.

In art 'play finds its perfection'. In this 'transformation into structure' art comes to stand autonomously of particular players and even of the artist. It requires participation, and in order to participate individuals must submit to the rules and aims of the game, they must temporarily suspend their own desires or place their subjectivity under the greater demands of the game. In this context, neither the players nor the author count for anything except insofar as they belong to the play. Neither does the world outside the play matter at this point; the world of the play is coherent and self-sufficient. Thus:

> The transformation [*Werwandlung*] is a transformation into the true... In the representation of play, what emerges. In it is produced and brought to light what otherwise is constantly hidden and withdrawn. If someone knows how to perceive the comedy and tragedy of life, he is able to resist the suggestiveness of purposes which conceal the game that is played with us. (Gadamer, 1975, p. 101)

In much modern art there have been strenuous efforts to break down the difference between the work and the spectator; the spectator is transformed into a participant, someone who is encouraged to take up

an active or playful relationship with the work.[5] For Gadamer, this need not be, indeed in the successful work cannot be, at the expense of the hermeneutical identity of the work; the work is not just an empty space to be filled in at whim by the participant. The spectator does not become an artist. The hermeneutical identity, the meaning of the piece, is retained or asserts itself but in such a way that it is as if a question were posed to which the audience must respond, if they are to experience the work authentically. The elements of the work must be brought together in an act of synthesis. 'We "read" a picture... like a text. We start to decipher a picture like a text' (Gadamer, 1986, p. 27). This 'reading' is not just taking in one word after another but 'performing a constant hermeneutical movement guided by the anticipation of the whole, and finally fulfilled by the individual in the realization of the total sense' (ibid., p. 28). Crucial here, certainly with works of visual art, is the 'autonomous significance of the perceptual content'. Perception is no longer in its pragmatic context of everyday life where meanings and signs relate to action, information, the resolution of practical problems but stands in its own significance. On the other hand, Gadamer wishes to avoid a formalist identification of the aesthetic with the isolated perceptual core of the experience of the work. This abstraction from the unity within the piece of perceptual characteristics with meaning[6] is for Gadamer absolutely characteristic of modern aesthetics; it is part of what he calls 'aesthetic differentiation' (*äesthetische Unterscheidung*).

Aesthetic differentiation

The effort to isolate, within the work of art, a purely aesthetic core is a process of abstraction.

> By disregarding everything in which a work is rooted (its original context of life, and the religious or secular function which gave it its significance), it becomes visible as the 'pure work of art' [*reine Kunstwerk*]... It [aesthetic consciousness] distinguishes the aesthetic quality of a work from all elements of content which induce us to take an attitude towards it, moral or religious, and presents it solely by itself in its aesthetic being. (Gadamer, 1975, pp. 76–7)

In this way, aesthetic consciousness is indefinite, in contrast with an ideal of taste; it will embrace anything in which it finds 'aesthetic quality'. Through aesthetic consciousness, artefacts are removed from their world. In a related way, artists lose their place also. While the free,

creative artist claims to produce works of pure aesthetic value, the wider society demands more than just the 'standpoint of art'. In the face of what we have seen Durkheim discuss in terms of gross individualism and anomic social dispersion, the artist is looked to for new images of social unity, and a certain cult of art appears. 'The experimental search for new symbols or a new myth which will unite everyone may certainly create a public and create a community, but since every artist finds his own community, the particularity of this community-creating merely testifies to the disintegration that is taking place' (ibid., p. 79). Aesthetic culture is, in one respect, universal; it is, in its universality, paradoxically full of individual content and also socially problematic. The formalism of aesthetics ultimately disappoints the promise of organic solidarity at the cultural level, of images and artefacts that connect individuality and multiplicity with cohesiveness, interdependence and conversation. When translated into the fields of ethics and politics, via theories that legitimise this form of the aesthetic, a critique of traditional values based on ideas of unfettered play begins to engender a wider cynicism and indifference, once infatuation with the abstraction of 'pure movement' and relentless deconstruction cools.[7]

Aesthetic differentiation is an attempt to isolate pure aesthetic content from the dimension of meaning that also belongs to the work. But, for Gadamer, the dimension of meaning is inescapable. Even supposedly wholly abstract or formal works do not escape it. 'Pure seeing and pure hearing are dogmatic abstractions which artificially and harmfully reduce complex phenomena. Perception always includes meaning' (ibid., p. 82). Even when works of art are seen to possess a hermeneutical identity of a different kind from linguistic meaning, from the word and its dominant cultural practices, they do not escape meaning; this distance, this fugitive quality, is indeed part of their specific meaning.[8]

For Gadamer, aesthetics cannot rest content with its purity. It must connect these discontinuities with other kinds of meaning back into the wholeness of human life and experience. In order to be preserved, the aesthetic must transcend itself by realising what its impossible purity means.[9] What is distinctive of art in the modern period, insofar as aesthetics in Gadamer's sense constitutes its self-understanding, is abstraction at two levels: from a socio-cultural location and of perception or pure form from meaning. The task is not so much to deny these phenomena but to understand them in the context of the continuity of human understanding as whole, not as the work or task of the human subject or of *Geist*, but as the radical challenge and grant of language as

such. In relating distinctive languages and practices (like art and aesthetics) back to language as whole, the task and scope of hermeneutics is universal:

> Every work of art, not only literature, must be understood like any other text that requires understanding, and this kind of understanding has to be acquired. This gives to hermeneutical consciousness a comprehensive breadth that surpasses even that of the aesthetic consciousness. Aesthetics has to be absorbed into hermeneutics... Conversely, hermeneutics must be so determined as a whole that it does justice to the experience of art. (ibid., p. 146)

So, hermeneutics responds to aesthetics and the multiplicity of languages in general by recalling their relationship to language. However, hermeneutics must avoid a reintegration on the 'ground' of language, that is the 'recapturing' of individuated languages and practices by and in a meta-theory of language, an objectifying or metaphysical discourse which would inevitably violate the freedom of languages to speak for themselves,[10] and would make language itself into either another objectified resource at the disposal of subjects[11] or a force or condition which has to be dealt with. The reflexive ramifications of this approach will be considered in more detail below.

The picture

Gadamer extends his critique of aesthetics to a discussion of the modern phenomenon of 'the picture', which is, in his view, the archetype of the modern work of art, at least from the point of view of aesthetics. The best known form of the modern picture is the framed painting. Detachable from any particular context in life the picture is another aspect of aesthetic differentiation. Modern galleries and museums tend to exhibit their collections as if they consisted exclusively of pictures, objects for individual aesthetic experience. Gadamer inquires into what he calls the 'mode of being of the picture'. He calls the mode of being of the work of art as such *representation*.

What does this mean in relation to the picture? Is the picture, as representation, a copy? If the picture is a representation but not a copy what is its relationship with an original? The purpose of the copy is to resemble the original; it has fulfilled its function when the original is recognised, and thus the successful copy cancels itself out. Its purpose is to point away from itself towards something else, and in so pointing it disappears. The ideal copy would be like a mirror image, which exists

only by virtue of the object mirrored. But there is a difference. The copy refers to an original and does not purport to provide us with the exact visual appearance of the thing itself; neither is its existence tied to the presence of the thing represented. The picture, as distinct from the copy, does not exhaust itself in pointing.

> Here the picture itself is what is meant, in that the important thing is how what is represented in it is represented [*Dargestellte*]. This means first of all that one is not simply directed away from it to what is represented. (ibid., p. 123)

The picture differs from the copy, in that the image matters in itself, and from the mirror image, in that the image is separable from the physical presence of the original. This stress on the importance of the picture itself is not the same as the stress upon discrete formal qualities associated with modern aesthetics. The 'how' of representation, the particular ways in which the picture is organised, is not to be seen as essentially separable from the representation; it is, rather, the very way in which the original comes to appear, comes to be. In Gadamer's words 'the picture affirms its own being in order to let what is depicted exist' (ibid., p. 124). This unity of form with content in the work of art belongs to what Gadamer calls 'aesthetic non-differentiation'.

The representation of something in a work of art is an 'ontological event',[12] an 'emanation' of the original. 'Emanation' can be understood here in the Neoplatonic sense of an outflow that does not diminish its source, and which is therefore equivalent to an increase in or amplification of being. This leads us to the question of artistic truth.

The work of art and truth

Gadamer insists, against contemporary aesthetics, that 'art is knowledge and the experience of the work of art is a sharing of this knowledge' (ibid., p. 87). But here mimesis, the idea of representational truth, is not 'copying' but a presenting which also originates. It suggests that something is brought into truth.[13] What is experienced in everyday life is not 'true' in this sense; even conventionally representational works of art do not copy an original, which then constitutes their truth or significance. The actual objects used by Cézanne in his still lives or the real landscapes painted by Turner are wholly irrelevant to the artistic core of their works. As Gadamer says, 'aesthetic experience cannot, by its nature, be disappointed by some more genuine experience of reality' (ibid., p. 75). It would be wholly inappropriate to submit the work of

art to a comparison with what it represents; this naturalistic view of mimesis as copying is entirely misleading. Rather, the art work presents or opens up a world which possesses a compelling, illuminated reality distinct from what we experience in everyday life.

In art 'we see how things are', we recognise something for what it is: 'From this viewpoint "reality" is defined as what is untransformed, and art as the raising up of this reality into its truth' (ibid., p. 102). The element of knowledge in art is this moment of profound recognition, in which we do not see again the familiar, but rather grasp fully and completely what we already know, yet only roughly or in outline. Put another way, in the work of art the feeling or spirit of something lived through or encountered is concentrated and expressed.[14]

Like Heidegger, Gadamer wants to distance himself and his view of art from the problems associated with a constructing or receptive subject. Hence the stress on the 'event' of truth and the idea of a theorising that entails, like play, a distance from subjective concerns and aims, a certain responsiveness in which one is 'totally involved in and carried away by what one sees' (ibid., p. 111). Being a spectator of a work of art is sharing in the presence of something. The work is 'timeless', it touches feelings and ideas directly, despite cultural and historical distance, because it gives access to a complete circle of meaning capable of providing a sense of the connection and value of the disparate experiences of life. Gadamer considers this distance between the spectator and the subject to be necessary for a proper sharing in what is represented.

> Thus to the ecstatic self-forgetfulness of the spectator there corresponds his continuity with himself... It is the truth of his own world, the religious and moral world in which he lives, which presents itself to him and in which he recognizes himself. (ibid., p. 113)

This estrangement from subjective singularity, simultaneously an elevation to a universal, is of the kind Gadamer discusses in relation to Hegel; in Hegelian aesthetics the multiplicity and, in the last analysis, the nihilistic vacuity of subjectivist interpretation is replaced by a vision of art as the embodiment of *Geist*, a world-view or 'moral world order'. The work of art enables the spectator to recover the ethical reality of the social and historical world he or she inhabits.[15] By what some would consider curious and circuitous routes Gadamer thus returns to the relation between art and society, but instead of presenting art as an epiphenomenon of social being, as resulting from, contributing to (or even disrupting) some particular social order, or as a preliminary form

of the self-disclosure of *Geist*, it is seen as a fundamental and unique disclosure of the human world.

Hermeneutics and contemporary art

In the discussion outlined above Gadamer says many useful and important things about aspects of art which traditional philosophical aesthetics,[16] and more recent sociological approaches, usually neglect. These issues are, in the context of the questions considered here, preliminaries or pointers to a reflexive dimension for a social theory of art.

First, the peculiar constructive or participatory, but not in the last analysis creative, relationship the spectator has with the work of art. Focusing not on a set of objects or an attitude, art is seen to require an active relationship with the object in which its hermeneutical identity, its meaning, is displayed. However, the occasion for this construction is not an empty space or a silence. The work speaks, but in its own way, and an effort must be made to hear it. While much recent art demands this kind of constructive relationship it is now, in the modern period as a whole, an unavoidable feature of our approach to older, traditional works.

Second, the peculiar relationship that modern works of art have with their tradition. Modern art has, from its origins in the nineteenth century, obeyed an imperative to innovate, to 'begin again', to individuate itself, yet in such a way that its best exponents have found new and deeper connections with the historical traditions of their practice. By rejecting conventions, and often the very idea of a tradition (as something 'handed down'), a more authentic tradition has sometimes been discovered.[17] Yet, while criticism and the rejection of conventions are necessary in the modern period, they are not sufficient conditions for artistic quality.

Third, the relationship between art and play, movement and rule. Gadamer is also right to remind us that while art may usefully be treated as an activity it is nevertheless quite specific when seen from the point of view of everyday life. The intentionality, the deliberation, skills and discipline it requires, the imperative to mean in a certain way, all distinguish it absolutely from the simple 'to and fro' of play. Yet its intentionality must also maintain its distance from concepts and abstract specifications of what a work of art is like. Its rules can spring only from the demands of an artistic vision as embodied in the work, certainly not from aesthetic, ethical or sociological theories.[18]

Fourth, and related to the point above, the problem of art and judgement. Judgements of the quality of a particular work or an

approach to practice cannot be made by comparing what one sees with supposed rules governing the practice of art as such, or even those pertaining to a particular genre form. It is not a question of deciding on quality by relating the work or the way it was produced to a notion of normal (or normative) artistic method; whatever the status of 'normal science'[19] normal art could not be an authentically modern art. The location of a particular work within the para-tradition of modernism is visible only *after* it has successfully resolved its particular artistic problems. One of the questions with which the work of art confronts the viewer in the modern period – and the historicity of understanding means that *all* works of art are now modern – is how highly individuated, innovative work remains within the continuity of a tradition. To dismiss questions of tradition and practice out of hand or to see them as completely 'open' misses the point and the real problem.

Fifth, overcoming art though science or practice. Much modern art has sought to draw the viewer into an active relationship with the object. As modern artists responded to the demand for individuation within their practice, so the relationship with an audience became more problematic. Artists could not assume that even those belonging to art worlds – and their particular world at that – understood the work or the activity behind it. They often initially experienced isolation from all but a very narrow circle of fellow artists; even success and recognition would not necessarily resolve this problem. They were stuck with the fact that it was precisely their efforts to produce works of quality and significance that had led towards this position. The practice could not be translated into a more popular form without betraying itself, it could not be understood, appreciated or legitimated outside a regional 'world' whose greater parent 'world' – that of art as a whole – exhibited little overall concrete coherence. From the point of view of the spectator,[20] the work must be seen in its own terms if a real relationship with it is to result. On the other hand, there was a strong desire among spectators, and perhaps even artists, for representations capable of connecting with individuated lives and diverse experiences, for works that created a wider sense of relatedness and significance. All of these difficulties remain for contemporary practice.

Sixth, art and the picture, the significance of the autonomy of art. The picture, in Gadamer's view, seems to belong and testify to the autonomy of art, to art as a discrete language. There can be no question of disposing of the picture, of going back to works in new, ritualised contexts within which they would be the direct expression of unproblematic collective beliefs.[21] The founding questions for the modern

period are: what does the picture mean?, what is the significance of the autonomy of art and of the abstractions which it entails? For Gadamer, play is a fundamental relationship with language and in art play finds its perfection.[22] To see art as what Gadamer calls a 'transformation' of play is not to devalue it *vis-à-vis* other discourses but to secure it. It is to see that, in the picture, language – as the *how* of representation – matters in its own right. But it would be a mistake to see this moment of the 'autonomous significance of the perceptual content' as equivalent to the formalist insistence that material and form, and the perceptual phenomena they provide for, can only matter in the absence of meaning. The tension between materialised form and meaning, in the sense of something that could be put into 'other words', for example those of science or theory or everyday practicality, is still of the utmost importance; nevertheless, a problem of translatability is not the same as an absence of meaning, and it is important not to reduce 'textual' semantics to prosaic meanings and their typical uses.[23]

We might think here of Monet, and in particular of a late painting like *Nympheas: Reflection of Willows (W 1862)* (1916–19), part of the marvellous series of garden paintings in the Musée Marmottan which seem to be about beauty and the destruction of beauty.[24] The work brings before us a garden, an Edenic world, which appears both on the surface of the water – the foliage of trees, sky – as a reflection, and by being represented directly – lily flowers, pads and the reflecting surface of the water itself. The image is held on the surface of the pond as it is also held on the surface of the paint. The arresting of 'other words', the beauty and integrity of the world of the painting, is the stillness of the water and the turbulence of the paint. In the water, the world shimmers, in its fragility, its tenseness. To seek 'another word', which we do as easily as drawing our hand through the water, is to want the painting to speak. Its world of mere paint is then utterly destroyed.

The difference of history: a discursive ethics and the troubles of social theory

Turning from the ways in which art and, in particular, aesthetic theory are understood by Gadamer, it is now necessary to consider his analysis of related difficulties in the human sciences. The second third of *Truth and Method* is concerned with the discipline of history, and specifically with the theory of history. A review of this section will enable us to raise some related problems in the social theory of art, identified in the discussion above as reduction and totalisation. We begin by looking in

greater detail at Gadamer's argument concerning the implications of hermeneutics for theorising about the historical and social world. As already mentioned, he is at pains throughout *Truth and Method* to point out that he is not trying to remedy social scientific method.[25] The task is the understanding of the phenomenon of understanding, specifically in terms of its contemporary problems.

During the later part of the nineteenth century, after the collapse of confidence in Hegelian speculative idealism, the works of Schliermacher, Ranke, Droysen and Dilthey began to pose a question that defines a whole intellectual period: How is knowledge of history possible for historical beings? The question asks how human beings can understand other times, other societies and cultures when they are tied to a particular time, society and culture, and where this connection may determine or shape their understanding. For Gadamer, in art and in historical consciousness – the latter is both a discipline and an historical event – an experience of difference and continuity reveals a specific truth of human being. Historicist social theory vigorously pursued a transcendental inquiry into the possibility of its knowledge, but simultaneously and inevitably neglected the more fundamental question of the meaning of historical experience. The efforts of these theorists to erect the human sciences on epistemologically secure foundations and to affirm the finite, historical character of all human thought and being set up profound tensions, and gave a characteristic shape to their shared anxieties.

What, in more detail, was the nature of the problem? Gadamer argues that a rejection of Hegelian philosophy's affirmation of the project of complete intelligibility and, in absolute speculative knowledge, of the identity of thought and being, propelled Schliermacher and others towards the outlook, concepts and methods of the natural sciences. The historical character of human existence meant that thought could neither in principle nor practice exhaustively fathom being. History is 'open at one end', and in such a way that later events may change the significance of earlier ones; the past is made unstable by the future. On the other hand, because human reality differs in important ways from the causal relations characteristic of the natural, physical world – not least in the ways it allows for choice and deliberate action – sciences of history must be conceptually and methodologically distinct. The basic concept, developed by Dilthey in particular, which was employed to describe the essential character of human existence, was 'life' (*Erlebnis*). While the natural sciences study the structures of nature, the human sciences study the structures of life. However, there is a unique relation-

ship between the human sciences and their object. Life moves towards an understanding of itself, it becomes its own object of knowledge insofar as it surpasses the flux of sheer temporality. Ceaseless, formless change is the content of 'pure' subjective experience[26] which is overcome through the construction of stable, self-identical 'shapes'. Thus, for example, the 'I' or ego, abiding as a stable reference point throughout the transience of subjective impressions, as well as specifically social structures (the family, the law, the state, religions, ideologies and so on), are to be seen as products of the self-transcendence of life. Knowledge of history is possible because history is the productivity of life, the birth of intelligible, durable (although not eternal) entities. In a renewal of themes developed by Romanticism, the work of the social scientist and the historian is seen to depend upon and interpret 'expressions of life'; life both realises itself in different forms and develops an understanding of them in which it reclaims its fundamental continuity. While Gadamer would substitute for 'life' something like 'human being in language' this notion is close to a central idea of philosophical hermeneutics.

Unlike Hegel, Dilthey saw these structures primarily in terms of their individuality. To study history was to witness a relentless spectacle of a succession of historical epochs and their manifold contents, cycles of the production and destruction of distinctive forms of life by the action of life. Historical methodology was effectively identical with that of Romantic hermeneutics' literary criticism; the whole (an historical period, for example) was to be understood from its parts (social institutions, works of art and literature, religious beliefs and so on); but equally, the parts could only be understood with reference to an emergent idea about the shape of the whole. The human sciences may witness a parade of heterogeneous differences, but were they also able to grasp the sequence as a whole? If life is inexhaustibly creative how could objective, comprehensive historical knowledge be possible? There is a parallel and urgent methodological problem: we have seen that, in order to understand constitutive elements, the wholeness of their framing historical period must be anticipated. In order to be understood, the 'unity' of these epochs in the whole process of history must also be anticipated. Gadamer notes that the closer these historicist thinkers came to developing a sense of a 'universal history' the closer was their proximity to Hegel. He finds Dilthey's position of particular interest.

Dilthey was obsessed by the danger of relativism. Does not the historicality of the scientist undermine the objectivity of his or her accounts, disclosing them in turn as 'evidence' of historicity but denying them truth? Are not these accounts simply another expression of their time

and place? For Gadamer, Dilthey's anxiety was misplaced. Historical consciousness rises above, creates a distance from, its immediate circumstances in order to understand, to provide an account. Understanding, in its modern historical form, confronts us with the objectification of the other, and of the act of understanding which is directed towards it; that is, the other is not immediately reproduced through a given stock of ideas which cannot themselves be objects of reflection. This removal from the immediate context is not, however, a transcendence of history; the 'space' created is particular and historical. To see and understand this is not self-forgetting but intensified self-possession. Crucial here is the way in which understanding embraces self and the historical other in the continuity of tradition.

> Hence it is not, like consciousness before its victorious development into historical consciousness, the direct expression of a living reality. It no longer applies the criteria of its own understanding of life to the tradition in which it stands that it may, in a naive assimilation of the tradition, simply carry it on. Rather it adopts a reflective attitude towards both itself and the tradition in which it stands. It understands itself in terms of its own history. (ibid., p. 207)

Dilthey was unable to grasp this notion of historical self-knowledge clearly, and therefore could not develop its implications for the human sciences, although it was, argues Gadamer, a position towards which his whole intellectual development led. Historical consciousness only arises when objectifications of the human spirit become strange, alien, problematic. Understanding meets this alienation with another of its own, making a space within the immediacy and continuity of its own tradition, from which, in a moment of reflection, it embraces both the strange and the familiar, and in such a way that the strange is taken to be part of the development of the familiar. This is a moment in which the truth of historical being becomes evident, and refers the charge of relativism back to its presuppositions.

Dilthey's failure to answer the question of relativism need not be seen as a flaw because it 'was not properly his question. He knew, rather, that in the evolution of historical self-reflection which led him from relativity, he was on his way to the absolute' (ibid., p. 209). It was Dilthey's lingering Cartesianism that engendered this unnecessary anxiety, leading him to believe that the human sciences must be able to withstand radical doubt. They must distance themselves from the assumption that reason or meaning is to be found in their object; rather, the intelligible shapes of the human world, its structures, must

be 'mathematically'[27] or formally constructed and imposed upon it. Consequently, reflection must free itself from tradition by rejecting the affirmations it contains. This extension of the Enlightenment's view of the natural world to the human, social, historical world denied the premise of the philosophy of life to which Dilthey was committed, that life understands itself, that at every moment it contains an insight into its identity and continuity as an active achievement. It contradicts an emphasis on the ultimately integrative force of historical consciousness.

The reconstruction of the social bond: aggression and infatuation

Gadamer's discussion of historicism might be extended to include a consideration of the social relationships between discourses which historicism makes possible. To recapitulate, in the self-differentiating cultural problematic of modernity, marked by the appearance of autonomous languages and practices, the immediacy of cultural transmission through tradition is fractured. Strange, alien realities, which require interpretation, appear not simply as the limits of the familiar; rather, the familiar is estranged, the alien erupts within the known and understood.[28] First, efforts are made by social theory to develop a meta-theory of society within which such transformations of familiar social and cultural phenomena may be reintegrated and rendered safe.[29] Yet, even in this reassimilatory process there is often a dawning recognition that the features of an estranged social world demand to be taken more seriously, a sense that they can only be fully grasped when they are accepted as autonomous social worlds; as expressed in the sociology of sub-cultures, they becomes 'worlds apart', internally coherent forms of life often lent wider ethical significance by being treated sentimentally or romantically as sites of opposition and resistance to the dominant culture.[30] Social theory thus attends to the reflectivity of languages, to the ways in which sub-cultures come to see 'the culture' as an abstraction, inert and dead from the point of view of their own vital concerns, irrelevant to their form of life.

Insofar as social theory belongs to the knowledge project it must free itself from purely local prejudices, traces of its own social and historical context, through a process of self-purification by methodology. It must also get to know and represent its objects; this representing is simultaneously the specific way in which it reconstructs the social bond. The externality of knowledge-oriented social theory from the discourses and practices which constitute its objects may be overcome, and the

semblance of a 'community' created, either by the negation of other, or self, through aggression or infatuation.

A Cartesian emphasis on method requires an assertion of self, but through withdrawal, purification and reconstruction; the chaos of belief and opinion is made intelligible by the imposition of formal structures and concepts. The knowing subject is filled out by assimilating the content which the other represents. The particularity of individual phenomena – the residue of their alienation – is rendered insignificant. In Lyotard's language, the question of the modern city, the possible community of multiplicity, is repressed by the empire of knowledge.

A social bond of sorts may also be created by the erotic negation of theorist and the knowledge project in the pursuit for another kind of cultural 'good'; the theorist falls in love with something 'beyond theory' and submits himself or herself to it. In deconstruction, for example, processes of formation and dissolution in language are effectively divorced from particular languages, their content and contexts, and the resulting display of intertextuality is at its roots an aesthetic of pure formation. At its most extreme, it becomes impossible to distinguish between the spectacle and the viewer; 'looking' becomes yet another work of the text.

Gadamer's discussion of Ranke and Droysen (ibid., pp. 179–92) suggests that a preference for the particular modes of discourse leads in another direction. The power of a language is revealed not just by the cultural and historical forms it shapes, but also by the constraints against which it must operate in order to do so. Thus, the vital, creative power of a language is only revealed as an interplay of discursive forces; this is close to Lyotard's 'agonistic community'. In order to play, one must identify with one or other of these contending moral, historical forces. The individual connects with history when he or she participates in its great moral projects.[31] This view can, however, provide a justification for the sacrifice of individuality and the distinctiveness of discursive worlds to a 'moral power of history'. As we have seen Lyotard warn, the demand for total commitment belongs to an unlimited form of the political, not just a commitment to the political as one form of life among others.

To summarise, we have been concerned with certain chronic problems confronted by the human sciences, historical or social, in relating to their objects. In representing (or proposing) to modernity models of actual and normative community, social–scientific discourse asserts itself as a specific language and social practice, and absorbs its objects into the totality of knowledge. However, the social nexus may equally be

constructed out of an abnegation of knowledge in favour of aesthetics or politics; this is to be seen historically as a response to 'knowledge' itself becoming problematic. Reconstructing the social bond on either wholly aesthetic or political lines produces, however, new totalities, which are no less problematic than that of knowledge, from the point of view of the languages and practices they seek to incorporate.

What light does Gadamer's emphasis on language shed on this difficulty? This raises again the question asked at the beginning of this chapter as to whether a politics of discourses can be derived from an ontology of language.

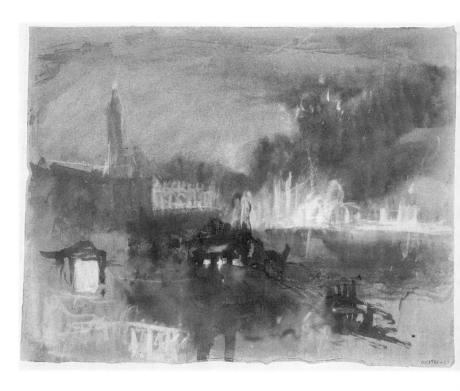

Plate 6. J. W. R. Turner, *Venice: Night Scene with Rockets*, 1833–5, Turner Bequest, Tate Gallery.

Chapter 9

Language and the Singularity of Art

The aspiration to devise a meta-theory of languages – social theory as an objectifying theory of discourses – is to be rejected on the grounds not only of its legislative, expropriating ambitions but also because of its futility. Its futility lies in the inevitability of resistance by the languages it seeks to control. Yet is the alternative a hermeneutical theory which can say little or nothing positive or concrete to languages about language as such, without contradicting its core intentions?; does this idea of language[1] mean anything from the point of view of the activities to which social theory belongs? Is there not a danger here of positioning oneself in a muddled middle somewhere between episte-mology, methodology and professional ethics?

Three points should be made in response. First, this would be to compare an emerging notion of reflexivity adversely with the supposed clarity, rigour and usefulness conventionally associated with the knowledge project, in a situation where this project is being examined as socio-ethical action. Second, it has been argued above that Gadamer's hermeneutical phenomenology does in fact successfully illuminate some of the more difficult and quite concrete aspects of contemporary art with which conventional social theory struggles or which it ignores; here, at least, it has quite tangible benefits. Third, I have argued that the idea of reflexivity raises meta-theoretical questions – here formulated primarily ethically – which refuse either to fit into or be driven from knowledge questions. The awkwardness of these questions is part of the larger hermeneutical question they provoke. If social theory is inextricably connected to knowledge then it would follow from arguments above that one cannot have a *reflexive social theory* of art or any other socio-cultural phenomenon. Rather, what is being proposed here is something like a meta-theoretical proem

to or commentary on social theory, one which will never quite cohere with knowledge-producing practices, and whose wider significance would reside precisely in its displaced role within theoretical discourse.[2]

One way to understand the problems better would be to aim for a less abstract idea of language as the fundamental hermeneutical phenomenon. Gadamer's discussion of the 'speculative structure of language' in the third and final section of *Truth and Method* may prove helpful, not only in itself but also because of the peculiarly intimate relationship within hermeneutics between language and art. The representations of art provide a clue to the emergence, from the speculative (or dialectical) structure of language, of the social as a specific discourse. The first part of this chapter will be concerned with these issues. The second part will look at another approach to art, discourses and language which has been informed by a different theoretical stance, that of the poststructuralism of Derrida.

The speculative structure of language

Gadamer writes: 'Every work of art, not only literature, must be understood like any other text that requires understanding' (Gadamer, 1975, p. 145). Hermeneutics must approach *all* works of art as if they were texts. This points not only to a further specification as to what this idea of language means, but also presents, at first sight, a difficulty when it comes to works of *visual* art or other forms whose primary means of expression are not to do with words. Does not this proposal threaten to ignore the specificity of drawings, paintings and sculptures by regarding them as 'really texts' beneath their superficial visual features?

What is a text? Paul Ricoeur's discussion provides a useful starting point. He writes that 'a text is any discourse fixed by writing' (Ricoeur, 1981, p. 145). He goes on to develop, in a way similar to Derrida, a distinction between speech and text. When the text takes the place of speech there is a radical change in the relation between language and the world.

> In addressing himself to another speaker, the subject of discourse says something about something; that about which he speaks is the referent of his discourse... The referential function is so important that it compensates, as it were, for another characteristic of language, namely the separation of signs from things. By means of the referential function, language 'pours back into the universe'... those signs which the symbolic function, at its birth, divorced from things. (ibid., pp. 147–8)

In practical, everyday contexts what matters about speech is the referent and not the speech itself: 'Sense fades into reference, and the latter into the act of showing' (ibid., p. 147). When, on the other hand, we come to the text, the indexical features of speech, which connect it to particular contexts of use, are missing. The text is not devoid of reference but the movement back towards the world is 'intercepted'. Ricoeur avoids saying that the flow is 'halted' or 'arrested' because he rejects the 'ideology of the absolute text' (ibid., p. 148), that is, the textual as a self-sufficient world. For him, 'the text is not without reference; the task of reading, qua interpretation, will be precisely to fulfil the reference' (ibid.). However, the interception of the flow of meaning makes possible a particular kind of relationship between texts:

> In virtue of this obliteration of the relation to the world, each text is free to enter into relation with all other texts which come to take their place in the circumstantial reality referred to by living speech. This relation of text to text, within the effacement of the world about which we speak, engenders the quasi-world of texts, or literature. (ibid., pp. 148–9)

The character and status of this interruption is of considerable importance if we are to approach visual art as a text. The everyday, practical text would seem to be a good deal closer to the 'circumstantial reality' of 'living speech' than, for example, the poetic text. Also, we have seen that, for Gadamer, the connection between art and the things of the world is not so much one of reference, even if 'intercepted', but of transformation into truth. If these points are accepted it would seem that the work of art belongs neither to speech nor text. Yet, for Gadamer, art does belong to language. Language is *intelligible being*; anything that exists for human beings – and this would obviously include art – is essentially language. As he puts it in a well-known passage:

> Being that can be understood is language.[3] The hermeneutical phenomenon here draws into its own universality the nature of what is understood, by determining it in a universal sense as language, and its own relationship to beings as interpretation. Thus we speak not only of the language of art [*Sprache der Kunst*], but also of a language of nature, in short of any language that things have. (Gadamer, 1975, p. 432)

In language is manifested an original unity of self and other, subject and object, thought and being. The real nature of language is shown in understanding, and understanding is the anticipation and recovery of this unity. Understanding is not finally an act of the subject but the

movement of the original unity, or relation, of subject and object in language. Understanding is another way of referring to the 'speculative' structure of language. What Gadamer means by this is complex, but it seems to involve the following ideas: First, any particular speech or discourse – and human beings can only utter particular speeches, not language as such – belongs to the whole of language, and can only be understood through an awareness of language as a whole. The whole of language contains or offers an infinity of meanings, of possible utterances and expressions, so the finitude or particularity of any speech is related to the boundlessness of language as a whole. Put another way, within any speech is a potential infinitude of meaning; hence language may be seen as 'contained' within speech.

> To say what one means... to make oneself understood, means to hold what is said together with an infinity of what is not said in the unity of one meaning... Someone speaks speculatively when his words do not reflect beings, but express a relation to the whole of being. (ibid., p. 426)

Considered abstractly, in isolation from its relationship with specific utterances, this makes language a field of pure, limitless possibility for being. The phenomena of experience (self, other, the art work, the scientific theory, the political programme and so on) are already realised possibilities for the being of things articulated within language by specific languages.

Understanding relates the phenomena of experience to one another; it may also relate, or re-collect, the forms of experience and expression (languages and practices) together. This relating necessarily occurs within languages, but also, when applied to the problematics of how one language might understand and be reciprocally understood by another, may also occur *between* them. For Gadamer, this is the task of philosophical hermeneutics.

It is in the speculative structure of language that subject and object, specific languages and their products, belong together. In the radical 'event' (*Ereignis*) of understanding, the interpreter confronts both his or her own language, and that of another, as realised possibilities for being. In their mediation, their mutual efforts to compose a sense of things which can include both, there may emerge new possibilities for meaning and being. This is Gadamer's sense of 'tradition', not a nostalgia for the past or the artificial preservation of a heritage, but a realisation, in the encounter with the past and with other languages and cultural forms, of what one's relationship with language, in a broad but still determinate sense, makes possible. Thus, to understand

is not to invent arbitrarily. The significance of another's language, its truth, is something that must be 'sought', even though its 'discovery' is to be seen as a realisation of the possibilities for speech offered by language. Here, the event of understanding is not unlike the creative act in art, and particularly perhaps visual art; the artistic process is simultaneously a shaping, forming, perfecting or creating, but is also an uncovering, a showing.

Art: creating and finding

This dual emphasis echoes a dense knot of ideas found in art theory concerning the relationship between art, nature, imagination and intellect. Charted by Panofsky for example, we see the ways in which different periods, artists and thinkers have conceived of this relationship, weighting it at one time towards creation and at another towards discovery. Ancient Greek thought 'was thoroughly familiar with the notion that the artist's relation to nature is not only that of an obedient copyist but also that of an independent rival, who by his creative ability freely improves on her necessary imperfections' (Panofsky, 1968, p. 15). For medieval thinkers, strongly influenced by Aristotle, the artist realises or projects onto matter, an inner, *a priori* image. In the last analysis, however, this image is God-given, not 'made' by the mind on the basis of experience or by a process of pure creativity. While Renaissance art theory stressed close attention to nature, verisimilitude, correctness, it also emphasised the ability of art to produce beauty in its representations by removing the imperfections which objects of nature invariably possess: 'nature could be overcome by the artistic intellect, which – not so much by 'inventing' as by selecting and improving – can, and accordingly should, make visible a beauty never completely realized in nature' (ibid., p. 48). The artist did not originate the idea; rather, it was 'taken from nature by way of a *guidizio universale*' and therefore 'seemed potentially prefigured in the "objects"'(ibid. p. 63).

Of particular interest, in this context, is Summers' analytical reconstruction (1981) of Michelangelo's views and, in particular, his complex, shifting relationship with the themes of invention and discovery, imagination and nature, fantasy and order, reason and faith. What can be discerned here, when its Neoplatonic sources are not overemphasised, is part of the background to the formation of a distinctively modern view of the defining features of artistic practice. I am not, of course, suggesting that Michelangelo's specific ideas have been followed directly by every artist since the Renaissance. There can,

however, be found in them elements of an approach to practice and creativity in the visual arts which remains of considerable importance, and which is contained in much modern art, understood in the broad way I have proposed.

For Michelangelo, the gifted artist has a capacity to see beauty in the beautiful; the realisation of this potential for developing artistic conceptions – images of beauty – thus depends in part upon experience of beauty in nature. Additionally, he or she also possesses the capacity to invent. In the *Dialogues* of Francisco de Hollanda, Michelangelo insists that 'design' (*disegno*) is a kind of creative and practical mastery which lies at the root of all types of creative art, including painting, sculpture and architecture. Someone with this mastery 'will be skilled in all the manual arts in the world... [and]... has the ability to invent that which never has been found, and of doing all the other crafts with much more grace and elegance than those that work in them' (Summers, 1981, p. 261). As Summers points out, the views of Plato in Book X of *The Republic* are here firmly contradicted:

> Plato's antithesis between the world of sense and the world of reason is denied. *Disegno*, instinct with *guidizio, intelleto, grazia* and *virtu*, partakes of order and harmony... Michelangelo thought of art as, like a certain kind of music, a union of reason and sense, or quantity and quality. The truth comprehended by the mind is also apprehended by the eye. (ibid.)

From the point of view of the hermeneutics discussed above, one might say that the truth 'invented' by the mind is also that 'discovered' by the senses.

This kind of coincidence of otherwise antithetical principles or practices may also be discerned in Summers' account of the importance to Michelangelo of the 'judgement of the eye' (*guidizio dell'occhio*). Often occurring in the context of discussions concerning the adjustment of proportions distorted by recession, particularly in architecture due to height, this notion came to have a more general significance. Michelangelo is believed to have said that 'it was necessary to have the compasses in the eye and not in the hand, that is, to have judgement' (ibid., p. 370). For Summers, this does not imply a rejection of proportion (or measure), or its connection with visual pleasure. Rather, the order of proportion, which might be seen to belong to the constructive activity of the intellect, had to be brought to coincide with the receptivity of the senses. As Summers puts it, Michelangelo's position was midway between that of the craftsman–painter and a Neoplatonic philosopher like Ficino who maintained that the 'light of eyes' enabled

them to receive the light which flows to them from material things illuminated by the sun. Michelangelo's views on the judgement of the eye reverse those of Boethius, for example, which gave absolute priority to intellect.

> The metaphor of the *seste dell'occhio*, or the *guidizio dell'occhio*, appealing to the principle that judgement is higher than what is judged (so that the judgement of sense is higher and more spiritual than sense itself) is thus made an integral part of the notion of the absoluteness of artistic vision. The insistence upon the opposition of quality and quantity, and upon judgement, is an insistence upon the spiritual nature of art. (ibid., p. 373)

For Summers, this is a declaration of the independence and distinctiveness of artistic judgement, which in the modern period was to become part of a claim to art's autonomy. There is also, here, the idea that the judgement of the eye overcomes the opposition of quality and quantity; indeed, it was believed essential to the transformation by art of quantity into quality. Intellect and the senses coincide in an act of judgement specific to visual art.

This might be extended. In theories that have tried to formulate the relationship within art between man and nature, imagination and intellect, observation and creation, there are often to be found claims about the distinctiveness, independence and significance of art's cognitive, practical and spiritual dimensions which have been important in the development of the language of art. There have also often been attempts – here expressed in the metaphor of the judgement of the eye – to say that, at a deep level, art is characterised by a certain conjunction of creating and finding, of constructive and receptive modes of seeing.

There is a parallel between art's claim to truth and that of understanding, as Gadamer sees it, in that both involve a relation of what, in other contexts, would be regarded as contraries: a revealing, via the effort to understand an other, of what possibilities are offered by a discipline, practice or language, and a creative act which brings something else to light, yet where this 'something else' is inextricable from the work itself:

> language constitutes the hermeneutical event proper not as language, whether as grammar or lexicon, but in the coming into language of that which has been said in the tradition: an event that is at once assimilation and interpretation. Thus here it really is true to say that this event is not our action upon the thing, but the act of the thing itself. (Gadamer, 1975, p. 421)

Does this suggest anything about the connection between a specific language like art and language as such?

When an artist like Michelangelo tried to articulate what is essential about the practice of art he came up with combinations of dynamic contraries. Gadamer's arguments would encourage us to hear this as an effort to assert and affirm the hermeneutical identity of art. The relationship with language is presented here in an inevitably negative way; the reference to language as such is contained in the claim that art lies beyond the self-contained world of languages and their productive force, beyond subjectivity or the productive machinery at its disposal, and beyond the capacity of languages and their sub-cultural communities for reflection, communication and construction.[4]

The difference of language and modern art

As is well known, Gadamer does not propose methodological reform for the human sciences. On the other hand, neither does he recommend they seek a union with art; he does not advocate the aestheticisation of theorising. One important effect of philosophical hermeneutics would be to remind discourses, and perhaps in particular theoretical and scientific languages and practices, of the dependent, 'second-order' character of bodies of knowledge and sound, practical achievements, by pointing out important questions or *aporiai* about their context and assumptions (or prejudices), to which they are incapable of responding adequately. Yet what difference, if any, could an awareness of these *aporiai* be expected to make to their operations?

Hermeneutical understanding refers to the ways in which language exists for human being: 'the concepts of "art" and "history" are modes of understanding that emerge from the universal mode of hermeneutical being as forms of hermeneutical experience' (ibid., p. 433). This might seem to imply parity between them. Of course, this must be set against an important distinction, for Heidegger and Gadamer, between discourses that, through methodologically governed procedures, objectify the world and render it available for human use, and those that, more 'thoughtfully', seek to attend to their relationship with language. Insofar as social theory belongs to the former it is a variety of technical speech.

Once language is taken to lie at the roots of meaning and being then it is literally all-embracing. What would be the consequences of accepting this notion? Does it not perhaps leave everything just as it is?; if so, what would be point of accepting it, rather than some other view?

Are we are being told everything and yet, perhaps for that very reason, nothing of any consequence? Does what some would see as the incipient reductionism of this philosophy of language contradict the fruitfulness of a hermeneutics of art which has been argued for above?[5]

A full enquiry into Gadamer's hermeneutical philosophy of language would take this work too far from its central concerns. It would be useful rather to examine the work of another writer, with a background in social theory but also an intense interest in visual art, who explores related ideas of a relationship between art and language, albeit from a somewhat different theoretical tradition. Of particular interest is how Michael Phillipson reshapes ideas about theoretical practice in the light of the challenge to its routine practices which art represents.

There are some striking similarities between the ideas discussed in relation to Gadamer, and Phillipson's approach, despite the overtly post-structuralist outlook he employs. He places art, and painting in particular, in a close relationship with language.

> Gathering painting within Language, showing painting's question to itself about itself as a question about its specific ways within Language, draws it into the play and circle of those practices whose 'being' it is to make Language and their modes of re-presenting within it, the very point of their project. (Phillipson, 1985, p. 38)

Painting is to be understood as a specific practice within language, but a practice devoted not to the pragmatic use or rational analysis of language but to the interrogation, or perhaps celebration, of language as language.

Texts occur widely in painting, traditionally as signatures. Modern painting, from Schwitters and Klee to Anselm Kiefer and Cy Twombly frequently includes words, phrases or sentences. Often the letters forming the text are formally integrated into the economy of the piece as a whole. So, if painting itself has raised the issue of its relation with text, then 'painting may be the bridge across the void between linear writing and Language' (ibid., p. 106). The difference of writing, its specific significance within the hermeneutical domain of language, may be revealed by painting.

While painting may or may not include texts, according to Gadamer's hermeneutics and Phillipson's deconstructionism, all paintings are to be approached as quasi-texts. Nevertheless, there is an obvious difference between most texts[6] and most paintings, namely the sheer plenitude and richness of the signifier in the former and its relative unimportance in the face of informative and communicative

content in the latter. It has also been widely observed that words are clumsy and generally ill-suited when it comes to the description of visual qualities. For Phillipson, the issue is more profound still: visibility exceeds the capacity of any text 'because it is the space within which we see; it contains all texts, but Language also contains all texts, so we need to recognize the way Language spaces, the way Language is in space and space in Language' (ibid., pp. 106–7). There is, then, a metaphoric relationship between language and visible space.

It is important at this point to understand the ways in which speech and writing as we routinely encounter them are here contrasted with language and with what Phillipson, following Derrida, calls 'writing-in-general'. Phillipson wants to treat writing, in the poststructuralist sense, as a metaphor for painting. Phonocentrism – a metaphysical outlook deeply ingrained in our ordinary approach to speech and writing – assumes that 'the concrete origin of Language is to be found in the voice, in the moment of speech, and that writing as a subsequent and derivative emergence is a corruption of the fundamental character of Language as speech' (ibid., p. 107). The idea of writing-in-general however, stresses not some supposed certitude modelled on the presence of speaking subject to itself or the origin of meaning in some signified 'thing-in-itself' beyond language, but the ways in which language works by a process of 'differing and deferring'; 'things', intelligible phenomena, are brought into being through language, by being differentiated from nature as a mute and absolute other. The dependency of these phenomena on language withholds from us their complete presence as things-in-themselves.

To return to the issue of space and spacing, Derrida points to the critical importance of space for writing, in particular to the ways in which letters and punctuation marks divide up the emptiness of the surface upon which they are inscribed. The importance of spacing to writing-in-general distinguishes it radically from the metaphysics of presence with which the voice is imbued. As Phillipson puts it:

> Spacing is, then, that which, precisely as lack, as the absence of a presence (the living speaker), gives writing and indeed presence itself its possibility. In developing the sense of painting's implication with writing-in-general the transposition of the work of spacing to painting is crucial at the most general level. The work of spacing points us to the ways that painting's marks are tied to Language as writing-in-general. (ibid., p. 114)

In other words, space and spacing are metaphors for the work of language. Continuing with his attempt to draw painting, writing and

language into a closer relationship Phillipson introduces the notions of the trace and the mark. The 'grapheme',[7] is required by any system of writing as its basic irreducible unit. The idea of this unit, Derrida says, 'implies the framework of the instituted trace, as the possibility common to all systems of signification' (quoted ibid., p. 114). Thus, the trace is the possibility of stabilised public meanings, or as Phillipson puts it 'the possibility of sign as duration of the same' (ibid.). By the same token, the trace would appear to be the possibility of difference. In other words, Derrida finds, 'behind' the metaphysics of presence and phonocentrism, writing, systems of signification that bring meaning to being through absolutely arbitrary connections between signifier and signified; thought of in this way writing is the possibility of the notions of language as such as they are developed by Gadamer and Phillipson. Trace is another word for *differance*, for the differing and deferring work of language, but refers specifically to language as writing.

The mark refers to the actual means, the particular system of signifiers, used by a language or practice, be it conventional writing, sculpting, film, dance or whatever. The mark in painting is then 'both an originary inscription and a secondary re-presenting where what it re-presents is the trace or *differance*, which in its differing and deferring movement brings both phenomena into their being in the system of differences that Language provides and, at the same time, perennially defers their full presence as things' (ibid., p. 118). This would seem to make the particular marks of painting important only insofar as they relate to *differance*, to trace. However, Phillipson is anxious to think through the specific significance and value of the painted mark. While painting, seen in this way, is intimately tied in with the life of language it may still be described as differing from the word because the word is understood and employed in our culture phonocentrically. The meaning of words is arbitrary and secured by convention, in the last analysis by repetition. Painting's question to a phonocentric culture concerns the possibility of repetition, a moment of re-presentation, of raw vision or savage utterance, 'before' repetition secures relatively stable public meanings, the possibility of language as a useful tool for the objectification of being. 'The gesture of the mark signifies before it has been held by the web of convention that signs apparently require; it is thus a signifier before signification as we know it has been instituted' (ibid., p. 119). In its self-imposed demand constantly to renew itself, to avoid repetition, and in this to challenge the phonocentric word, painting is utterly concrete; it is *this* mark, next to *this* mark, of *this* size, *this* shape, *this* colour that matters, and

in ways that are unique and thus incapable of being described analytically, or for that matter being taught by rule or convention. The radical tradition in painting, and perhaps in art in general, is from this point of view the questioning of the repetitions which create stable, generalised, taken-for-granted meanings.

There are strong echoes, then, in Phillipson's discussion of painting, of points made by Gadamer; given the influence of Heidegger on both Gadamer and Derrida perhaps this should not be surprising. The question remains as to whether Phillipson offers a response to the difficulty of the verbal or textual prejudices of any approach that identifies meaning with language. His efforts to acknowledge the specificity of painting are surely due, at least in part, to an awareness of this difficulty; the debate about the mark and space reflects this concretely. Yet the 'illusory' space depicted in paintings, or the space created by the division of the picture plane by marks and shapes, and also the space articulated by the abstract or formal components of the painting, are understood in terms of the spacing of language, its work of differing and deferring. Equally, the painted mark is understood as the concrete expression of the trace, itself a metaphor for *differance*. Space and the mark, both central to painting, subserve language. While the visual work of art does not essentially refer to some real thing in the ordinary world, the fundamental significance of its vital concrete construction, its particularity as a signifier, is to defer to language as such, itself the formless abstraction of poststructuralist theory. At a 'political' level Phillipson's point seems to be that paintings are only read correctly as texts when they are treated as resistance to the spoken word, that the meaning and significance of vision in art is the textual subversion of speech.

This raises a number of difficulties. First, for art world members, form – the particular marks, textures, colours, scale, materials, spaces and so forth, in a particular arrangement – is not merely the *means* through which art secures its philosophical or theoretico-political significance. Formed materiality matters in and of itself. This emphasis is not an endorsement of formal*ism*, but rather the familiar (but difficult to define) idea of a concrete intertwining of material and abstract elements with meaning. Art in the modern period has been shaped by a recognition that the success or failure of particular pieces depends, in part, on their capacity to make the concrete, the *how* of representation, matter in itself.[8] This seems, initially at least, at odds with the idea that the concrete details of the work matter insofar as they either relate to a particular philosophical concept of language or challenge a phonocentric culture.

Second, what are the implications of this view for the social relationship of languages? Here Phillipson is quite specific. Art, as a language marginal to the wider cultural forces of modernity, provides a unique – even if socio-culturally or politically 'weak' – challenge to the power of phonocentric, word-dominated practices. It is, however, not only 'externally' critical but, as itself an organised practice of representation, it is inevitably driven towards self-subversion, towards constantly making itself problematic, unfamiliar even to itself. When it reflects on itself it seeks to escape from re-cognition, it looks towards another moment of wild vision.

This view of the wider significance of art for other languages and the question of their relationship seems harsh indeed. The stark and simple choice is between phonocentric discourses and art; there would appear to be no possibility of contact or communication. Art stands for an absolute discontinuity between the worlds of knowledge and practice, and language as such. It stands beyond, or perhaps at the limits of, the social relationship of languages, it confronts other languages with their remoteness from its concerns. It would seem that social theory could have little, if anything, to learn from art. Put slightly differently, the distinctiveness of art could not pose a question to which social theory could respond, except by ceasing to be social theory, because to respond to the call of language is to demand a very different kind of discourse, one much more like art, perhaps an aestheticised theorising?[9]

If the hermeneutical and poststructuralist idea of language as a challenge to the social theory of art is to be more than an abstract category, or an abandonment of theorising in favour of aesthetics, then it needs to be brought to life metaphorically.[10] What is language 'like', if it is a limit, beyond projects of knowledge, practicality, and right behaviour?; if it is 'active' rather than a resource or toolkit, sometimes offering possibilities by opening up, through the medium of poets, visionaries, thinkers or socio-cultural movements, new possibilities for expression, evaluation and action?; if it sometimes permits but sometimes disrupts or disallows or impedes communicative interchanges?; if its shape is constantly obscured behind the intelligible phenomena and linguistic practices it provides for? Perhaps the sea would be an appropriate visual metaphor? To be reflexive in the midst of the multiplicity of languages, practices and their products would then be to situate the city – the question of the social relationship of languages – close to the sea, the question of language. The relationship between the city, with its determinate multiplicity of languages and practices, and the sea, with its indeterminate, protean multiplicity, the relationship between culture and language, is the question of the social itself.

Although Phillipson does not identify art or poststructuralist theory with a systematic, positive meta-theory of language, nevertheless it is difficult to see a context in which the differences between languages could be significant. What matters is the difference between languages as phonocentric discourses on one side, and art and language as such on the other. Put in Heideggerian terms, the price paid for the ontological difference between discourses and language, between phonocentrism and art, is a loss of ontic differences between value-spheres, of the defining multiplicity of modernity, and thus of the open question of its culture. Even in the case of art, there is a loss of detail. With painting, for example, space is not part of an organisation of marks which makes the painting and its meaning significant in itself, but rather a metaphor for language as such (or writing in general), the occluded context of writing and painting. How then can the magnetic sublimity of the sea be seen and acknowledged, yet prevented from distracting the viewer from the aesthetics of architecture and questions of justice?

Politics and language

We have seen above how difference as difference figures in Phillipson's text. Difference as difference is *differance*, the differing and deferring work of language.[11] Here, we are not primarily concerned with the concrete, ontic phenomena that language makes available, or the reflective conception that languages have of themselves and others, but with the 'process' through which this occurs, a process of emergence into a 'light' which is necessarily obscured or veiled by what it illuminates. The concrete, in the case of art the specific arrangement of formal and semantic elements that make up the work, could only be significant insofar as it represents the fundamental availability of the thing to us (through language) which, in a phonocentric culture, is constantly overlooked, exploited, squandered. This threatens to eliminate one of the most important features of works of art; the priority which must be given to their particularity.

The concreteness, the extraordinary event of the thing, its 'thatness', difference as difference, is understood by Derrida and Phillipson, here following Nietzsche and Heidegger, as 'some-thing' which cannot be signified, the no-thing of language. Stanley Rosen spells out some of the implications:

> Possibility is higher than actuality in the same sense that silence is source of speech. The Being-process, or pure differentiation, is higher (more powerful) than any of the elements of that process of differentiation. So

too Heidegger's exaltation of creativity, or rather, the creative power, as higher than the products of that power: the creative process is the human exemplification of the Being-process… And the *that* of disclosure is higher than what is disclosed… Like Aristotle Heidegger holds that Being is 'working' but, unlike Aristotle, that 'working' does not achieve fulfilment (*entelecheia*) in a determinate form. Every determinate formation of man's psyche or creativity is a deformation of his existence in the deepest sense – a limitation, and hence an obscuring, of the Being-process by one of its emanations. This is the ontological significance of Nietzsche's remark that the world is an art work continuously given birth to itself, as well as his emphasis on play. (Rosen, 1969, p. 99)

This position, while apparently valuing art highly, in fact more highly than anything else, is strikingly at odds with the view discussed above which emphasises not only creation but also discovery, and the positive significance of the 'resistance' offered by materials and the demands of visual specificity. Art, understood as a medium for the exercise of an absolute will, has no sense of anything beyond itself, except either as an impediment to self-assertion or creativity (as chaos, formless material which must be set upon and shaped), or as an erotic invitation for a display of mastery.

This totalised view is itself made relative with the realisation that what it produces, for art or indeed any language that chooses to adopt this formal view of itself, are impossible to distinguish from what Rosen calls 'second order manifestations of chaos'. Languages or practices[12] bring intelligible phenomena into cultural life. Yet this imposition of an order or shape cannot be authorised by reference to some pre-existent or more stable structure beyond the act of ordering.[13]

To Nietzsche and his followers, nineteenth-century European culture presented the spectacle of a series of futile attempts to cling to the last vestiges of religious and humanitarian ideologies, the purpose of which was to repress recognition of unrestricted human freedom and power. Put slightly differently, the leading ideas of bourgeois civilisation sought to nullify the consequences of a dawning awareness of the poetic or constructive power of art, whether understood as the product of exceptional individuals or socio-cultural movements. The two principle strategies recommended the continued development and rule of knowledge or the priority of a value-related goal, for example that of human emancipation.[14] Eventually, however, the legislative project of knowledge was undermined by the emergence of its hidden presuppositions and conditions: for example, science's politically and culturally structured social and economic infrastructure, its inability to

deal with unanticipated consequences except in ways which routinely produce new and more intractable side-effects,[15] and its chronic deviations from its rhetoric of rationality. The ethical or political project proved vulnerable to an endless succession of critiques which discovered specific and partial interests 'behind' supposedly universalistic values. The result, Nietzsche prophesied, would be decadence and ultimately nihilism. His well-known solution was a therapeutic intensification of historicism, the final destruction of the traditions of European thought; art would, in the name of language, declare unrestricted civil war against all other discourses.[16]

The preference for 'thatness' over particularity perhaps relates to an excessive interest in the sublime, in the sublimity of post-nature as opposed to the seemingly intractable difficulties of the city. If, however, theory becomes engrossed by the absolute difference between language and discourses then material and semantic specificity disappear into 'thatness' and art vanishes, or rather persists as the name of the place where this negation occurred.[17] While recognition of the wider significance of art, what its achievement – understood as epiphany, as painful beauty, the dynamic stability of a realised artistic form – is supported by the recall of language, for a reflexive social theory – even as proem or commentary – this could not be at the expense of the differences between discourses which are characteristic of modernity.

I have argued that if art is a language it must, in order to be itself, resist the rule of the word, or rather, the drive of reflective prose to dominate and prescribe criteria of success and failure to all other forms of expression. On the other hand, while the resistance to prose is a necessary condition for an authentic practice of art, it is not sufficient to produce art of quality and significance. Art's task is to find ways in which to achieve particularities that matter; the scope of the particular, for visual art, goes all the way from its materials and processes through to the artist's emotional and imaginative responses to people, places and things, and specifically to everyday life.

When the work of art achieves epiphanic representation something is saved from the destruction of things in time and by human productivity, but in a way that also makes human experience more vulnerable to the pain of irreplaceable loss. The roots of art lie in the ways in which human beings give and receive value, particularly in the context of the life world of intimacy. In other words, the capacity to be vulnerable to value, to be a subject of feeling and significance for others, is to be defined or discovered by particularity. As Gadamer argues, the work of art takes this further, transforming the phenomenon of particularity

into an event for others in the wider public realm. The work needs to resist impatience, inattention and objectification, and in order to do so must deploy materials, conventions and codes. The artist who responds to the demands of art seeks to make images and artefacts that seem right, that convince through the organisation of their structure and appearance; they are made and yet, because they communicate their inner necessity, they seem to have been found.

Turning to social theory, it has been argued above that reflexive recognition of the social character and effects of theorising – which would include conceptualisation, analysis, methodologically guided research, criticism and so forth – is to recall that discourses, as major cultural practices and institutions, spring from language. For Gadamer, it is the 'speculative structure of language' itself, revealed by the nature of understanding, which moves towards a re-collection or mediation of the multiplicity which discourses open up. This recall of language is, as he says, nothing 'positive', in that it adds nothing directly to knowledge, nor to the human capacity to regulate nature or society. Language in this way resists being objectified and thus entering directly into cultural worlds. Yet it is still important to recognise that the productivity of languages and practices, and the variability of human needs and wants, are answered by the ways in which understanding anticipates and discovers unanticipated connections. The social relation of languages, the question of the modern city, is the question of an unsecured, fragmentary process of exploration and recovery between cultural practices, all of which individuate and some of which totalise. Citizens inevitably speak and practice within the languages available; the possibility of culture, as opposed to sub-cultural indifference or strife, relates to the capacity to recognise, from within the productivity of languages, unintended social consequences and the anticipation of relatedness, resemblance and recovery.

Chapter 10

Conclusion: The Point of *Aporiai*

I began with three studies in the social theory of art representative of broad approaches within social theory. Wolff's works have been influential by being extensively used on undergraduate courses and Bürger's book has been widely seen as important in its own right, frequently quoted and discussed. They represent and reinforce an approach to the arts in general and visual art in particular that has become increasingly common. Their themes and arguments are found everywhere, and have assumed the status of a new orthodoxy for the supposedly theoretically informed. Important phenomena of art worlds – including works, critical vocabularies, value hierarchies, choices of media and techniques and so forth – are represented as caused and controlled either by deep social–structural forces, like entrenched systems of power or dominant cultural ideologies, or by everyday micro-sociological processes relating to the shaping or survival *of* art worlds as a necessary social reality for their members, or as the efforts of members to raise their rewards and status *within* art worlds.

These theories have been treated as an occasion for questions not only about art but also about social theory. Specifically, they raise broader problems about social relationship between languages, where this relationship is treated primarily as raising ethical or broadly political questions for the practice of social theory. These questions seem to me important and urgent.

I have suggested that where these theories are antithetical to art they are intrinsically – rather than casually, accidentally or idiosyncratically – hostile; neither is hostility the product of conceptual or methodological mistakes of one kind or another. First, they attack specific, key ideas

and beliefs of art worlds. In some cases, these ideas and beliefs may have been produced originally by philosophers, critics or historians, rather than artists. Nevertheless, whatever their provenance, many have become widely used in everyday art world contexts. For example, notions of artistic quality, a canon of great works, expressive truth, integrity and vision as necessary personal qualities for an artist, all regularly play an important part in everyday conversations in art worlds, and as such contribute to their social reproduction and thus ultimately to works of value.[1]

Second, the attack often takes the form of an argument that these ideas are caused by social forces or circumstances, and that, as a consequence, they cannot be 'true' or 'valid' in the ways in which members take them to be. It is also argued that members are incapable of recognising this because their perceptions and thoughts about themselves and their world are themselves caused socially, and in such a way as to preclude this recognition or because they have a vested interest in self-delusion.

It is not clear what beliefs and ideas are to replace those which sociological enlightenment destroys. This need not, of course, be a problem for the sociologist if he or she is committed to a project of pure knowledge or knowledge applied externally to an object; on the other hand, it must be a problem for artists, and for all those, including theorists, who appreciate works of art. It must also be a problem for those social theorists who care about the social world in question and, more generally, for theorists who are reflexively aware of the social or ethical implications of their work.

On occasions, members of a social world may hold and express beliefs that are either manifestly untrue or morally wrong; they may also be unable or unwilling to accept legitimate criticism. Yet it is also the case that other members of that world are often able to see that these beliefs are wrong, and to point this out; they may also, as lay sociologists, often be able to connect beliefs to circumstances and motives. It may be seen by intelligent members that someone holds a false or inadequate opinion because it is to his or her advantage to hold this view or to act as if it were true. The question of whether, in a particular situation, members use this capacity for critical understanding is an empirical one, and in most non-extreme situations it would be a reasonable assumption either that they do or at least that it exists as a resource. For much of the sociology of art, however, the converse is a routine, *a priori* assumption, because this complication does not fit conveniently with the way in which this kind of sociology wants to see art.

Some of social theory's assaults on art during the last two decades have been even more profound. Not only are art world members seen as wrong and self-deluding, but the whole practice to which they are committed is viewed as contributing to false cultural values and hierarchies, to ideologically distorted views of history and society, and to the perpetuation of social injustice. For these social theorists, there is a need not only to put visual art in a social context but to destroy its key ideas and values.

What then of social theory? I have treated social theory as having a general commitment to the production of valid and generally useful knowledge of social phenomena, while noting its other founding interest in *Verstehen*, its hermeneutical dimension. The hermeneutical side of social theory is, of course, capable of participating in knowledge projects. As Bauman points out, the demise of social science's legislative ambitions leaves interpretation and technical expertise as the only games in town; the result is an institutionally sanctioned choice between the celebration (or condemnation) of sub-cultures, or technical contributions to social problems where 'empathy' might help.[2]

I have been particularly concerned with a reflective recognition of the connection between scientific outlooks, theories and methods, and their production of what is widely accepted as the most valid, reliable, useful knowledge available, a capacity widely seen as connected to specific characteristics of scientific language and practice. In philosophy this awareness has its roots in Kant. The turn to language in the twentieth century relates a bounded field of objecthood, experience and intelligibility to the concepts and procedures characteristic of a constructive and reflectively analytical system. Taken one step further, it emphasises a view of language as the source for all available ordering, shaping, constructing, poeticising possibilities. Within these possible ways of speaking – or hermeneutical regimes – discourses aimed at grasping and exploring the character of different object realms have had special importance in the cultural history of the West, at least since the Enlightenment; this is also to say, of course, that they have been important in social, economic and political history during this period.

Once languages begin to be seen, necessarily through available images and metaphors, *as* languages, and to be presented to understanding in this way, the ensuing process of individuation strengthens and makes more prominent forms of awareness of the methods and materials, the resources and actions, the grammar and the performances through which they shape, construct and communicate. At this point, three dimensions of a discourse's history emerge: first,

there is the possibility of debates about and struggles over different ideas of a discourse's identity. Second, there is the possibility of related discussion and struggle about the nature and status of one discourse in relation to other discourses. Third, practitioners within a discourse may embark on a self-conscious exploration of the possibilities for representation, expression and innovation offered by its language, an exploration of the language as such. Here, then, the explicit distinctiveness of a language becomes something of interest and value in itself, one of its defining and most productive features, and as such a topic for reflective self-understanding and expressive articulation.

The question of the relationship between discourses is particularly significant here. The notion of the possibility of a common language, perhaps derived from older religious or moral frameworks, recedes or becomes more problematic as individuation progresses. The relationship between languages becomes not so much an open question, given differences in the status and influence of some over others, but certainly more pervasive and difficult. This is, in other words, the emergence of the problematics of culture as the idea of a language capable of articulating the differences and connections, the individuality and the sociality, of discourses. Social and, particularly, cultural theory are, of course, specifically relevant to this problematic, although insofar as the question of a common culture or of sociality itself is rejected – as repressive or conservative, or as part of an anachronistic emancipationist metaphysics – theories centred around sub-cultural poetics, reflecting what Rosen describes as an obsession with difference as difference, tend to eclipse older traditions of enquiry into normative and symbolic orders at a social level. I have linked the idea of reflexivity to the persistence or reanimation of these traditions in the context of reflective individuation.

There is an inchoate reflexivity related to language and practice in the classical sociological tradition. Weber identified the emergence of value spheres in modernity in a way which precipitates questions about individuation, totalisation and responses to totalisation, questions which can be seen behind the debate he initiated around rationalisation, bureaucracy, art, religion, and erotic intimacy. The question of a politics beyond party struggles over state power is related to that of the politics of social theory itself. Absolute commitment to incompatible values, in this context to individuated languages, brings about not so much politics but tribalism or civil war. Weber advocates an ethics of responsibility; this is both a specific political outlook and, more fundamentally, relates to the possibility of a *polis* itself. Against this,

Weber might be accused of assuming what he needed to demonstrate; an ethics of responsibility does not of itself create the cultural conditions for Weber's broader sense of politics. Some of the paradoxes and difficulties of his position are, however, perhaps best seen as springing from a deep sense of the tragic character of the life of the intellect – of the historical relationship between theory and practice, of important aspects of modern culture itself – rather than from a failure of logic. It is not evident that many of the deeper questions raised by his social theory have yet been resolved.

Durkheim's question, in this context, is that of a binding social framework in the face of gross individualism, a cult of the self as opposed to a cult of humanity, within which genuine individuality could flourish. This was despite what he saw as the real conditions for organic solidarity, here understood to include a positive social relation-ship of individuated languages. This state of affairs could not be just assumed, hence his view of the need for compelling symbols, collective representations. The latter could not, however, resemble the symbols and rituals of traditional societies, the vivid invocation of a pre-given, powerful, embedded and meaningful collective; this is, perhaps, the central question for a Durkheimian sociology of art. Rather, under modern conditions, representations would need to be highly individu-ated yet also, and in a manner connected with this particularity, imbued with a sense of the transcendent. The idea of the modern work of art as an epiphany, discussed by Taylor, is highly relevant here.

The question of reflexivity for social theory is not raised here as that of a new type of social theory in the ways demanded by Wolff and Bürger, who at this point follow Habermas and his influence upon the intellectual tradition of critical theory. This is not just a problem of new concepts or methods of investigation, essentially because the problem is ethical or political rather than technical, epistemological or indeed aesthetic. The ethical cannot be subsumed within the project of knowledge, as Habermas seeks to do, but is radically discontinuous.

If reflexivity does not demand a new theory then what are its implications? I have suggested that it is better understood as something like a prologue or subtext, a distinctive accompanying inflection, a voice emanating not from the security of any one language or cultural location, but as the displaced and displacing question of the social itself.

I have outlined some aspects of Gadamer's view of the origin of specific reflexive, hermeneutical questions in the philosophical theory of the humanities and human sciences. He offers a rigorous critique of the

ways in which art has been conceptualised by aesthetic theory in its notions of aesthetic differentiation, the picture and so forth. On the other hand, he does not simply reject these ideas, but seeks to understand their significance. The result is the hermeneutical recovery of aspects of art and its practice, which artists, good critics and sensitive viewers strive to conserve and develop, often using mixed, imperfect philosophical and critical vocabularies. There is also the implication in Gadamer's discussions that, insofar as artists accept aesthetic theories at face value, they make too many concessions to the rhetoric of the natural sciences. Art is truth, here a way of revealing the question of a social world[3] posed by individuation and objectification. Yet the problematics of the social is again displaced from theory. Gadamer's discussion of Dilthey suggests that, in his struggles with the questions of historicity and objectivity, he sought to remove, as a methodological impediment, the very conditions of his, and anyone's, understanding. Acceptance of this situation would, however, mean for theory a more insecure relationship with itself, less piety with respect to itself and, at a deep level, more ambivalence and ambiguity.

From the point of view of what might be called social hermeneutics, the question of language as such relates to the dispersion of meaning into the monological sub-cultural communities characteristic of modernity, and to the registering and explicit recognition – enshrined as the inviolable principle of difference – of this state of affairs in late-modernity. Yet there remains the problem of a certain abstractness or formalism in this conception of language as something[4] beyond the horizon of both ordinary and theoretical perspectives. I have suggested that there cannot be a reflexive social theory, insofar as theorising belongs to projects of knowledge and clarification; nor, for that matter, can social theory become reflexive by aligning itself with aesthetics. The idea of reflexivity remains not that of displacement as such but of the specific displacement of the theoretical voice within a specific arrange-ment of discourses. While this voice, as historically displaced, cannot offer direct contributions to the work of art or to knowledge it is, nevertheless, significant, perhaps even important, in restating the question of individual responsibility for the construction of the other within the languages and sometimes predatory sub-cultures of modernity, and in keeping open the fugitive question of the social as such. What Gadamer calls the 'speculative structure of language' is not present in the formal structure of communication as the real founda-tion for a discourse ethics, but resides rather in an open, uncompelled recognition of the significance of understanding, its capacity to relate

identity and difference, beings and being, one individual's experience to that of another, across history, culture and language, something threaded through at all levels with receptivity and disclosure.

I have argued for a formal resemblance between the moment of discovery, available through an active process of shaping and discrimination with which many artists throughout the period since the Renaissance have been familiar, and this notion of displaced reflexivity. What distinguishes them, however, is theory's historical legacy. The disengagement of theory from opinion and belief which, as radicalised by Descartes, marks the onset of a new acceleration and deepening of modernity, is the key to its power in organising the social relationship of discourses. Yet art is, along with knowledge, a powerful region in the political and cultural topography of modernity, and the placing and displacing poetics of which both are capable is one of the keys to their specifically modern character. The placing of art by knowledge, eventually contested by Romanticism, then by Nietzsche and his postmodern disciples, and the enormous power of expressive individuation, both as a universal political and cultural principle and as realised and exploited by consumer capitalism, demonstrate the dynamic instability of modern cultural politics. I have also tried to show how the ethical or reflexive question of placing and displacing, of individuation and totalisation, of value spheres and the social – presented here as a chronically unsettling question for social theory itself – has appeared in the tradition of classical social theory, but is now perhaps best heard at its margins. Both Lyotard and Bauman make this point, that the issue of totalisation is inevitably both a specially pertinent one for social theory, but also wholly marginal to its newly strengthened expertise-oriented pragmatics.

Finally, I want briefly to consider, beyond theoretical and meta-theoretical problems, some more concrete implications of this essay for art worlds and art pedagogy. One important psychological implication of this essay is that artists need not and should not feel guilty about what they do. They should not allow themselves to be made to feel that their existing practice is stupid, dumb, deluded or wicked, at least without asking some questions to and about those who try to make them feel this way. Art and artists are not necessarily philosophically naïve; nor are they, by virtue of the very nature of their activity, witless propagators of ideology. Neither should artists feel they cannot use terms like imagination, feeling, expression, form, content, meaning, beauty, aesthetic quality, commitment, integrity, honesty, courage, all of which are frowned on or ridiculed by postmodern new-speak. In other words, they should not be frightened to use a critical vocabulary

that has demonstrated its appropriateness over the years, and that, if employed properly, may further their development as artists. The ultimate test of the vocabulary is, of course, whether it is compatible with learning and development. A vocabulary must enable criticism and discrimination, of course, and I have argued that the demands made by new expressive projects often turn out to be understandable and developable through the flexible employment and modification of existing terms. In practical areas like art, housing, agriculture and child rearing there should be good evidence that radical new arrangements are actually necessary, and that they will work better, or at least as well, as older ones, before they are embraced wholesale.

The teaching and practice of art have traditionally been closely related. All of the points made above about the necessity for artists to retain their self-confidence and belief in what they are trying to do apply directly to the pedagogy of art. The relationship between studio teaching and the history and theory of art has rarely been an easy one, and difficulties have increased with the popularity of a kind of art history and theory that is hostile to art, viciously reductive, intellectually shallow and purblind to the moral character of its own constructions. It describes itself more honestly when it drops the title 'art history' and declares itself to be concerned with the sociology, or social history, of visual culture ('visual culture' being less elitist and ideological than 'art'). If the commitment to sociology is serious then I would argue that the diversity and complexity of the sociological tradition needs to be seen and engaged with; even more importantly, the moral challenge provided by sociological reflexivity is unavoidable.

The depth of the problem with the relationship between studio teaching and the history or theory of art is indicated by the fact that the suggestion that those teaching art history should be capable of enjoying and valuing art, and of communicating their enthusiasm to others, has come to sound naïve, or even preposterous! Art needs a history and a theory that is capable of being supportive and complementary to practice, as well as critical. History and theory must, of course, maintain their rational character, but simultaneously set themselves in a broader cultural context, which would include a view of the question of the relationship between discourses that modernity brings with it. As I have argued throughout, these troubles are not just external. They are inherent in modern discourse, even in efforts, like this one, which try to reflect upon them.

The tasks of good art teaching remain what they have always been; like most educational aims they have often been honourably striven for,

and sometimes achieved, however imperfectly. Students need to develop an active respect for tradition without being intimidated, overawed, or immobilised by it. They need to understand that authentic tradition only lives through significant, disciplined innovation. Individuality should be valued not as a commodified, marketable, post-human difference but as something that will become artistically significant only through its encounter with the demands of form and meaning, that is, through the effort to open up the work to a public without sacrificing its integrity.

Notes

Chapter 1

1. For Althusser, a 'symptomatic' reading 'divulges the undivulged event in the text it reads, and in the same movement relates it to a different text, present as a necessary absence in the first' (Althusser and Balibar, 1970, p. 28). In this case the 'different text' would be one that presents, and therefore preserves, the integrity of art.
2. See also G. J. Fyffe's review in *Sociology*, **17**(1) February 1983.
3. See also below.
4. See Danto (1964, 1973), Dickie (1964, 1969, 1973, 1977), Elton (1954). For a critical review of this literature from the point of view of contemporary analytical philosophy see Mothersill (1984), pp. 33–73; also Hanfling (1992), pp. 19–32, and Wollheim (1987), pp. 13–17.
5. For a different view see Witkin (1995).
6. See Haskell (1976).
7. The effect would, of course, be acceptable to someone who thought that art was a bad thing; thus, for example, simplistic readings of Plato have encouraged some to believe that art, in stirring up the emotions, makes people more difficult to govern, while for vulgar Marxists art is merely ideology in the service of a ruling class. In fact few are prepared to go quite so far. Critics of art usually rely upon an escape clause enabling them to save the particular kind of art – although sometimes the name changes – of which they happen to approve. Thus, some canonical works are judged acceptable because of their educational, moral or political usefulness.
8. For example, the Preface and the paragraph just quoted from (ibid., pp. 149–50). Cf. T. J. Diffey's question in his review (*British Journal of Aesthetics*, vol. 23, 1983, pp. 367–8) as to whether Becker's approach is sociological, philosophical or both, and if the latter whether this is a coherent possibility.
9. See Wilson (ed.) (1970), and Hollis and Lukes (eds) (1982).
10. It might also be argued, against this point, that part of the real intellectual challenge represented by postmodernism is an imperative for disciplines largely produced by modernity – like sociology – to undertake the kind of self-reflection I am proposing. Peter Wagner writes:

its [postmodernism's] contribution does not reside in the rightness of its own positive claims (which, as is well known, many authors like to keep somewhat obscure), but in the critique of social science that it provides. The discourse on postmodernity sees modernist social science as being founded on assumptions, a priori, of the intelligibility of the social world, of the coherence of social practices and of the rationality of action. (Wagner, 1994, p. 151)

Wagner quotes Dahrendorf's opinion that German sociology's general reaction to the positivism and methodology debate was that neither Popper nor Adorno were sufficiently in touch with the real problem of improving the quality of empirical studies. For Wagner, this indicates that 'key features of modernity had become standard assumptions of modernist social science rather than phenomena that can and should be exposed to inquiry' (ibid.).

11. The restriction of reflection to the useful – as defined for sociology by its own institutional, bureaucratic social context – leaves it vulnerable to revelations about its politics by activists who are now largely outside the academy. More importantly, it also tends to blunt the capacity of the discipline to raise fundamental reflexive questions which are, from the point of view of its paymasters and controllers, literally useless. On the 'hollowing out' of sociology's radical and humane core see Horowitz (1993).

12. See below, Chapter 4, note 9.

13. See Douglas, cited in Wolff (1983), p. 38.

14. There is a close connection here between American symbolic interactionism and a Puritan tradition for which everyday life itself has a strongly spiritual dimension; see Charles Taylor (1989), pp. 211–302.

15. Examples of this eclecticism are legion in the history of art. It is not uncommon for theorists to find the imprecision, profligacy, even recklessness of artists with academic and philosophical concepts frustrating or risible. Wiser theorists, however, recognise that there is often more going on here than mere misunderstanding or legitimating rhetoric, and that often eccentric, wildly unscholarly interpretations of philosophical ideas, even downright misunderstandings, can serve the purposes of creativity. For an interesting recent example of the former see Bois (1993), pp. 66–97.

16. It plays a role in what is called elsewhere 'will-formation'.

17. Using Giddens' term, this might be described as an instance of the 'disembedding' typical of modernising processes.

18. These arguments and remarks upon which this interpretation of Durkheim is based, which contradict the usual image of the cheery positivist, are fragmentary in his writings. The interpretation is not, however, unreasonable; see also Jenks (ed.) (1993a), pp. 124–5.

Chapter 2

1. Bauman (1987), Touraine (1995), Wagner (1994).

2. Now, in 1997, it is still in print and has indeed gone to a second edition.

3. If 'essential' means here something like 'factually necessary' then one could not object. However, if 'essential activity' means 'defining characteristic' then there are some problems. There seems nothing specifically, uniquely human about the basic activities through which human beings, as natural creatures, fulfil their basic needs. What makes human beings human are the ways in which they

respond to basic (and other) needs, not just some natural response or behaviour. If it is the case that a defining characteristic of human being is the social organisation of labour a lot depends upon what the social is taken to include; for example, the reasons for excluding the political sphere, as does Wolff, are not immediately obvious, either logically or empirically. As Giddens notes:

> It certainly does not follow that, because material production is necessary to sustain human existence, the social organization of production is more fundamental to explaining either the persistence of, or changes in, societies than other institutional forms. (Giddens, 1981, p. 88)

4. One immediately thinks of the critical photography of Victor Burgin in this context. Peter Fuller recalls a piece shown at the Hayward Annual in 1977:

> He decked a room with examples of the same printed poster which showed a chic advertising photograph of a glamorous model and jet-set man... The photograph was sandwiched between the slogans, 'What does possession mean to you?' and '7% of the population own 84% of our wealth'. Here we have Warhol, less the residual materiality of paint and the ever-so-imperceptible trace of imagination, plus an added extra ingredient. Political content! (Fuller, 1980, p. 29)

5. Wolff insists that it is not the case that the ideology of social classes or groupings is simply 'reflected' in art; rather, ideological content must be articulated through the codes and conventions of the art form in question. This does not, however, get Wolff round the problem of the reduction of artistic meanings to ideology. All it suggests is that the process through which this is supposed to happen is 'mediated', 'complex' and so forth; a complicated reduction is still a reduction.

6. Of course, for discourse theory, aesthetics could be relatively autonomous not in relation to some non-discursive real world but only *vis-à-vis* other discourses, which might be ranked in terms of their relative power.

 It may be that Wolff does not develop discourse theory's most distinctive suggestion – to see art as one discourse among others with which it is involved in a complex set of social relations – because she fears an idealist thread at odds with her Marxist stance. As she notes, Laclau's proposal of the discursive character of class antagonisms is 'controversial'; given her position, 'untenable' would have been better.

7. See Lacan (1979), pp. 67–105.

8. She presents a summary of Bourdieu's (1979) *La Distinction: critique sociale du jugement.*

9. Unfortunately such has been the impact of these sociological and political views on some artists that many now seem to suffer from a chronic lack of confidence. This kind of demoralisation rarely helps with their capacity to improve the real artistic quality of their work. All too often their pieces become illustrations of half-understood theories, of a kind of insipid, sociologically tinged self-mistrust.

10. Students of art are often brought to appreciate these complexities through deliberate oversimplifications, which invite misunderstanding if grasped too concretely. For example, in the successful work of art, form and context are fused and inextricable. But in teaching it is often useful, indeed essential, to encourage consideration of these dimensions in relative isolation from each other.

11. It is interesting to recall Lukács' struggles here. Of particular interest is how he understood the role of 'perspective' in the actual production and organisation of the work of art. The artist, like the scientist, must select from the myriad details of life, discarding what is 'inessential', imposing a structure that gives the resultant work a formally satisfying unity or inner coherence. Without these characteristics, a representation could not claim the status of having achieved artistic objectivity. This might suggest that the artist, like the scientist, must follow a methodology, or at least a set of rules and principles. Lukács shies away from this conclusion. Nevertheless, knowledge, an objective viewpoint, is involved. The ordering principle must be knowledge of where, historically, society is going, and although *The Meaning of Contemporary Realism* (1963) does not spell it out, it is clear that this can only be provided by Marxist theory. In the last analysis, although artists must be allowed some independence, their works still have to be judged against the truth about the social and historical totality, a truth which is the privileged possession of the Party. As Plato anticipated, when philosophers or theorists rule the subordination of art is either concurrent or postponed.

12. I am unaware of any sociologist who practices in this way. I argue elsewhere – Heywood in Whiteley (ed.) (1997) – that various pieces by the German artist Gerhard Richter should perhaps be understood along these lines.

13. See Lyotard (1984b) and Lyotard and Thébaud (1985), *passim.*

14. Historically, it seems to be relatively unusual for this kind of ethical sensitivity to survive Marxist-Leninism as a political practice, at least once it gets close to exercising state power, despite the fact that its commitment to social justice is what often attracts recruits in the first place.

Notes to Chapter 3

1. Of course, throughout *Truth and Method* (1975), Gadamer denies that he is prescribing a methodological reform of the human sciences. What Bürger learns from hermeneutics, then, is its refusal to conflate understanding *per se* with scientistic objectification, and more generally the aspiration to dialogue as an ideal form of human being.

2. See White, H. C. and White, C. A. (1965).

3. The non-organic art work is a 'mediated unity': 'In the organic (symbolic) work of art, the unity of the universal and the particular is posted without mediation; in the non-organic (allegorical) work… the unity is a mediated one' (Bürger, 1984, p. 56). It is not immediately apparent from the text what this difference amounts to.

 Bürger also makes a somewhat complex argument that political engagement in art works becomes possible in a new and more satisfactory way once organic form has been abandoned; the point seems to be roughly that, with the non-organic work, the political element need not be subordinated to a formal principle of unity or harmony (see ibid., pp. 89–91).

4. The metaphor of vision for fundamental ideas of knowledge and truth is of particular importance. It has been famously argued by both Heidegger and Derrida that a reflective (but not reflexive) notion of presence, related to vision and speech (but not 'language' and 'writing'), has been foundational for dominant 'Western' notions of truth.

5. For a fairly typical discussion of the often positive things Marx said about art – perhaps by now embarrassing for the politically correct – see Laing (1978), pp. 3–12. For a far-left, anarchist critique of the excessive reverence of the Marxist tradition for 'bourgeois' art see Taylor, R. L. (1978), pp. 59–87. In fact, this chapter is entitled, appropriately enough given Taylor's views, 'The Fraudulent Status of Art in Marxism'.

6. There follows a lengthy discussion of the Lukács–Adorno debate in which Bürger is more concerned with assumptions they share rather than with what they conceived of as the content of the dispute. He feels that neither deals adequately with what he takes to be the *function* of art within bourgeois society, mainly because they fail to break with the notion of aesthetic autonomy. He admits that, for Adorno at least, the autonomy of art does, paradoxically, suggest its function; in being removed from the means–ends rationality of bourgeois life it stands as perhaps the sole remnant of difference and criticism. For Adorno, the study of the supposed effects of art stands in danger of missing everything that is distinctive and important about it: its negative social content. Bürger urges us to note that the

> juxtaposition of the speculative content of the work of art for which he is indebted to the aesthetics of idealism, and the positivistic conception of effect. But in this juxtaposition, he forgoes the possibility of mediating work and effect with each other. (ibid., p. 11)

In a later chapter Bürger indicates somewhat more clearly where his approach differs from that of Lukács and Adorno. What this seems to come down to is that art should be studied as a functional institution within bourgeois society, and that its operation as a whole determines the effects of particular works. The quarrel between realism and modernism is a waste of time:

> But once the historical avant-garde movements revealed art as an institution as the solution to the mystery of the effectiveness of art, no form could any longer claim that it alone had either eternal or temporally limited validity. (ibid., p. 86)

The implication for scholarly inquiry is that questions of norms and validity are completely displaced by questions of functional analysis aimed at assessing the 'social effect' of the 'art system'; quite how this escapes the charge of being a 'positivistic conception of effect' writ large is not clear, at least to this reader.

7. As Bauman would put it, this is another victory for the garden of culture over nature's wilderness.

8. But certainly not, for Adorno, artistic structure or form.

9. The themes of violence, aggression, military organisation were relatively neglected themes in ways in which social theorising thought about itself, at least until the advent of some postmodern critiques of the involvement of social science disciplines in the development of modernity. Before these became well known, Alvin Gouldner, analysing what he took to be one crucial element within Marxism, described its 'Critical' incarnation as leading to a policy of 'active interventionism, organizing instruments such as the Party vanguard or military forces that facilitate intervention' (Gouldner, 1980, p. 59). In contrast to 'Scientific Marxism' this 'Critical' tendency is activist, voluntarist, anxious and willing to engage in organised struggle.

Its militaristic tendencies were given adds impetus by Lenin and later Leninists. As Parkin writes:

> Lenin's alternative reading systematically plays down the vocabulary of organic growth into socialism in favour of the equally authentic language of violent transformation... Nothing could be further from the spirit of the organic model of transition than Lenin's relentless underlining of those passages by Marx and Engels that exult in the creative possibilities of political violence. (Parkin, 1979, p. 147)

Of the military history of philosophy Stanley Rosen writes:

> In contrast to what one may call the official pacifism of contemporary liberal intellectuals, it is interesting to note the regular conjunction of philosophy and war in the history of western thought. Between Plato's philosopher–soldier and Nietzsche's artist–warrior falls the war against nature, symbolized by the scientific experiment, and made on the basis of philosophy by the ex-soldier, Descartes. What is today called 'hard-headedness' or 'tough-mindedness' in analytical circles is technologicized version of Cartesian militarism. (Rosen, 1980, p. 193)

See also Lampert's recent study (1993) of Bacon, Descartes and Nietzsche for a compelling view of a very militant strand in the history of philosophy.
10. Cf. Odo Marquard's brilliant essay 'Indicted and Unburdened Man' in Marquard (1989).
11. See in particular Habermas (1981, 1987). Chapter 5 of the latter work on myth and enlightenment in Adorno and Horkheimer is especially useful.

Chapter 4

1. See for example his defence of Berlin – who, he believes, sets out a similar argument in 'Two Concepts of Liberty' – from Michael Sandel's criticism (Rorty, 1989, pp. 46–7).
2. See for example Kuhn (1962), p. 24.
3. I am not suggesting, of course, that the details of Rosenberg's position represent a consensus, but rather that, on the issue of novelty, he sets out and tries to defend a very widely held conviction regarding an important aspect of avant-garde and, more broadly, modernist art.
4. Rosenberg pointedly writes:

> That art... is 'currently without standards or criteria' causes one standard to prevail among modern art officials – the practical one of exhibiting whatever is most publicized as the new as promptly and conspicuously as possible. The vacuum of values is filled by the activity of opening doors to the future. (ibid., p. 229)

5. It also suggests that the ground of the possibility of conversation is a community of interest. In its general character the argument here seems close to Kantian transcendentalism: as conversation clearly is possible for Rorty, we must presuppose the agreement that makes it so.
6. See Cladis (1992), Chapters 4 and 9.

7. Unsurprisingly, Rorty does not examine edifying theory in terms of its everyday interests. Rosen is perhaps making this kind of point when he notes that: 'In his account, the task of hermeneutics, whether of written or spoken sentences, resembles an endless series of high-level academic conferences, or the exemplifications rather than the destruction of bourgeois civilization' (Rosen, 1987, p. 185). In *Contingency, Irony, Solidarity* Rorty is very keen on his readers embracing their own 'contingency' in respect to language, self and community. Rejecting a teleological view, which would represent the history of culture as leading towards the disclosure of truth or human emancipation, he remarks that his preferred version would be 'compatible with a bleakly mechanical description of the relation between human beings and the rest of the universe' (ibid., p. 17). Genuine novelty can occur within this mechanically contingent culture; was it not chance genetic mutation that produced orchids and anthropoids? Might there not have been some similar random events behind the genetic or psychological makeup of thinkers like Aristotle, Saint Paul and Newton which engendered their decisive ideas, the new metaphors which sent the world around them spinning off in a new, unprecedented direction? But when he develops his argument for the paradigmatic status of the 'strong poet' he evidently does not believe 'that any poet could seriously think trivial his own success in (adapting Larkin's poem) tracing home the blind impress born by all his behavings' (ibid., p. 24), that is, his own utter mechanical contingency, presumably because of the contradiction between this idea and the image of the poet as the archetypal self-made man. Equally, if the only difference between idiosyncratic cultural mutations represented by the fantasies of the sexual pervert and those of the artistic genius is that the latter manages 'because of the contingencies of some historical situation' to 'catch on' (ibid., p. 37) with a larger and more influential public than the former (one hopes), then one begins to question why Rorty writes, or expects his books to be read, with any degree of seriousness or attention.

8. As Rorty admits:

> Metaphors are unfamiliar uses of old words, but such uses are possible only against the background of other old words being used in old familiar ways. A language which was 'all metaphor' would be a language which had no use, hence not a language but just babble. (Rorty, 1989, p. 41)

9. Any discussion of its intrinsic qualities beyond its specified function would be pointless and meaningless. Here, again, there is an ironic convergence of different political camps; the supposed economic realism of the Right, its impatience with what is seen as an old-fashioned cultural paternalism and the obstacles to radical reforms it throws up begins to sound remarkably similar to the kind of language employed by new strategic theories of the Left. One thinks, for example, of Stuart Hall's Gramscian turn away from epistemological concerns towards pragmatically defined interventions in popular culture and ideology; see Hebdidge (1988), pp. 203–4.

10. In Bernstein (ed.) (1985).

11. As opposed to the special language uses of poets, edifying theorists and the deranged.

12. Even though, for Rorty, liberal society needs the liquefactive balm of high-minded, edifying discourse to keep it liberal.

13. Sociology once discussed this in terms of social roles; now ideas about the self-as-project are more common. See for example Giddens (1991), Chapter 3.
14. Deconstructionism, being anxious to avoid the substantiality and presence of the artefact, goes one step further and stresses processes within language ('intertextuality') rather than its products.
15. I do not wish to suggest that human agents are wholly passive, while language is active, in this kind of process. Conflicts between discourses are always also conflicts between those who use them, often with quite concrete ends in mind. On the other hand, it is also important not to relapse into a view that a language is a mere tool at the disposal of those who operate within it, or that intentions, goals, values, strategies and so on can be formulated outside the specific set of possibilities offered by a discourse.
16. Among the better-known works in the area of social theory, which have something to say about this process, are those by Weber (1948, 1958), Horkheimer and Adorno (1979), Habermas (1984), Lyotard (1984b), Wagner (1994). It should perhaps go without saying that there are very important differences between all these authors. The topic also appears in philosophical works; see for example Lampert's discussion (1993) of the contribution of Bacon and Descartes to the formation of modernity. Also Gadamer (1981) and Heidegger (1981).
17. See also below, Chapter 5.
18. See Giddens (1991).
19. See Calinescu (1990).
20. See Giddens (1991), Beck (1992), and Beck, Giddens and Lash (1994).
21. This unfolding is not however, *pace* Hegel, itself a logical or dialectical process. There are multiple possibilities for languages to explore and realise; which get taken up and how exactly they develop is influenced by contigent historical and social circumstances.
22. As Bauman says:

> in such philosophies communities (or forms of life, or traditions, or languages) have become synonymical with the idea of truth: community is the area in which a truth is objective and binding in as far as there is a community which accepts this and thus makes it into a reality inside its boundaries. Community and truth are two rhetorical figures which refer to each other, each one legitimizing itself through the other in the world of experts and compartmentalized truth. (Bauman, 1993, p. 94)

23. An exception is Lyotard, who is very concerned with the whole question of totalisation; see for example the discussions in *Just Gaming*, and also below, Chapter 7.
24. Mourning the passing of an older tradition of critical radicalism, Bauman speaks of the 'intellectuals' neolithic revolution'. He means by this a late-modern shift in the aspirations of many in the social sciences and humanities from positions from which criticism was possible (the category of stranger) to the securities and comforts of modest but useful expertise.
25. This position is taken, with different inflections, by Adorno, Merleau-Ponty, and more recently Michael Phillipson. See also below, Chapter 9.

Chapter 5

1. In his *When Words Lose Their Meaning* (1984) particularly Chapter 1.
2. See Williams (1985), Chapter 8.
3. I do not mean to imply here that this kind of position inevitably suffers from false consciousness, only keeping theory at bay through a denied theoretical involvement. A stance can keep its distance from theory without being theoretical, although it has to be quite sophisticated, for example by having a fair idea of what theory is and why it needs to steer clear of it; various atheoretical positions and practices within art, usually developed and deployed by highly intelligent artists, have shown a capacity to manage theory in this way.
4. Below, we will see Charles Taylor locate this recognition of the constitutive power of language in the modern era, foreshadowed by Herder, but only really explored by poets and philosophers in the twentieth century. For Louis Dupré, however, the idea was introduced by the early humanists of the fifteenth century:

> As Dante had written, through metaphor the poet creates 'from nothing' in the order of language as God through his Word creates ex nihilo in the order of nature. Form became an ideal, partly realized through divine creation and partly to be realized through the human word. (Dupré, 1993, p. 45)

5. I do not mean to imply that the distinction between 'passive' and 'active' notions of reflection is only to be found in respect to modern theory. Its pre-modern origins probably belong to theology and the arts.
 The connection between finding and reflection in the sense of mirroring, and making and reflection in the sense of active illumination, is the theme of Abrams' classic study *The Mirror and the Lamp* (1953). See also below.
6. Taylor makes this point in his essay 'Social Theory as Practice' in Taylor (1985).
7. Dupré (1993) covers similar territory to Taylor but disagrees extensively, particularly with respect to placing the origins of important modern ideas and cultural forms much earlier.
8. This has been, of course, an important issue for many thinkers, including Weber, Simmel, and more recently Habermas, who says: 'pluralization of diverging universes of discourse belongs to specifically modern experience… We cannot now simply wish this experience away; we can only negate it…' (Habermas in Bernstein, 1985, p. 192, also quoted by Bauman). For a summary of his reading of Weber on this issue, see Habermas (1984), pp. 163–4.
9. Taylor quotes Wordsworth:

> Poetry is the most philosophic of all writing:… its object is truth, not individual and local, but general and operative; not standing upon external testimony, but carried alive into the heart by passion; truth which is its own testimony. (Taylor, 1989, p. 372)

10. This kind of work is sometimes called 'auto-telic'. As Taylor notes:

> An influential strand of thought from the Symbolists on has conceived of the work not as an epiphany of being, either of nature or of a spiritual reality beyond nature. They have tried to detach it from all relation to what is beyond it and yet, paradoxically, to retain the epiphanic quality. The work remains the

locus of revelation, and of something of ultimate significance, but it is also utterly self-contained and self-sufficient. (ibid., p. 420)

This is, indeed, a highly paradoxical position; quite how can the work manage to be of 'ultimate significance' if it does not refer to anything, if it is 'beyond language'? Yet some (but not all) of the best of twentieth-century art is, in my view, close to being like this. I have in mind a lot of abstract painting and sculpture. As Taylor suggests in his discussion of the symbol (or image) versus the allegory, it is not perhaps that the work is beyond language but that it is beyond discourse. Here, music is a paradigm case.

11. See ibid., p. 422.
12. Courbet is mentioned in this context.
13. It is interesting to note the resemblance between Taylor's 'interspacial' epiphany and the idea, popular in the 1970s and 80s in the wake of structuralism, of a system of differences without positive terms.
14. Taylor goes on to discuss modernist art in relation to Adorno, Benjamin and Proust, but the main point he wants to clarify is that of the differences and the continuities between the Romantic and modernist epiphanies. The important type of modernist work, aimed at a 'framing' or 'interspacial' epiphany, breaks with Romantic epiphanies of being which '(1) show some reality to be (2) an expression of something which is (3) an unambiguously good moral source' (ibid., p. 479), specifically by rejecting (2). Other modernists break with (3); he mentions Thomas Mann's *Death in Venice* here. With expressionist painting (he presumably has in mind painters like Nolde) both (1) and (3) are rejected. He claims that what all these modernists share is a consciousness of existing on a variety of levels in a variety of ways that are irreducibly different and that makes problematic the idea of a unified 'centre' to experience, whether expressive, rational or instrumental. He also insists that, even where modernists explicitly reject subjectivity in favour of, for example, the primordial forces of language, this is still a turn inward, a radical form of reflexivity; access to language is through a personal vision of some kind, and the artist or poet, even when fully 'de-centred', is no less important in modernism than for the Romantics.
15. As is well known, Kant grapples with the consequences of Enlightenment for morality, religious belief, and the politics of freedom, reason and autonomy in his three *Critiques*.
16. Habermas remarks on this point:

Nietzsche enthrones *taste*, 'the Yes and No of the palate,' as the sole organ of 'knowledge' beyond truth and falsehood, beyond good and evil. He elevates the judgement of taste of the art critic into the model for judgement, for 'evalua-tion'. The legitimate meaning of critique is that of a value judgement that establishes an order of rank, weighs things, and measures forces. (Habermas, 1987, p 123)

17. Novels by writers like Musil and Joyce provide good examples.
18. Yet the commitment to the decisive, epiphanic work of art remained central for many of the most important modernist artists through into the twentieth century, although for some the idea of expression was replaced by that of interspacial (or decentered) epiphany. The well-known Lukács–Adorno dispute is in part about this issue. See Bloch *et al.* (1977).

19. His essay 'Legislators and Interpreters' (in Bauman, 1992) provides a useful summary of his earlier eponymous book. The arguments of the two are not substantially different, although the latter contains some material of direct relevance to my arguments; see below.

20. A problem appears immediately: Bauman no sooner sets up the deep, inescapable pluralism of the postmodern age than he seeks to evade it. The intellectual, here the social theorist, is to be reflexively treated within the societal figuration (a difference in a system devoid of 'positive terms'), which itself is a definitive totality. What I take this to mean is not only that the social theorist is to be reflexively included in the field of study, but also that social science is arbitrary with respect to its content (theories, meta-theories, methodologies, findings and so on). It has a definite character at any one time only by serving a particular function within the social totality. If this is the case it would include this view also; it is very difficult, then, to see how Bauman could claim it to be 'true' in anything like a normal sense. Not only does this image of society exclude plurality – in being entirely a concept belonging to social theory – but it makes the discipline and its meta-theory arbitrary with respect to knowledge.

21. Lewin is quite happy to apply this characterisation not only to Constructivism, Futurism, de Stijl, and the Bauhaus but also to such strange bedfellows as Impressionism, Dada, and Abstract Expressionism. He tries to make this look less implausible than it is by arguing that, as the spell of modernism fades, movements which at one time looked radically different are now revealed to be identical.

22. Bauman is perhaps overlooking here the famous and important nineteenth-century battle fought by artists, dealers and critics against the academy system, which had been instituted in its modern form by that 'hero' of legislatively inclined intellectuals, Louis XIV. See his remark on this topic, ibid., p. 171.

23. This seems not only unfair but also dangerously close to a 'damned if they do, damned if they don't' tactic.

24. Still perhaps the best philosophical contribution to this topic is by Sibley's 'Aesthetic Concepts' in J. Margolis (1987), pp. 29–52.

25. One well-known example is Greenberg's influence not only on criticism but also, apparently, on the actual practice of some artists during the 1960s. Anthony Caro is often mentioned in this context.

26. See Bois' interesting argument about Cubism and Kahnweiler's paradoxical (mis)use of Kantian aesthetics to understand it. It does not seem to me that we have yet really come to terms at a theoretical level with what great modern artists like Manet, Cézanne, Monet, Matisse and Picasso were up to.

27. For example, Sartre's existentialism and work by artists like Bacon and Giacometti.

28. Perhaps the most famous influence of a theory on artistic practice is that of psychoanalysis on Surrealist practices like 'automatic drawing' and the ideal, in Breton's phrase, of 'pure psychic automatism'. On the other hand, much of Surrealist doctrine and practice had very little connection with Freud or psychoanalysis.

Chapter 6

1. At the level of visual art as such, at genre level, and at that of the individual work.
2. By 'right judgements' I do not imply that criticism must come to universal, eternal and binding truths or fail completely. However, it does seem clear that the members of a social world, as part of having a world in common, must have some sense of the reality, or at least the possibility, of reasonably sound evaluations of its works and deeds, and of improving them through discussion and criticism.
3. The 'intentions of the piece' are in most cases closely tied to the intentions of its producer; but there are cases where the two do not coincide, where the piece seems to have set off in some direction of its own, or to have shifted the rules of the game through which existing intentions could be formulated.
4. Critical practice cannot, however, look to theory to *resolve* its central problems of the interpretation and judgement of particular works.
5. See above, Chapter 5, Abrams (1953), pp. 3–63, and Taylor (1975), Chapter 1.
6. See Greenberg's classis essay 'Modernist Painting' in Battcock (1966), pp. 66–77 and Fried's equally classic 'Art and Objecthood' in Battcock (1968), pp. 116–47.
7. For a recent and powerfully expressed argument along these lines, from a somewhat unexpected quarter, see Bois' *Painting as Model.*
8. One notes here the fervent efforts of Benjamin Buchloh to recruit Gerhard Richter to the cause of Leftist cultural politics. Richter is, however, adept at manipulating critics like Buchloh, refusing to be pinned down to anything very definite. His wonderfully self-contradictory statements could be made compatible with almost anything.
9. Gombrich's *Art and Illusion* argues for cognitive advances embodied in Western art by understanding artistic practice along the lines of Popper's hypothetico-deductive view of science; the modification of what Gombrich calls 'visual schema' by the testing demands of the artist for greater verisimilitude is analogous to Popper's view of scientific method. A Popperian description of the way science works 'is eminently applicable to the story of visual discoveries in art' (Gombrich, 1959, p. 272). Gombrich's story of art traces the development of man's ability to represent the world from relatively crude, undifferentiated Egyptian wall paintings through to the sophisticated, individuated vision of Constable's *Wivenhoe Park.* The story has some difficulties accommodating what seems to be a characteristically modern rejection of the investigation of nature. Gombrich notes that Impressionism, that crucial entry point into the 'visual conundrums of twentieth century art' (ibid., p. 169), cut the tie between loose brush strokes and the contours of objects; in order to 'read' the picture the eye must traverse across brushstrokes. This new emphasis on the picture surface is understood by Gombrich as an effort by Impressionists to allow the spectator some of the pleasure previously only experienced by the artist. 'The artist gives the beholder increasingly "more to do", he draws him into the magic circle of creation and allows him to experience something of the thrill of "making" which had once been the privilege of the artist' (ibid.). From the point of view of this essay this characteristic of much modern painting owes as much to the attempt to establish and explore the specificity of the artistic signifier, and thus distinguish it from those of other languages, including science, as it does to any 'democratisation' of artistic vision.

10. 'Push-pin' is Bentham's famous example (see Abrams, 1953, p. 301).
11. See Abrams, ibid., pp. 312–15.
12. Cézanne's profound and complex devotion to 'nature' famously sparked what is still one of the most profound encounters between philosophical theory and modern painting, that of Merleau-Ponty. See for example the selected writings of Merleau-Ponty and critical essays in Johnson (1993), essays in Dillon (1991) and Phillipson (1985), pp. 47–57.
13. See Lyotard in Johnson (1993), pp. 323–35.
14. There is a large literature reviewing these developments. See for example Lentricchia (1980) *After the New Criticism*, Eagleton 'Marx After Derrida' in *Diacritics* **15**:4 (Winter, 1985), and Pollock 'Vision, Voice and Power: Feminist Art History and Marxism', *Block 6* (1982). The development of various feminist perspectives in the visual arts, and the effort to devise practices in line with these views, is interesting and complex. It bears only tangentially, however, on the more important ideas discussed here. Mainstream social theory has developed in such a way as largely now to include the possibility of a feminist 'interest' and its specialist research, and certainly issues related to some of the meta-theoretical and ethical questions raised in relation to what has been called reflexivity have been discussed from a feminist point of view. On the other hand, I do not think that the issues can only be discussed from an explicitly feminist position. I also believe that they pose issues *for* a wide range of intellectual and quasi-political positions, including those found in contemporary feminism.
15. An interesting example of this kind of problem erupting is the response of younger female (and in some cases explicitly feminist) painters to Griselda Pollock's efforts to declare painting off limits for women artists. See conversations with Rebecca Fortnum, Rosa Lee *et alia* in a series entitled 'Women and Contemporary Painting' in the journal of *Women Artists Slide Library* (UK), no 28 (April–May 1989).
16. Things do not seem to have improved much since Eagleton's comments in 1976. Discussing the 'theoretical prudery' of much Marxist aesthetics he writes:

> At its simplest level it appears as an egalitarian unease about the 'elitism' of assigning certain works to second-class status: how patrician to prefer Blake to Betjamin. In its more sophisticated form, it presents itself as a rigorous scientificity hostile to the idea of 'normative' judgement. (Eagleton, 1976, p. 162)

17. See Lukes (1985).
18. Tracing the origins of nihilism to a loss of belief in a meaning beneath all events, Nietzsche writes:

> This meaning could have been: the 'fulfilment' of some supreme ethical canon in all events, the ethical world order; or the growth of love and harmony in social intercourse; or the gradual approximation to a state of universal happiness; or even the departure toward a state of universal nothingness – any goal constitutes at least some meaning. What all these notions have in common is that something is to be achieved in the process – and now one grasps the fact that becoming aims at nothing and achieves nothing. (Nietzsche, 1967, p. 12; quoted in Heidegger, 1981, pp. 24–5)

19. It is interesting to compare here Danto's celebration of the post-philosophical utopia for art initiated by Warhol's *Brillo Boxes*:

> Warhol was, appropriately, the first to set foot in this free moral space... Who can fail to believe that, in art at least, the stage had been attained that Marx forecast for history as a whole, in which we can 'do one thing today and another tomorrow, to fish in the morning, and hunt in the afternoon, rear cattle in the evening, and criticize after dinner, just as I have a mind, without ever becoming hunter, fisherman, shepherd or critic'. Its social correlate was the Yellow Submarine of Warhol's silverlined loft, where one could be straight in the morning, gay in the afternoon, a transsexual in the evening and a polymorphic rock singer after taking drugs. (Danto, 'Andy Warhol', *The Nation*, 3 April, 1989, p. 459; quoted by Herwitz, 1993, pp. 31–2)

20. From a postmodern view one would probably have to discuss this in terms of the semiotic disturbance represented by the post-self, if indeed anything like discussion is possible, given this framework.

21. Modern formalism is usually traced back to Gautier, Pater, Bell and Fry, and is seen to have influenced the visual arts through the postwar critical writings of Clement Greenberg. Perhaps the only thing neo-Marxists, feminists and postmodernists have had in common is their hostility to Greenberg and all his works. I have no wish to revisit this episode. Bois, however, makes some valuable points when he adversely compares a French critical tradition with an American one, dialectically related to Greenberg (and his concern for form), even when rejecting him. See Bois (1993), pp. xv–xx.

22. This is all too easily recalled: thick, gooey paint, garish colours, crude drawing, sad clowns, floating waifs, red roses.

23. Bad examples of work in this genre are again common: crude colours, imprecise surfaces, laboured composition.

24. Richter seems sometimes to be operating in this area. For example, in his versions of Titian's *Annunciation* representational and narrative content is almost obliterated, yet the paint handling is such as to suggest considerable formal adequacy within a modernist painterly genre. The presence of form is explicitly achieved by the competent elimination of content; see also Heywood 'An Art of Scholars', in Jenks (ed.) (1995).

25. In good art today this is what it remains.

26. For Calinescu, not generally someone who would spring to mind as a proponent of art theory, this kind of modernism is fundamentally supportive of the 'bourgeois idea of modernity':

> The doctrine of progress, the confidence in the beneficial possibilities of science and technology, the concern with time (a measurable time, a time that can be bought and sold and therefore has, like any other commodity, a calculable equivalent in money), the cult of reason, and the ideal of freedom defined within the framework of an abstract humanism, but also the orientation toward pragmatism and the cult of action and success – all have been associated in various degrees with the battle for the modern and were kept alive and promoted as key values in the triumphant civilization established by the middle class. (Calinescu, 1990, pp. 41–2)

This exposes one point of possible disagreement about modernism; radical postmodernists would like to be rid of the whole thing, while many other art theorists find works and artists within the modern movement they would wish to preserve. For example, those from a Marxist background might emphasise the progressive social engagement of Russian Constructivism and the Bauhaus, and in this way seek to distinguish them from the ideology of bourgeois modernity.

27. Art theorists are invariably contemptuous of what they call 'art appreciation', which often seems to mean any approach they see as insufficiently hostile to art.

28. His three disciplinary premises:

> (1) that artworks say (express, reveal, articulate, project) something determinate; (2) that such determinacy be grounded ultimately in authorial or artistic intention – what the *maker meant* to express or convey about a view of the world or about the truth of some internal or emotive state; and (3) that the properly equipped analyst could mimetically approximate such determinate intentionality by producing a *reading* that... similarly trained and skilled experts might agree possesses some consensual objectivity. (Preziosi, 1989, p. 29)

29. Preziosi uses the term 'ideology' fairly frequently. He sometimes wants it to suggest a belief which is simply untrue, on other occasions he seems to mean by it – along the lines of the classical Marxist definition – a widely propagated and believed system of lies or illusions which reflect and serve sectional interests. Given his general theoretical commitments (see below), it is difficult to see how it could comfortably have either meaning. Rather, it would have to indicate an idea which should not be taken at face value or a metaphor which has come to be taken literally.

30. See also Jay's interesting discussion of Lacan's interest in anamorphosis (Jay, 1993, pp. 360–4). He also notes Lyotard's use of the famous anamorphic skull from Holbein's *The Ambassadors* on the cover of the 4th edition of *Discours, Figure.*

31. The question is not asked as to whether phenomena are not equally or even *more* available for classification, knowledge and power through the application of numerical or algebraic symbols or the kinds of categories with which Aristotle and later Kant were concerned, which are formal in being abstracted from appearances; this strategy was argued for in one version by Plato himself and, as developed by Descartes and others in its more mathematical dimensions and within a somewhat different framework, eventually became a key in the growth of the Enlightenment's disciplinary sciences.

32. The approach of a Marxist social history approach like that of T. J. Clark and others associated with the New Art History. Wallach is quoted to this effect by Preziosi, see ibid., pp. 159–60.

33. See for example ibid., p.83: the panoptic disciplinary science renders hermeneutically obscure items legible by placing them in a discursive space of form and style which can be organised diachronically and synchronically.

34. See ibid., pp. 126–7.

35. See ibid., pp. 146–8, 152. It is not inconceivable that cave paintings simultaneously served referential, socio-structural, religious and aesthetic purposes for their creators.

36. This is a very overwritten book, full of avoidable jargon and obfuscation. Examples are legion; the sentence below is not untypical:

> Logocentrist paradigms of artistic activity are deponent metaphors oriented upon a core ontotheologism, one of whose historical manifestations was the co-ordination of Vision and Voice in Renaissance iconology. (ibid., p. 48)

Preziosi is also fond of peculiar double or triple negatives: 'There is no history that is not uninvested ideologically' (ibid., p. 44). This is presumably meant to suggest that all history is ideological; I think it actually says the opposite.

37. The latter being the term Lyotard employs to distinguish his approach from that of Rorty; quoted by Rosen (1987), p. 179.

38. For example, the rise of pop art during the 1960s has been seen as the inversion of values and conventions associated with the preceding movement, abstract expressionism and its critical climate. Abstract expressionism was serious (indeed in some cases positively angst ridden) and committed, endorsed painterly surfaces, and saw itself as belonging to high culture. Pop was deliberately frivolous or ironical, rejected painterly surfaces (or ironised them), drew upon and not infrequently saw itself as part of lowbrow culture. The contemporary transition from modernism to postmodernism has, in some of its cruder variants, similar binary-opposite characteristics.

Chapter 7

1. See for example Brubaker (1984), in particular Chapter 3. Also, as Schluchter (1983) notes, there is a 'double dualism' in Weber's philosophy of value, first between reality and value, and then within value between the theoretical (cognitive) and the practical (moral). For Parsons (1968) and Habermas (1984), Weberian value spheres rely upon distinctions between the logical, the religious or moral, and the aesthetic. To these correspond different kinds of symbolism or language in a broad sense: cognitive, evaluative and expressive respectively. Within the evaluative sphere, Weber is particularly concerned with possible (and often historically actual) conflicts between other-worldly and this-worldly orientations. This can be diagramatically represented:

Value Spheres I logical – cognitive symbolism

 moral
 or } evaluative symbolism { other worldly
 religious this worldly

 aesthetic – expressive symbolism

In 'Religious Rejections of the World and their Directions', Weber (1948) distinguishes between religious, ethical and, under the general heading of the expressive, the erotic and the aesthetic. Represented diagramatically:

Value Spheres II cognitive – science

 ethical – { politics
 economy
 family

 expressive – { art/the aesthetic
 erotic

Schluchter usefully summarises Weber's approach to value conflict:

> Socially significant value realisations congeal into institutional arrangements, which can have an history of their own. They elaborate symbols and regulate the possession of other-worldly and this-worldly goods. Therefore, institutional realms always consist of relations of legitimation *and* appropriation. They develop tensions with one another *because* they are based on values with different claims and interests. (Schluchter, 1983, p. 20)

Schluchter goes on to insist that it is only this institutional mediation of values – from which springs the social reality of value sphere conflict – that enables Weber to escape the charge that autonomous realisation of the inner logics of value spheres amounts to an Hegelian teleology.

Finally on this issue, Habermas notes that, for Weber, the autonomy of art means that the 'inner logic (*Eigengesetzlichkeit*) of art' (Habermas, 1984, p. 160) can develop. This makes possible 'a rationalization of art and, therewith, a cultivation of experience in dealing with inner nature, that is, the methodical–expressive interpretation of a subjectivity freed from the everyday conventions of knowledge and action' (ibid., p. 161). From a sociological point of view, an autonomous art in this sense does not contribute to societal rationalisation but comes to have a 'compensatory function', a 'counter world' to the objectified reality of civil society. On the other hand, the aesthetic, even as a constantly differentiating sphere of otherness, nevertheless belongs together with science and technology, and ethical and legal systems, to the culture of modernity as a whole, and cannot be considered outside that context.

2. Cf. Lyotard's array of incommensurable language games discussed below.

3. Formulated along the lines of Lyotard, this would suggest that if the rise of science and rationalisation in general initiates modernity then the withering away of confidence in the capacity of science, or any metaphysical or grammatical discourse, to ground the whole ushers in a position beyond modernity.

4. Not surprisingly, given the neo-Kantian background to Weber's thought, Kant's discussion of judgements of taste in the *Critique of Judgement* resonates at certain points with the ways in which Weber seems to understand value choice.

Judgements of taste determine the beautiful, which is quite distinct from the merely agreeable. He who finds something beautiful 'requires the same thing from others; he then judges not just for himself, but for everyone, and speaks of beauty as if it were a property of things' (Kant, 1987, pp. 55–6). To judge in this way is, then, to make a claim upon others not on the basis of empirical generalisation about what one might expect them to like, as this might be predicted on the basis of experience. It is rather to 'demand agreement' of others.

The imperative character of judgements of taste is not rooted in or justified by knowledge of the object, by a concept. Such judgements have only 'subjective', not 'objective' or 'universal' validity. 'But if a judgement has *subjective* – i.e., aesthetic – *universal validity*, which does not rest on a concept, we cannot infer that it also has logical universal validity, because such judgements do not deal with the object [itself] at all' (ibid., p. 58). These characteristics of judgements of taste, that they cannot be authorised by something external to them (either conceptual or, seemingly, empirical) but that they also entail a universality and significance that could not be grounded in

arbitrary personal preference, catches something of the paradoxical and problematic nature of fundamental value judgements for Weber.

5. As Parkin points out (Parkin, 1982), there is a clear distinction in Weber's work between the state and the nation, the latter being a cultural community unified by a common language, and powerful sentiments and symbols. 'Politics as a Vocation' concentrates exclusively on the state. It is also notable that in this essay and, for Parkin throughout Weber's work, there is so little discussion of what this power, in the last analysis, this violence, is actually for. Weber seems to believe that states are naturally predatory, and therefore tend to acquire the means of defence and attack. This pessimistic assumption, that predation is the normal state of affairs in social and political life, also seems to apply to the relationship between groups or classes within a society. Social order, nationally and internationally, is fragile and temporary. It must be imposed on contending groups by violence or the threat of violence. The influence of Machiavelli and Hobbes is clear.

6. Compare with Schluchter: 'In spite of some remarks to the contrary, [an ethic of convictions and an ethic of responsibility] denote in the final analysis two diametrically opposed political ethics between which he [Weber] chooses with regard to their appropriateness for the present time' (Roth and Schluchter, 1979, p. 88).

7. In his essay 'Value Neutrality and the Ethic of Responsibility' (in Roth and Schluchter, 1979) Schluchter discusses 'Politics as a Vocation'. While, for Schluchter, the conflict between these two ethics is *within* ethics, it seems to me more correct to say that the ethic of responsibility is both a specific ethical view and that it is part of an effort to establish a sense of the political in modernity, a broader sense which informs his theorising as a whole. For Schluchter, Weber's view that science can enable value clarification and can comment on suitable means for goal attainment and likely consequences, protects him from the charge of 'decisionism', levelled at him by Habermas and others: the belief that the contemporary political process he describes amounts to no more than the arbitrary choice of goals by political leaders that are then rationally implemented by a wholly subservient, technocratic bureaucracy. These arguments suggest also that Weber's response to the moral difficulties of modernity may be more complex than MacIntyre allows in his well-known and important discussion (MacIntyre, 1985, Chapter 9).

8. This corresponds to a rejection of the Kantian view that an analysis of practical reason will yield rationally grounded, universal moral rules.

9. See Lukes (1973), pp. 465–70.

10. Speaking of the totem, the emblem or symbol of a clan, Durkheim writes:

> By expressing the social unity in a material form, it makes this more obvious to all... But more than that... for the emblem is not merely a convenient process for clarifying the sentiment society has of itself: it also serves to create this sentiment; it is one of its constituent elements. (Durkheim, 1971, p. 230)

11. Cf. the discussion of Gadamer below, Chapter 8.

12. 'Science is unsuitable because, in so far as religion is action, and in so far as it is a means of making men live, science could not take its place, because even if this expresses life, it does not create it; it may well seek to explain the faith, but by that very act it presupposes it' (Durkheim, 1971, p. 430).

13. He writes: 'we are going through a stage of transition and moral mediocrity' (ibid., p. 427).
14. 'Men cannot celebrate ceremonies for which they see no reason, nor can they accept a faith which they in no way understand' (ibid., p. 430).
15. The issue is left hanging in the final passages of the discussion:

> From now on, faith no longer exercises over the system of representations, which we can continue to call religious, the same hegemony as before. Confronting it stands a rival power, its offspring which will subject it to its own criticism and control. All the signs indicate that this control will continually increase, and be ever more effective, while no limit can possibly be fixed on its future influence. (ibid.)

16. As opposed to the 'spiritual' individualism of philosophers like Kant, for example; see Durkheim (1975), pp. 59–73.
17. See Durkheim (1970), pp. 363–4.
18. And, for Durkheim, the origin of art; see Durkheim (1971), p. 127.
19. At first sight, a Durkheimian approach to the sociology of art might be taken to point in the unpromising direction of traditional collectivist art; one thinks perhaps of Russian socialist realism, of Latin American muralists, or even of community art. However, the Durkheimian view would run counter to the idealised depiction of one class or national group as expressive social symbols. The ideal of organic solidarity is 'liberal' in the respect it entails for genuine individuality and diversity. For example, the rejection of the positivist view that science, and particularly social science, could or should seek a legislative political power constitutes a recognition of the autonomy, specificity, and limits of science. In this sense, a concrete image of sociality for art to 'express' is simply not available.
20. Also cited in his interesting argument against 'doom and gloom' detraditionalisation theories by Heelas in Heelas, Lash and Morris (eds) (1996), pp. 200–22.
21. For Lyotard, this is the idea of a saving 'meta-language'; see below.
22. Historically, the emergence of this possibility for self-consciousness is associated with institutions of various kinds: in particular, universities, academies, laboratories, bureaucracies engaged in instrumental–rational action of various kinds. Yet, once a language exists self-consciously in this way, it is in principle separable from its institutional context; even if its institutions were politically suppressed the discourse would not necessarily be deprived of its capacity for self-consciousness and reflection.
23. See Chapter 4.
24. This is not to suggest, of course, that before the Enlightenment human life and experience were holistic. The point is to evaluate the significance of the structures divisions and articulations characteristic of modernity.
25. In Hegelian terminology, this would correspond to a shift from *an sich* to *für sich*.
26. See below, Chapter 8.
27. The concept of reflexivity has been widely discussed in recent years. My interest in the idea goes back to undergraduate studies at Goldsmiths' College in the 1970s. See for example Sandywell *et al.* (1975) and also various works by Alan Blum (1974, 1978) and Peter McHugh *et al.* (1974).

28. See Oakeshott (1962). In the discussion that follows, poetry is taken to represent the arts in general.
29. It would be interesting to explore some of the resonances with Adorno. While Adorno is in some respects similarly pessimistic, nevertheless the very formality and uselessness of good modern art are replete with determinate social and philosophical significance. They are themselves important forms of resistance.
30. See for example Paul Guyer's (1979) discussion, particularly pp. 39–53, pp. 110–19.
31. For example: 'The history of mankind can be seen, in the large, as the realization of Nature's secret plan to bring forth a perfectly constituted state as the only condition in which the capacities of mankind can be fully developed, and also bring forth that external relation among states which is perfectly adequate to this end' (Kant, 1963, p. 21).
32. One is reminded of Matisse:

> What I dream of is an art of balance, of purity and serenity devoid of troubling or depressing subject matter, an art which might be for every mental worker, be he businessman or writer, like an appeasing influence… something like a good armchair in which to rest from physical fatigue. (Chipp 1968, p. 135)

Against this, however, it would seem to me that Matisse's best work is in fact demanding, austere despite its opulence, and sometimes strangely disturbing.
33. The endorsement of the unconscious and the development of techniques to explore its mysterious promptings can perhaps better be understood as rejections of predominant views about reason, practicality and acceptable behaviour than in terms of their aesthetic fruitfulness. One thinks here of Dadaism, and perhaps even more of Surrealism's rejection of the 'bourgeois' outlook on life. Consider Breton's remark:

> I do know that art, which for centuries has been forced to stray very little from the beaten path of the ego and superego, cannot help but be eager to explore the immense and almost virgin territory of the id in all directions. (Breton, 1972, p. 232)

Chapter 8

1. One finds in Heidegger and Gadamer a particular view of the achievements of great thinkers. It is not so much that Kant and Hegel, for example, invent monumental systems of thought which, perhaps through their originality, complexity, rigour or scope somehow impose themselves upon later thinkers. Rather, their thought reveals dimensions of a fundamental relationship with being which cannot be 'got round' and certainly never manipulated. Thinkers like these are not primarily architects of grand mental constructions, or Nietzschean artist–warriors, but rather vehicles or channels for thought.
2. I would insist here that this kind of approach is capable of being both 'affirmative' and critical.
3. The discussion above should indicate why I believe it to be highly relevant to a social theory which is concerned with the kinds of reflexive questions at stake here.

4. This is 'movement as movement, exhibiting so to speak a phenomenon of excess, of living self-representation' (Gadamer, 1986, p. 23).
5. Another way of putting this would be to say that the detraditionalisation of art leading up to the modern period finally eliminates the ritualised bond between audience and work, thus creating a 'barrier' which many modern artists have then tried to overcome through the interpretative requirement of participation.
6. Or of form with content, or signifier with signified.
7. See Lash in Beck, Giddens and Lash (1994).
8. Cf. Barthes' critique of the image as something removed from or resisting meaning (Barthes, 1977, pp. 32–51), and Bryson's conception of the image as the site of a struggle between the opposing forces of the discursive and the figural, which is much indebted to Lyotard (Bryson, 1981, pp. 1–28).
9. Even when a language envisages a limit to its scope, perhaps as 'nature' or perhaps out of political or ethical considerations, it is necessary to see how this 'other' belongs to the continuity of human understanding.
10. This would not, of course, be Heidegger's way of putting the problem.
11. As Weinsheimer notes, this view of the task of hermeneutics appears to risk a new 'global imperialism'.

> With respect to the tradition of art, aesthetic differentiation – the differentia-tion of art from non-art, from the world, from time, and from us, that creates aesthetics itself – is one symptom of the loss and disintegration that hermeneu-tics exists to repair. The assimilation of difference – of aesthetic difference, as of any other – is not just the purpose of hermeneutics, but its essence as well. (Weinsheimer, 1985, pp. 130–1)

12. 'Das Bild ist ein Seinsvorgang – in ihm kommt Sein zur sinnvoll-sichtbaren Erscheinung' (Gadamer, 1960, p. 137).
13. Compare with Taylor's view of the art work as an 'epiphany'; see above, Chapter 5.
14. This kind of point about the distinctive claims of works of art to truth is notoriously difficult to put without sounding tautologous or claiming that art objects are true in the ways in which ordinary knowledge can be, but somehow 'more so'. Despite the difficulty, it is still important. A perhaps minor example, but one which is very familiar, is the disappointment of the photograph, that is, the feeling of anticlimax when photographs of holidays, news events, and so forth do not quite live up to expectations. Of course, some photographs do succeed – they possess the quality discussed by Barthes as *punctum* – but not just by being chemical deposits left in a mechanical recording device pointed at the event in question.
15. To paraphrase Durkheim, we might then say that the question of society is the soul of art (Durkheim, 1971, p. 419). Of course, for Hegel the binding moral character of society is not so much a question as a given reality.
16. I would want to restate the difference here between purely theoretical or philosophical aesthetics and the practical aesthetic discourse of art worlds.
17. It is from this imperative – constantly to radicalise itself – that difficulties with the identity and quality of art arise. The works of Cézanne, Matisse or Picasso are innovative but do not weaken the distinctions between art and other practices. These reformations of art remain decisively within art, certainly not by observing a prescribed set of rules; yet they enable one to see retrospectively what

some of the 'rules' might be. In this modernist para-tradition, in Lyotard's terms, imagination or violence is not restricted to the moves but extends to rules as well; yet the imagination still belongs to art. Difficulties arise when games other than art are played with the rules.

18. Paradoxically then, while the work of art begins without rule it succeeds only when it discovers rules which govern it absolutely. As Rieff remarks, touching on this difference between art and politics:

> in a true culture a genius is not considered a criminal, nor is criminality honored as genius. Life is not confused with Art. *Terribilita* should remain an aesthetic, not a political, capacity; it rightly belonged to Beethoven and Michelangelo, in their work, not to the condottieri, or Hitler, in theirs. An extraordinarily rare talent does not emerge in transgressions; rather, in works of art or science that control their own spheres with full interdictory force, called 'form'. (Rieff, 1985, p. 46)

19. See Kuhn (1962); also Vattimo (1988).
20. Artists are inevitably spectators when they confront not only the work of others but also when they review their own.
21. This idea of the picture would include works of art like installations and performances which seek more contact with unconventional artistic settings.
22. Gadamer writes: 'human play finds its true perfection in being art' (ibid., p. 99).
23. I am indebted to Nicholas Davey for this point.
24. As my colleague George Hainsworth pointed out in a lecture, it is surely no accident that these deeply felt and moving works were produced by Monet during and shortly after the First World War. While they are certainly not paintings of war they should perhaps be considered as war paintings. See Spate (1992), Chapter 6.
25. 'The hermeneutics developed here is not… a methodology of the human sciences, but an attempt to understand what the human sciences truly are, beyond their methodological self-consciousness, and what connects them with the totality of our experience of the world' (Gadamer, 1975, p. xiii).
26. Both Dilthey and Husserl regarded 'pure' subjective experience in this sense as an abstraction. As Gadamer notes: 'Just as Dilthey begins with experience only in order to reach the concept of psychic continuity, so Husserl shows that the unity of the flow of experience is anterior to the discreteness of experiences and necessary to it' (Gadamer, 1975, pp. 220–1).
27. 'Mathematics' is here perhaps best understood in the sense of *mathematica universalis* discussed by Heidegger in *What is a Thing?* (1967, pp. 101–6). This is an axiological project which must be absolutely certain, and is to establish in advance the nature of being and its relationship with the thought of the subject.
28. Cf. Bauman's discussion (1991, Chapter 3).
29. For example, the concepts of social theory can be seen as reactions to the progressive estrangement of social phenomena as modernity widens and deepens its hold: the key ideas of workers, women, teenagers, deviants, and more recently, of children (see Jenks, 1996) all provide examples.
30. Cf. Hebdige's classic *Subculture: The Meaning of Style* (1979).
31. 'It becomes an historical power, in that the moral sphere is what is lasting and powerful in the movement of history' (Gadamer, 1975, p. 189).

Chapter 9

1. This is the question posed by Lyotard with respect to Kant's Idea of justice; see above, Chapter 7.
2. Cf. Bauman's various discussions of 'strangerhood': (1991) Chapter 3, (1993) Chapter 6.
3. 'Sein, das verstanden werden kann, ist Sprache' (Gadamer, 1960, p. 450).
4. Cf. Hodge's suggestion that Heidegger's ethics, closely connected to his notion of language, is concerned with modes of experience which modernity characteristically sees in a negative way. Thus her distinction between ethics and metaphysics: 'ethics is concerned with responsiveness, and metaphysics with monological construction' (Hodge, 1996, p. 39). I take 'monological construction' to correspond to sub-cultural poetics, and the celebration or condemnation they receive at the hands of social theory.
5. I have argued that Gadamer's specific arguments are fruitful and interesting when applied to contemporary visual art; for example, his suggestion that understanding must presuppose that the art work is definite and complete in its meaning; that this meaning is a specific truth; that the formalistic appreciation of materials and technique is a debasement of a proper appreciation of the art work.
6. There are exceptions, of course: for example, illuminated manuscripts and Eastern calligraphy.
7. This parallels the notion of the *phoneme* and the *mytheme* as the basic units for the signifying systems of speech and mythology respectively.
8. This idea has, of course, been repudiated by some theorists and their artist followers. Whatever the theoretical interest of ideas about 'dis-affirmative art' the results *vis-à-vis* artistic value, however determined, have been minimal. I have in mind Kossuth, Levine, Art and Language.
9. Phillipson quite consistently follows through some of the implications. In his subsequent book *In Modernity's Wake* he abandons many of the usual academic conventions in favour of a more playful way of writing in keeping with what he is trying to write about. Yet what is going on is still recognisable as theory. It does not restructure itself according to the demands of another literary genre like poetry or the novel, which it would have to if it were going to be considered as art rather than theory. Having said this, Phillipson's writing since *Painting, Language and Modernity* should probably be seen as a sustained attempt to write 'between' theory, practice, and a kind of cultural politics, an attempt which is shared by my approach here.
10. In a Heideggerian vein, this would be to ask what kind of no-thing is language?
11. For Heidegger, the difference between Being – in later works, language – and beings is the 'ontological difference'.
12. For Nietzsche, 'perspectives'.
13. 'Perspectives are chaotic organizations of chaos: the order is itself the activity of chaos and not of a separate principle' (Rosen, 1980, p. 194).
14. Alvin Gouldner's *The Two Marxisms* remains an admirable analysis of how European Marxism experienced and tried to deal with these tensions.
15. Cf. Beck's (1992) discussion, Chapter 2.
16. As Rosen notes, 'Nietzschean historicist ontology therefore takes practical shape as poeticist politics' (Rosen, 1969, p. 106).
17. This is, I think, the core of the pathos of Gerhard Richter's various 'post-art' works.

Chapter 10

1. Nor is it the case that these ideas and beliefs are necessarily closely connected to any particular political, ideological or aesthetic point of view, except perhaps that which recognises and values creative art practice.
2. For example, it would seem sensible in many cases to believe that, in order to intervene successfully in a social problem, the state or one of its agencies must influence attitudes and behaviour; legislation aimed at infrastructural change, and assumed then to alter behaviour, is not enough. One needs to understand the situation from the inside, from the point of view of the 'limited' rationality of members, and at this point interpretation of some kind comes into play.
3. In the old sense of a moral world.
4. The idea of language as a 'something' is, of course, highly problematic; for Heidegger, quite consistently, it is better referred to as 'No-thing'.

Bibliography

Abercrombie, N., Hill, S. and Turner, B. S. (1980) *The Dominant Ideology Thesis*. London, George Allen & Unwin.

Abrams, M. H. (1953) *The Mirror and the Lamp: Romantic Theory and the Critical Tradition*. Oxford, Oxford University Press.

Altham, J. E. J. and Harrison, Ross (eds) (1995) *World, Mind, and Ethics*. Cambridge, Cambridge University Press.

Althusser, Louis (1971) *Lenin and Philosophy and Other Essays*. London, New Left Books.

Althusser, Louis and Balibar, Etienne (1970) *Reading Capital*, trans. by Ben Brewster. London, New Left Books.

Apel, Karl-Otto (1980) *Towards a Transformation of Philosophy*, trans. by G. Adey and D. Frisby. London, Routledge & Kegan Paul.

Apel, Karl-Otto *et al.* (1971) *Hermeneutic und Ideologiekritick*. Frankfurt am Main, Suhrkamp Verlag.

Arato, Andrew and Breines, Paul (1979) *The Young Lukács and the Origins of Western Marxism*. London, Pluto Press.

Barthes, Roland (1977) *Image–Music–Text*, trans. by Stephen Heath. Glasgow, Fontana/Collins.

Battcock, Gregory (1966) *The New Art*. New York, E. P. Dutton.

Battcock, Gregory (1968) *Minimal Art: A Critical Anthology*. New York, E. P. Dutton.

Bauman, Zygmunt (1987) *Legislators and Interpreters*. Cambridge, Polity Press.

Bauman, Zygmunt (1991) *Modernity and Ambivalence*. Cambridge, Polity Press.

Bauman, Zygmunt (1992) *Intimations of Postmodernity*. London, Routledge.

Bauman, Zygmunt (1993) *Postmodern Ethics*. Oxford, Blackwell.

Beck, Ulrich (1992) *Risk Society*, trans. by M. Ritter. London, Sage.

Beck, Ulrich, Giddens, Anthony and Lash, Scott (1994) *Reflexive Modernization*. London, Routledge.

Becker, Howard (1982) *Art Worlds*. Berkeley, University of California Press.

Beckett, Wendy and Wright, Patricia (1994) *The Story of Painting*. London, D. K. Publishing.

Berger, John (1972) *Ways of Seeing*. London, BBC and Penguin.

Bernstein, Richard J. (1985) *Habermas and Modernity*. Cambridge, Polity Press.

Bleicher, Josef (1980) *Contemporary Hermeneutics*. London, Routledge & Kegan Paul.

Bloch, Ernst, Lukács, Georg, Brecht, Bertolt, Benjamin, Walter and Adorno, Theodor (1977) *Aesthetics and Politics*. London, Verso.

Blum, Alan (1974) *Theorizing*. London, Heineman.

Blum, Alan (1978) *Socrates: The Original and Its Images*. London, Routledge & Kegan Paul.

Bois, Yve-Alain (1993) *Painting as Model*. Cambridge, Mass., MIT Press.

Bourdieu, Pierre (1974) *La Distinction: critique sociale du jugement*. Paris, Editions de Minuit.

Bradbury, Malcolm and McFarlane, James (eds) (1976) *Modernism.* Harmondsworth, Penguin.

Breton, André (1972) *Manifestos of Surrealism,* trans. by R. Seaver and H. R. Lane. Ann Arbor, University of Michigan Press.

Brubaker, Rogers (1984) *The Limits of Rationality.* London, George Allen & Unwin.

Bryson, Norman (1981) *Word and Image.* Cambridge, Cambridge University Press.

Bürger, Peter (1984) *Theory of the Avant-Garde,* trans. by M. Shaw. Manchester, Manchester University Press.

Calinescu, Matei, (1990) *The Five Faces of Modernity.* Durham, Duke University Press.

Chipp, Herschel B. (ed.) (1968) *Theories of Modern Art: A Source Book by Artists and Critics.* Berkeley, University of California Press.

Cladis, Mark S. (1992) *A Communitarian Defence of Liberalism: Emile Durkheim and Contemporary Social Theory.* Stanford, Stanford University Press.

Clark, Kenneth (1969) *Civilization: A Personal View.* London, BBC.

Clark, T. J. (1990) *The Painting of Modern Life: Paris in the Art of Manet and His Followers.* London, Thames and Hudson.

Cole, Bruce (1980) *Sienese Painting.* New York, Harper & Row.

Danto, Arthur (1964) The Artworld. *Journal of Philosophy,* **61**(10):571–84.

Danto, Arthur (1973) The Last Work of Art: Artworks and Real Things. *Theoria,* **39**:93. Reprinted in G. Dickie and R. J. Sclafani (1977).

Danto, Arthur C. (1986) *The Philosophical Disenfranchisement of Art.* New York, Columbia University Press.

Dickie, George (1964) The Myth of the Aesthetic Attitude. *American Philosophical Quarterly,* **1**:1.

Dickie, George (1969) Defining Art. *American Philosophical Quarterly,* **6**.

Dickie, George (1973) Defining Art II. In Lipman, M. *Contemporary Aesthetics.* Boston, Allyn & Bacon.

Dickie, George and Sclafani, R. J. (1977) *Aesthetics.* New York, St Martin's Press.

Dillon, Martin C. (1991) *Merleau-Ponty Vivant.* New York, State University of New York Press.

Dilthey, Wilhelm (1976) *Dilthey: Selected Writings,* edited and introduction by H. P. Rickman. Cambridge, Cambridge University Press.

Douglas, Mary (1981) High Culture and Low. *Times Literary Supplement,* 13 February.

Dupré, Louis (1993) *Passage to Modernity.* New Haven and London, Yale University Press.

Durkheim, Emile (1938) *The Rules of Sociological Method,* trans. by S. A. Solovay and J. H. Mueller, edited by G. E. G. Catlin. New York, The Free Press.

Durkheim, Emile (1970) *Suicide,* trans. by J. A. Spalding and G. Simpson, edited and with introduction by G. Simpson. London, Routledge & Kegan Paul.

Durkheim, Emile (1971) *The Elementary Forms of Religious Life.* London, George Allen & Unwin.

Durkheim, Emile (1974) *Sociology and Philosophy,* trans. by D. F. Pocock. New York, The Free Press.

Durkheim, Emile (1975) *Durkheim on Religion,* edited by W. S. F. Pickering. London, Routledge & Kegan Paul.

Eagleton, Terry (1976) *Criticism and Ideology.* London, Verso.

Eliot, Thomas Stearns (1975) *Selected Prose of T. S. Eliot*, edited and introduction by Frank Kermode. London, Faber & Faber.

Elton, William (1954) *Aesthetics and Language*. Oxford, Blackwell.

Foucault, Michel (1972) *The Archaeology of Knowledge*, trans. by A. M. Sheridan Smith. London, Tavistock.

Frascina, Francis and Harrison, Charles (eds) (1982) *Modern Art and Modernism*. London, Harper & Row.

Fried, Michael (1965) Three American Painters. In F. Frascina and C. Harrison (1982).

Fuller, Peter (1980) *Beyond the Crisis in Art*. London, Writers and Readers.

Gadamer, Hans-Georg (1960) *Warheit und Method*. Tübingen, J. C. B. Mohr.

Gadamer, Hans-Georg (1975) *Truth and Method*. London, Sheed and Ward.

Gadamer, Hans-Georg (1976) *Hegel's Dialectic*, trans. by P. Christopher Smith. New Haven, Yale University Press.

Gadamer, Hans-Georg (1976) *Philosophical Hermeneutics*, trans. and edited by David E. Linge. Berkeley, University of California Press.

Gadamer, Hans-Georg (1981) *Reason in the Age of Science*, trans. by F. G. Lawrence. Cambridge, Mass., MIT Press.

Gadamer, Hans-Georg (1986) *The Relevance of the Beautiful and Other Essays*, trans. by Nicholas Walker. Cambridge, Cambridge University Press.

Giddens, Anthony (1981) *A Contemporary Critique of Historical Materialism*, vol. 1. London, Macmillan.

Giddens, Anthony (1991) *Modernity and Self-identity: Self and Society in the Late-Modern Age*. Cambridge, Polity Press.

Gombrich, Ernst (1959) *Art and Illusion*. Oxford, Phaidon Press.

Gouldner, Alvin (1980) *The Two Marxisms*. London, Macmillan.

Graham-Dixon, Andrew (1996) *A History of British Art*. London, BBC.

Gutkind, E. A. (1969) *Urban Development in Southern Europe: Italy and Greece*. New York, The Free Press.

Guyer, Paul (1979) *Kant and the Claims of Taste*. Cambridge, Mass., Harvard University Press.

Habermas, Jürgen (1972) *Knowledge and Human Interests*, trans. by J. J. Shapiro. London, Heineman.

Habermas, Jürgen (1981) *Modernity versus Postmodernity*, New German Critique, 22.

Habermas, Jürgen (1984) *The Theory of Communicative Action*, vol. 1, *Reason and the Rationalization of Society*, trans. by T. McCarthy. London, Heinemann.

Habermas, Jürgen (1987) *The Philosophical Discourse of Modernity*, trans. by F. Lawrence. Cambridge, Polity Press.

Hanfling, Oswald (ed.) (1992) *Philosophical Aesthetics*. Oxford, Blackwell.

Harrison, Charles and Wood, Paul (eds) (1992) *Art In Theory*. Oxford, Blackwell.

Haskell, Francis (1976) *Rediscoveries in Art*. Oxford, Phaidon Press.

Hebdige, Dick (1979) *Subculture: The Meaning of Style*. London, Methuen.

Hebdige, Dick (1988) *Hiding in the Light*. London, Routledge & Kegan Paul.

Heelas, Paul, Lash, Scott and Morris, Paul (eds) (1996) *Detraditionalization*. Oxford, Blackwell.

Hegel, Georg Wilhelm Friedrich (1975) *Aesthetics: Lectures on Fine Art*, vols 1 and 2, trans. by T. M. Knox. Oxford, Clarendon Press.

Hegel, Georg Wilhelm Friedrich (1977) *Phenomenology of Spirit*, trans. by A. V. Miller. Oxford, Clarendon Press.

Heidegger, Martin (1967) *What is a Thing?* trans. by W. B. Barton and V. Deutsch. Chicago, Henry Rognery.

Heidegger, Martin (1968) *What is Called Thinking?*, trans. by F. D. Wiek and J. Glenn Grey, introduction by J. Glenn Grey. New York, Harper & Row.

Heidegger, Martin (1969) *Identity and Difference*, trans. by Joan Stambaugh, edited by J. Glenn Gray. New York, Harper & Row.

Heidegger, Martin (1971) *On the Way to Language,* trans. by Peter D. Hertz. New York, Harper & Row.

Heidegger, Martin (1971) *Poetry, Language, Thought*, translations and introduction by Albert Hofstadter. New York, Harper & Row.

Heidegger, Martin (1973) *The End of Philosophy*, trans. by Joan Stambaugh. London, Souvenir Press.

Heidegger, Martin (1977) *The Question Concerning Technology and Other Essays*, trans. and with an introduction by W. Lovitt. New York, Harper & Row.

Heidegger, Martin (1981) *Nietzsche,* vol. 1: *The Will To Power As Art*, trans. and with analysis by D. F. Krell. London, Routledge & Kegan Paul.

Herwitz, Daniel (1993) *Making Theory, Constructing Art: On the Authority of the Avant-Garde*. Chicago, University of Chicago Press.

Heywood, Ian and Sandywell, Barry (eds) (1997) *Exploring the Hermeneutics of the Visual*. London, Routledge.

Hodge, Joanna (1995) *Heidegger and Ethics*. London, Routledge.

Hollis, Martin and Lukes, Steven (eds) (1982) *Rationality and Relativism*. Oxford, Blackwell.

Horkheimer, Max and Adorno, Theodor (1979) *The Dialectic of Enlightenment*, trans. by John Cummin. London, Verso.

Horowitz, Irving Louis (1993) *Decomposition of Sociology*. Oxford, Oxford University Press.

Horton, John and Mendus, Susan (1994) *After MacIntyre*. Oxford, Blackwell.

Hoy, David Couzens (1978) *The Critical Circle*. Berkeley, University of California Press.

Hughes, Robert (1980) *The Shock of the New*. London, BBC.

Jay, Martin (1993) *Downcast Eyes: The Denigration of Vision in Twentieth-Century French Thought*. Berkeley, University of California Press.

Jenks, Chris (1993a) *Culture*. London, Routledge.

Jenks, Chris (ed.) (1993b) *Cultural Reproduction*. London, Routledge.

Jenks, Chris (ed) (1995) *Visual Culture*. London, Routledge.

Jenks, Chris (1996) *Childhood*. London, Routledge.

Johnson, Galen A. (1993) *The Merleau–Ponty Aesthetics Reader*. Evanston, Northwestern University Press.

Kant, Immanuel (1928) *Critique of Judgement*, trans. by James Creed Meredith. Oxford, Oxford University Press.

Kant, Immanuel (1956) *Critique of Practical Reason*, trans. by Lewis White Beck. Indianapolis, Bobbs-Merrill.

Kant, Immanuel (1963) *On History*, edited by Lewis White Beck, trans. by L. W. Beck, R. E. Anchor and E. L. Fackenheim. Indianapolis, Bobbs-Merrill.

Kant, Immanuel (1964) *Groundwork of the Metaphysics of Morals*, trans. by H. J. Paton. New York, Harper & Row.

Kant, Immanuel (1973) *Critique of Pure Reason,* trans. by Norman Kemp Smith. London, Macmillan.

Kant, Immanuel (1978) *Critique of Judgement*, trans. by James Creed Meredith. Oxford, Oxford University Press.

Kant, Immanuel (1987) *Critique of Judgement*, trans. by Werner S. Pluhar. Indianapolis, Hackett.

Kuhn, Thomas (1962) *The Structure of Scientific Revolutions*. Chicago, Chicago University Press.

Lacan, Jacques (1979) *The Four Fundamental Concepts of Psychoanalysis*, trans. by Alan Sheridan. Harmondsworth, Penguin.

Laing, Dave (1978) *The Marxist Theory of Art*. Sussex, Harvester Press.

Lampert, Laurence, (1993) *Nietzsche and Modern Times*. New Haven, Yale University Press.

Larner, John (1980) *Italy in the Age of Dante and Petrarch 1216–1380*. London, Longman.

Lukács, Georg (1963) *The Meaning of Contemporary Realism*, trans. by J. and M. Mander. London, Merlin Press.

Lukes, Steven (1973) *Emile Durkheim*. London, Allen Lane.

Lukes, Steven (1985) *Marxism and Morality*. Oxford, Oxford University Press.

Lyotard, Jean-Francois (1984) *Driftworks*. edited by Roger McKeon. New York, Semiotext(e).

Lyotard, Jean-Francois (1984) *The Postmodern Condition: A Report on Knowledge*, trans. by G. Bennington and B. Massumi. Manchester, Manchester University Press.

Lyotard, Jean-Francois (1992) *The Postmodern Explained to Children*, trans. and edited by J. Pefanis and M. Thomas. London, Turnaround.

Lyotard, Jean-Francois and Thébaud, Jean-Loup (1985) *Just Gaming*, trans. by W. Godzich. Manchester, Manchester University Press.

MacIntyre, Alasdair (1985) *After Virtue: A Study in Moral Theory*. London, Duckworth.

MacIntyre, Alasdair (1988) *Whose Justice? Which Rationality?* London, Duckworth.

MacIntyre, Alasdair (1990) *Three Rival Versions of Moral Enquiry*. London, Duckworth.

Margolis, Joseph (ed.) (1987) *Philosophy Looks at the Arts*. Philadelphia, Temple University Press.

Marquard, Odo (1989) *Farewell to Matters of Principle*, trans. by R. M. Wallace. Oxford, Oxford University Press.

Marx, Karl (1973) *Grundrisse*. trans. by Martin Nicolaus. London, Penguin Books.

Marx, Karl (1975) *Early Writings*, trans. by R. Livingstone and G. Benton. London, Penguin.

Marx, Karl and Engels, Frederick (1970) *The German Ideology*, edited and with an introduction by C. J. Arthur. London, Lawrence & Wishart.

McHugh, Peter, Raffel, Stanley, Foss, Danield C. and Blum, Alan (1974) *On the Beginning of Social Enquiry*. London, Routledge & Kegan Paul.

Mothersill, Mary (1984) *Beauty Restored*. Oxford, Clarendon Press.

Nairn, Sandy (1987) *State of the Art*. London, Chatto & Windus.

Nietzsche, Friedrich (1967) *The Birth of Tragedy and The Case of Wagner*, trans. by Walter Kaufmann. New York, Vintage Books.

O'Neill, John (1995) *The Poverty of Postmodernism*. London, Routledge.

Oakeshot, Michael (1962) *Rationalism In Politics*. London, Methuen.

Osborne, Harold (1968) *Aesthetics and Art Theory*. London, Longman.

Panofsky, Erwin (1968) *Idea: A Concept in Art Theory*, trans. by J. J. S. Peake. New York, Harper & Row.

Parkin, Frank (1979) *Marxism and Class Theory: A Bourgeois Critique*. London, Tavistock.

Parkin, Frank (1982) *Max Weber*. Chichester, Ellis Horwood.

Parsons, Talcott (1968) *The Structure of Social Action*. New York, The Free Press.

Phillipson, Michael (1985) *Painting, Language and Modernity*. London, Routledge & Kegan Paul.

Phillipson, Michael (1989) *In Modernity's Wake: The Ameurunculus Letters*. London, Routledge.

Plato (1963) *The Collected Dialogues*, edited by E. Hamilton and H. Cairns. Princeton, Princeton University Press.

Preziosi, Donald (1989) *Rethinking Art History: Meditations on a Coy Science*. New Haven, Yale University Press.

Ricoeur, Paul (1970) *Freud and Philosophy*, trans. by Denis Savage. New Haven, Yale University Press.

Ricoeur, Paul (1981) *Hermeneutics and the Human Sciences*, edited and trans. by J. B. Thompson. Cambridge, Cambridge University Press.

Rieff, Philip (1985) *Fellow Teachers/Of Culture and Its Second Death*. Chicago, University of Chicago Press.

Rorty, Richard (1980) *Philosophy and the Mirror of Nature*. Oxford, Blackwell.

Rorty, Richard (1982) *Consequences of Pragmatism*. Brighton, The Harvester Press.

Rorty, Richard (1985) Habermas and Lyotard on Modernity, in R. J. Bernstein (1985).

Rorty, Richard (1989) *Contingency, Irony, and Solidarity*. Cambridge, Cambridge University Press.

Rosen, Stanley (1969) *Nihilism*. New Haven, Yale University Press.

Rosen, Stanley (1980) *The Limits of Analysis*. New York, Basic Books.

Rosen, Stanley (1987) *Hermeneutics as Politics*. Oxford, Oxford University Press.

Rosen, Stanley (1995) *Plato's Statesman: The Web Of Politics*. New Haven, Yale University Press.

Rosenberg, Harold (1959) *The Tradition of the New*. Chicago, University of Chicago Press.

Rosenberg, Harold (1964) *The Anxious Object*. New York, Collier/Macmillan.

Rosenberg, Harold (1985) *Art and Other Serious Matters*. Chicago, University of Chicago Press.

Roth, Guenther and Schluchter, Wolfgang (1979) *Max Weber's Vision of History*. Berkeley, University of California Press.

Sandywell, Barry, Silverman, David, Roche, Maurice, Filmer, Paul and Phillipson, Barry (1975) *Problems of Reflexivity and Dialectics in Sociological Enquiry*. London, Routledge & Kegan Paul.

Sandywell, Barry (1997) From Reflection to Reflexivity. In I. Heywood and B. Sandywell (1997).

Schama, Simon (1995) *Landscape and Memory*. New York, Alfred A. Knopf.

Schluchter, Wolfgang (1983) *The Rise of Western Rationalism*, trans. and with an introduction by G. Roth. Berkeley, University of California Press.

Schmeckebier, Lawrence (1981) *A New Handbook of Italian Renaissance Painting*. New York, Hacker Art Books.

Silverman, Hugh J. (ed.) (1991) *Gadamer and Hermeneutics.* London, Routledge.
Spate, Virginia (1992) *The Colour of Time: Claude Monet.* London, Thames and Hudson.
Summers, David (1981) *Michelangelo and the Language of Art.* New Jersey, Princeton University Press.
Taylor, Charles (1975) *Hegel.* Cambridge, Cambridge University Press
Taylor, Charles (1985) *Philosophy and the Human Sciences: Philosophical Papers II.* Cambridge, Cambridge University Press.
Taylor, Charles (1989) *Sources of the Self.* Cambridge, Cambridge University Press.
Taylor, Charles (1995) *Philosophical Arguments.* Cambridge, Mass., Harvard University Press.
Taylor, Roger L. (1978) *Art, an Enemy of the People.* Sussex, Harvester Press.
Touraine, Alan (1995) *Critique of Modernity,* trans. by D. Macey. Oxford, Blackwell.
Vattimo, Gianni (1988) *The End of Modernity,* trans. by J. R. Snyder. Oxford, Polity Press.
Vattimo, Gianni (1992) *The Transparent Society,* trans. by D. Webb. Oxford, Polity Press.
Wagner, Peter (1994) *A Sociology of Modernity: Liberty and Discipline.* London, Routledge.
Warnke, Georgia (1987) *Gadamer.* Cambridge, Polity Press.
Weber, Max (1947) *The Theory of Social and Economic Organization,* trans. by A. M. Henderson and Talcott Parsons. New York, The Free Press.
Weber, Max (1948) *From Max Weber,* trans. and edited by H. H. Gerth and C. Wright Mills. London, Routledge & Kegan Paul.
Weber, Max (1949) *The Methodology of the Social Sciences,* trans. and edited by E. A. Shills and H. A. Finch. New York, The Free Press.
Weber, Max (1958) *The Rational and Social Foundations of Music,* trans. and edited by D. Martindale, J. Riedel and G. Neuwirth. Southern Illinois University, Southern Illinois University Press.
Weinsheimer, Joel C. (1985) *Gadamer's Hermeneutics.* New Haven, Yale University Press.
Whimster, Sam and Lash, Scott (eds) (1987) *Max Weber, Rationality and Modernity.* London, Allen & Unwin.
White, Harrison C. and White, Cynthia A. (1965) *Canvases and Careers: Institutional Change in the French Painting World.* New York, John Wiley.
White, James Boyd (1984) *When Words Lose Their Meaning: Constitutions and Reconstitutions of Language, Character, and Community.* Chicago, University of Chicago Press.
Whiteley, Nigel (ed.) (1997) *Detraditionalization and Art: Aesthetic, Authority, Authenticity.* London, University of Middlesex Press.
Williams, Bernard (1985) *Ethics and the Limits of Philosophy.* London, Fontana.
Wilson, Bryan (ed.) (1970) *Rationality.* Oxford, Blackwell.
Witkin, Robert W. (1995) *Art and Social Structure.* Cambridge, Polity Press.
Wolff, Janet (1981) *The Social Production of Art.* London, Macmillan.
Wolff, Janet (1983) *Aesthetics and the Sociology of Art.* Hemel Hempstead, George Allen & Unwin.
Wollheim, Richard (1987) *Painting as an Art.* London, Thames and Hudson.

Index